IMAGES
of Rail

GRAND RAPIDS, GRAND HAVEN & MUSKEGON RAILWAY

IMAGES
of Rail

GRAND RAPIDS,
GRAND HAVEN &
MUSKEGON RAILWAY

David Kindem and James Budzynski

ARCADIA
PUBLISHING

Published by Arcadia Publishing
Charleston, South Carolina

Library of Congress Control Number: 2014948588

For all general information, please contact Arcadia Publishing:
Telephone 843-853-2070
Fax 843-853-0044
E-mail sales@arcadiapublishing.com
For customer service and orders:
Toll-Free 1-888-313-2665

Visit us on the Internet at www.arcadiapublishing.com

This book is dedicated to the men and women who built and worked for the Grand Rapids, Grand Haven & Muskegon Railway, 1902–1928.

CONTENTS

ACKNOWLEDGMENTS

The Grand Rapids, Grand Haven & Muskegon Railway did not leave behind business records, so the information for this book has been assembled through the efforts of a number of individuals over the years. Without their support, this volume would not be possible.

Carl Bajema, our coauthor for an earlier book on this interurban line, spent years gathering information from newspaper archives and a variety of other sources that provide a framework for the story. Jack Rollenhagen spent a lifetime collecting the photographs that visualize the line's history.

Others include west Michigan local historians, former interurban employees, and their families who have contributed photographs, artifacts, and knowledge of the line and its practices. These include Fred Brown, Harry F. Brown, the Streeter family, Albert French, Claude Taylor, Clyde Tissue, Rachael Reister, Elizabeth Van Allsburg, Eleanore Drooger, the William Thielman family, the Jubb family, Ron Cochran, David Trealoar, Larry Cooke, Ruth Horton, the Orrie Sietsema family, Art and Joy Kulicamp, Denny Hoffman, Art Gibson, Jerre Jean McDaniels, and Mary Cuson.

Unless otherwise noted, all images appear courtesy of the Coopersville Area Historical Society Museum.

INTRODUCTION

In the late 1890s, "Interurban Fever" came to west Michigan. Promoters were busily forming companies to adapt the new and somewhat mysterious electric motors that powered city streetcars and use them to propel cars into the countryside and beyond. What the promoters offered was a vision of quiet, clean, electric cars providing frequent and comfortable service between the cities of Michigan. In 1898, such cars were already running between Detroit and Ann Arbor and from Saginaw to Bay City. Promoters roamed west Michigan, trying to establish potential routes before some other group snapped them up. Several such groups began to acquire land and franchises to connect Grand Rapids with Lake Michigan, focusing on the port cities of Muskegon, Grand Haven, and Holland.

One group was formed by Charles W. Taylor of Detroit, who teamed up with a pair of Grand Rapids attorneys, Thomas Carroll and Joseph Kirwin. Carroll, a director of the street railway system in Grand Rapids, saw an opportunity to use the technology to connect the city with the lakeshore.

The three promoters formed a company, the Grand Rapids, Grand Haven & Muskegon Railway, and began assembling property for their right of way. In search of additional funding, they turned to Detroit and approached Wallace Franklin, a former Grand Rapids resident. Franklin was the Midwest representative of Westinghouse, Church, Kerr & Company, an engineering subsidiary of the Westinghouse Manufacturing Company. The Westinghouse firm was already at work designing and building electric interurban railways to connect Detroit with Jackson and Toledo with Cleveland in Ohio. As an engineering firm, Westinghouse designed and built the railways for a fee (and, of course, specified Westinghouse components) but did not own them.

At Franklin's suggestion, Westinghouse decided to back the group, but this time as owners, not just engineers. So, after a brief shuffling of personnel, the final company emerged, with Westinghouse firmly in control. Wallace Franklin recruited a friend and associate, James Dudley Hawks, as president. Hawks and Franklin had worked together to electrify the Detroit street railway in the early 1890s, and Hawks was the promoter of the Detroit–Ann Arbor interurban, which Westinghouse, Church, Kerr & Company was building at the time. With Hawks as president, Carroll as vice president, Franklin as secretary, and Kirwin as treasurer, the group began to complete its plans and prepared to begin building the Lake Line.

The interurban cars would leave Grand Rapids using the tracks of the city streetcar system, then travel on private right of way through the communities of Walker and Berlin (now Marne). At this point, the tracks would parallel the Detroit and Milwaukee Railroad to Coopersville and Nunica. From Nunica, the company would build on the abandoned roadbed of the old Chicago and Michigan Lakeshore Railroad to Fruitport and then strike a straight line to the northwest toward Muskegon, where cars would enter using the Muskegon street railroad. A branch would also be built to Grand Haven from a junction just south of Fruitport.

In Coopersville, on September 20, 1900, Thomas Carroll turned the first shovelful of dirt, and the project was begun. Construction continued through 1901, as crews worked both east and west from Coopersville. The line was completed to Muskegon in January 1902 and to Grand Haven in June 1903.

By 1904, construction was complete, and the GRGH&M had settled into day-to-day operations. Wilmot K. Morley was recruited as general manager, and James Hawks returned to his other activities, which included an effort to connect the GRGH&M with Detroit, Ypsilanti, Ann Arbor, and Jackson via Lansing. But the Grand Rapids to Lansing section was never built.

The interurban represented something new: hourly cars moving quietly along their tracks that stopped to pick up passengers at road crossings, not just stations. A farmer in Berlin could make a trip to Grand Rapids after work. A Nunica resident could commute to Muskegon to work in a factory. A company in Grand Rapids could charter a car for an employee outing at a Lake Michigan beach.

Ridership increased throughout the early years, and the company made a small profit. Arrangements were made with the Goodrich and Crosby steamship lines for through passage on the interurban cars and the lake boats. Passengers could buy a ticket and check their luggage in Grand Rapids, and then pick their bags up in either Chicago or Milwaukee after an evening trip on the interurban and an overnight ride on a boat.

In addition to passengers, interurban cars carried packages and freight. A fleet of freight motors made scheduled trips to move less-than-carload freight between the towns on its route and transport goods to Chicago and Milwaukee via the boats. Express shipments, packages, newspapers, and US mail all moved via the interurban cars, whose frequent schedules made same-day service possible. Fruit and produce grown in the region was important cargo also. The GRGH&M moved vast quantities of crops to wholesalers and processors in Chicago and Milwaukee each year during the growing season.

The Lake Michigan shoreline was resort country at the beginning of the 20th century. Vacationers from throughout the Midwest arrived at resorts in both Grand Haven and Muskegon via the cars of the interurban. The cars also carried the residents of the cities and towns it served on summer outings to the beach.

Since both resorts and farming are seasonal, the GRGH&M adopted a seasonal pattern, too. During the fall, winter, and spring, the company maintained a less-frequent schedule, running cars every 90 minutes instead of every hour. The Chicago and Milwaukee boats operated all winter, but also on a reduced schedule. Throughout the summer months, the Lake Line pulled out all the stops and ran at nearly full capacity.

For short distance travel, the passenger and freight cars of the GRGH&M were a serious competitor to the Pere Marquette, Grand Rapids and Indiana, and the Detroit and Milwaukee, which was part of the Grand Trunk system.

By 1911, Westinghouse, Church, Kerr & Company had decided to leave the business of owning and operating interurban railways and began to look for buyers for the GRGH&M and the Lackawanna and Wyoming Valley Railway in Pennsylvania, which it also owned. In early 1912, United Light and Railways, a fast-growing utility holding company based in Grand Rapids, became the new owner. UL&R owned interurban railroads in Iowa, the largest being an interurban–city street railway operation in Davenport, so the railway operations and engineering for the group were headquartered in that city. While the offices of the GRGH&M were located in the same building as the parent company in Grand Rapids, the railway took much of its direction from the railway headquarters in Davenport, Iowa.

During the first years of its ownership, United Light and Railways brought a new enthusiasm to its interurban business. A new, two-car boat train was purchased to improve the Chicago connection at Grand Haven, and many of the existing cars received new motors and electrical controllers. In addition, new passenger and freight stations were built in Berlin and Spring Lake, and a new freight house was built on the west side of Grand Rapids.

Through the early part of the 1910s, the line continued to do well. Both passenger and freight traffic grew each year, the beaches and resorts continued to draw huge crowds in the summer, and many west Michigan residents had built at least part of their lives around interurban commutes. It was not until the United States entered World War I that the first hints appeared to indicate the future might not be quite so rosy as the company hoped.

World War I brought inflation that strained the profits of the company and disrupted the boat traffic across Lake Michigan. The GRGH&M was not alone in its struggles. Other Michigan interurban lines, including the Detroit United Railway and the Michigan Railway, found themselves in similar positions. Together, the interurban companies began to petition the state legislature for permission to increase rates.

As the war wound down, a new threat appeared: the automobile, with its internal combustion engine. The technology behind the automobile had been around since the beginning of the interurban, but it was the combination of mass-produced automobiles and the concrete highways that began to appear in the late 1910s that seriously threatened the electric cars. As the home of the automobile industry, the state of Michigan was more aggressive than most in the pursuit of concrete roads, and in 1919, the state embarked on an extensive road-building program. Soon, west Michigan residents could take their own cars to work or to the beach, rather than riding the interurban.

In 1920, the GRGH&M carried 1,367,642 passengers; by 1924, this number had fallen to 810,731. The trend accelerated in 1924 and 1925. Michigan finally approved a passenger rate increase, but it could not begin to compensate for the loss in passenger revenue. In addition, buses and trucks began to erode income even more. In an attempt to meet the competition, the GRGH&M launched its own truck and bus services. Trucks picked up and delivered freight in towns and transferred it to freight motors for the trip between cities.

By 1926, it was clear that the Grand Rapids, Grand Haven & Muskegon Railway could not continue to operate as it had. United Light and Railways spun the railway off to a group led by the line's management but still controlled by United through a subsidiary. But by then, the revenues the line produced were no longer adequate to pay expenses and the interest on the debt to bondholders.

The company entered receivership on July 28, 1926, but continued to operate. A fleet of buses was purchased and run in place of all but a few of the interurban trains in an effort to meet the competition. The reality was that, as an interurban, the GRGH&M had to support its infrastructure: the tracks, power distribution system, and all of its support facilities, in addition to the buses. The bus and truck competitors did not have any of these expenses. Instead, they operated on roads maintained by the public.

During 1926 and 1927, ridership continued to dwindle, and debts continued to mount. The bondholders continued to press for payment of the interest owed on the debt. In addition, the bonds themselves had matured in 1926, and repayment in full was overdue. Given the costs and revenue situation, the courts could see no way out for the company and ordered that operations end on April 8, 1928, and the assets sold to partially repay the debts.

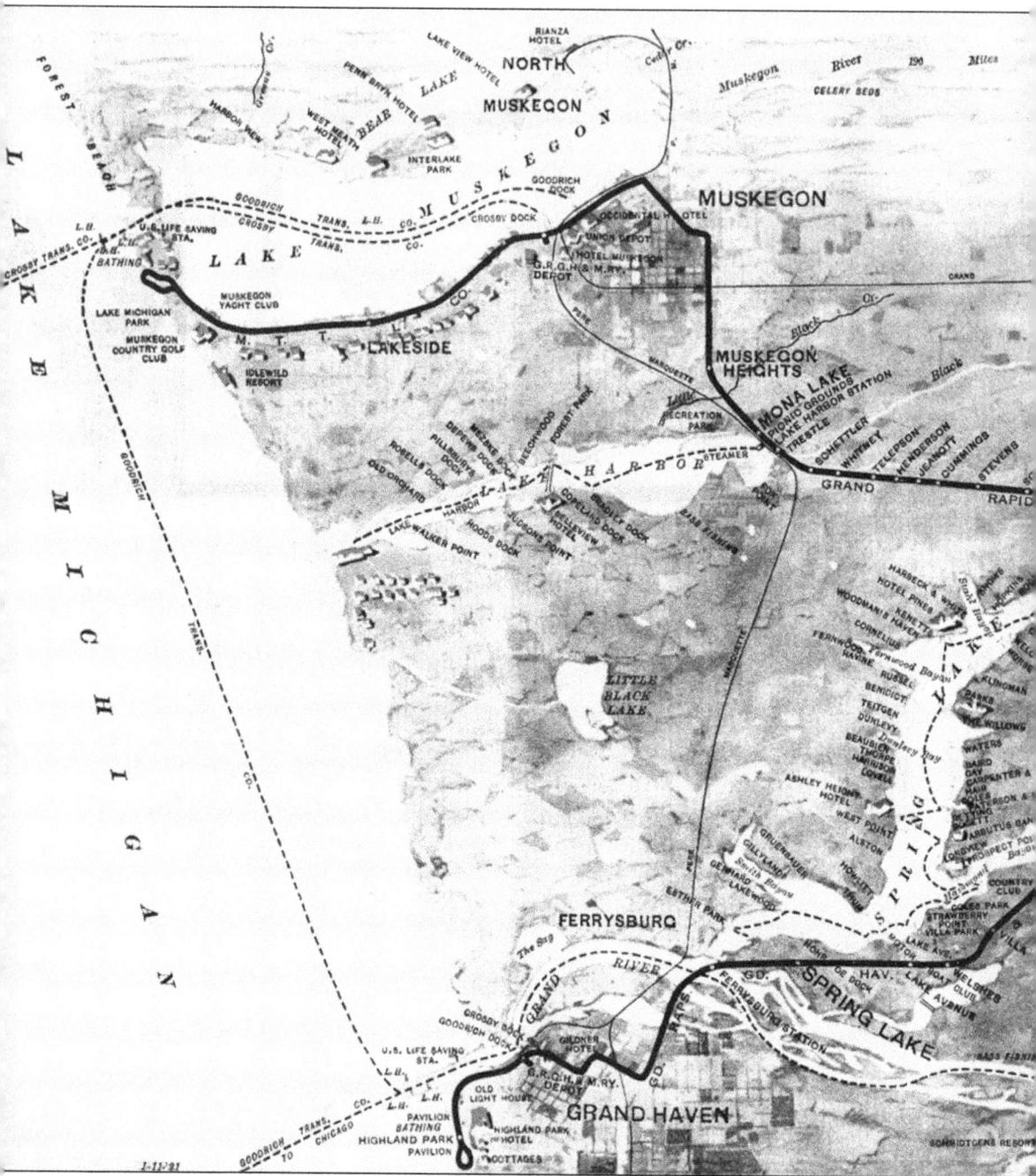

This Grand Rapids, Grand Haven & Muskegon Railway map shows both the main line from Grand Rapids to Muskegon and the Grand Haven branch, from Grand Haven Junction, Spring Lake, and Grand Haven. All cars from Muskegon, Grand Haven, and Grand Rapids would meet at Grand Haven Junction to exchange passengers, eliminating the need to wait at the

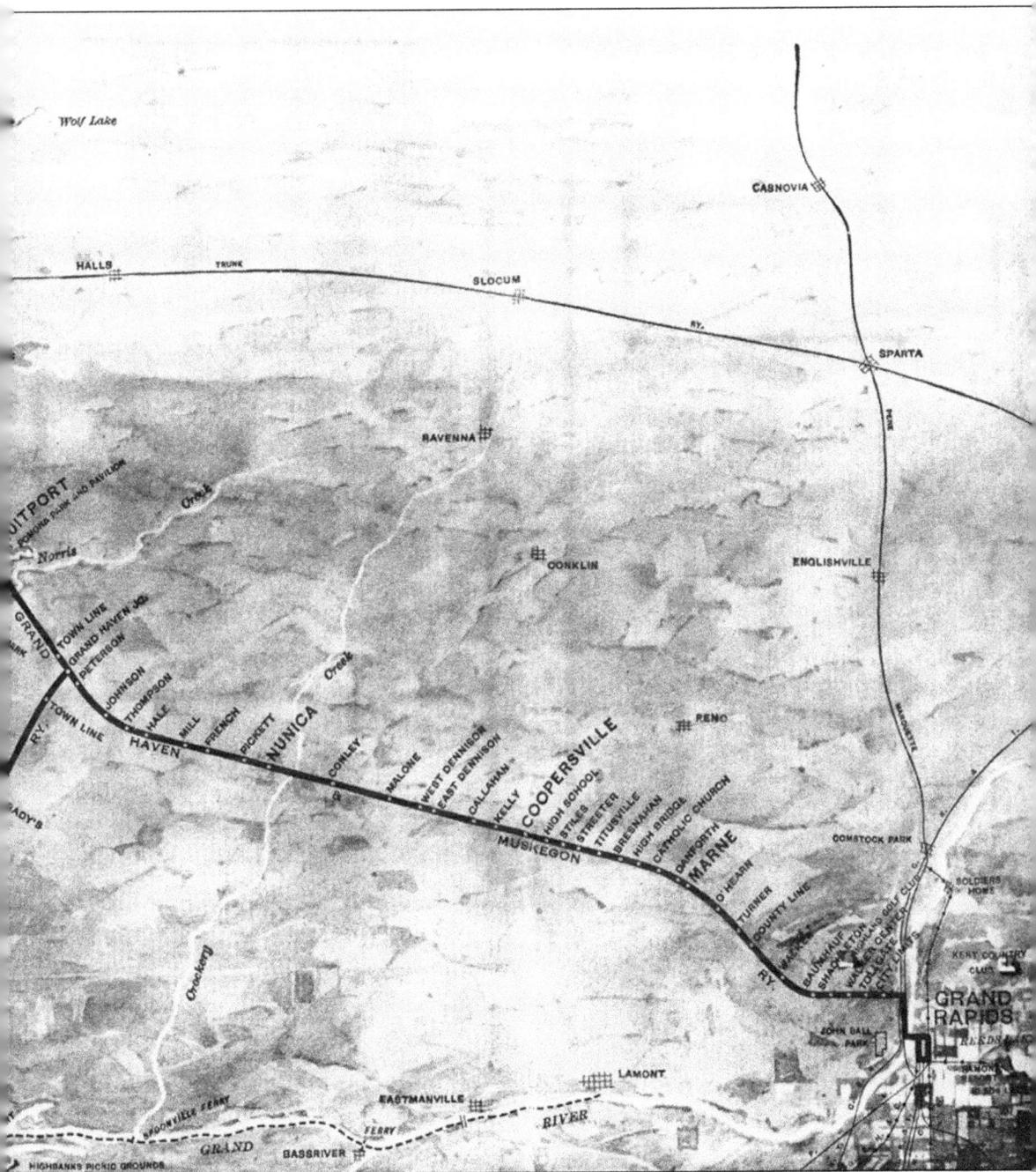

junction. The route shown along the southern edge of Muskegon Lake was actually operated by Muskegon Traction and Lighting Company, not the GRGH&M. Passengers wishing to continue on to the Lake Michigan beach in Muskegon would transfer to a city streetcar at the Muskegon interurban depot.

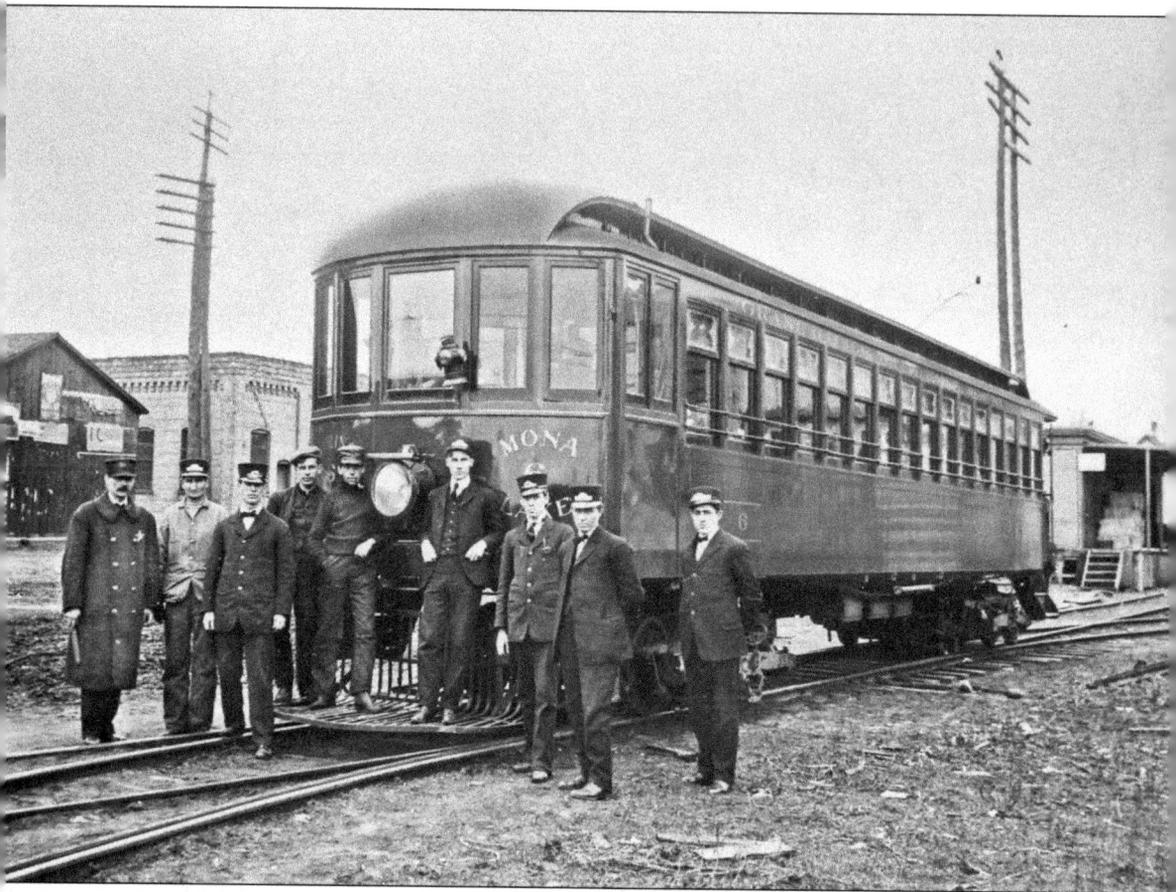

A Muskegon police officer (far left) joins a group of GRGH&M employees in front of Car No. 6 in the Muskegon yard. Car No. 6 was one of the original 15 passenger cars built by the Barney and Smith Car Company of Dayton, Ohio. These 15 coaches were the backbone of the passenger operations through virtually the entire existence of the line, from 1902 to 1928.

One

BEFORE THE INTERURBAN

Electric interurban railroads did not just suddenly appear in the landscape. Rather, they developed out of trends and technologies that had been at work for several decades.

Originally, the Grand River was the main transportation corridor in the region. Beginning in 1837, steamboats sailed between Grand Rapids and Grand Haven, and a series of river landings developed along the banks of the Grand River. Jenison, Lamont, and Eastmanville grew from settlements into towns as gristmills and other small industries developed. Other communities, such as Spoonville, built around a sawmill at the mouth of Crockery Creek, were primarily small industrial sites that did not outlast the industries that brought them into existence.

The first steam railroad appeared in the late 1850s, pulling the population away from the older towns along the Grand River and spurring the growth of inland communities like Coopersville and Berlin. These towns developed along the tracks of the Detroit and Milwaukee Railroad, which built through the area in 1858. It was not until after the Civil War that additional railroads began to connect Muskegon with Holland, and eventually, Chicago.

The growth of cities after the Civil War spawned the first street railways, with horse-drawn carts running on rails in the street. In other cases, small steam engines, outfitted to look like streetcars and known as dummy motors, pulled passenger cars in towns. When the overhead trolley systems were developed in the 1880s, the stage was set for replacing horsepower with electric power, moving a step closer to electric interurbans.

Still, residents in the countryside faced limited choices for transportation. They could walk, hitch a horse to a buggy or wagon, or they could wait for the train, which typically ran on an infrequent schedule. This was an improvement over river travel, but a trip from Coopersville to the county seat in Grand Haven or to Grand Rapids was still an all-day affair.

Photographers in west Michigan captured glimpses of these evolving technologies.

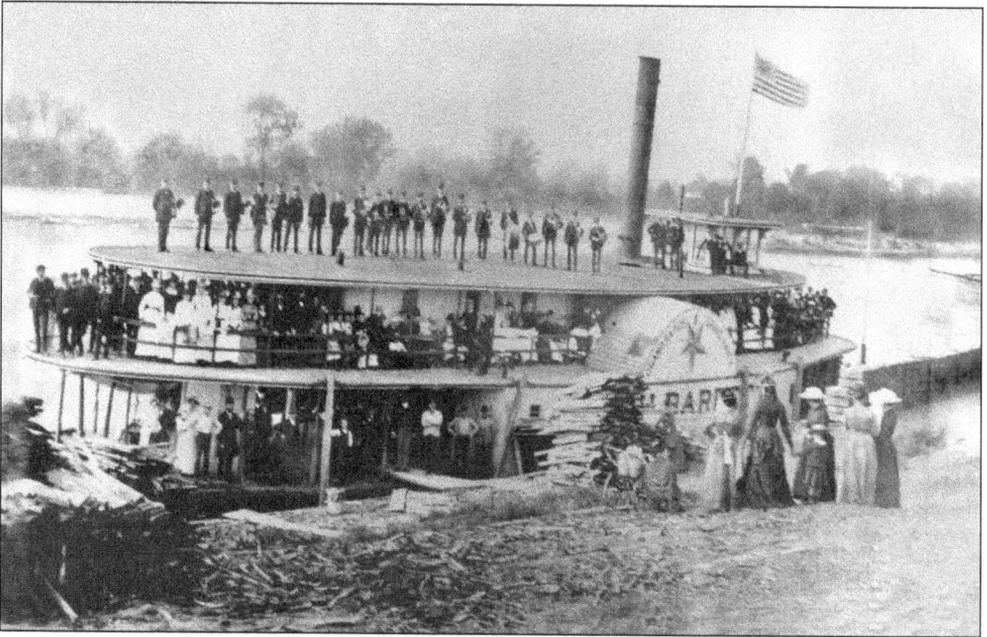

The *W.H. Barratt* docks at the Lamont landing on the Grand River. The Grand River was the first transportation system in west Michigan. Steamboats began making the run from Grand Rapids to Grand Haven in 1837 and continued until the early years of the 20th century. Due to its location on the river, Lamont was a sizeable community with a post office and sawmill. The *Barratt* operated on the Grand River from 1874 through 1894.

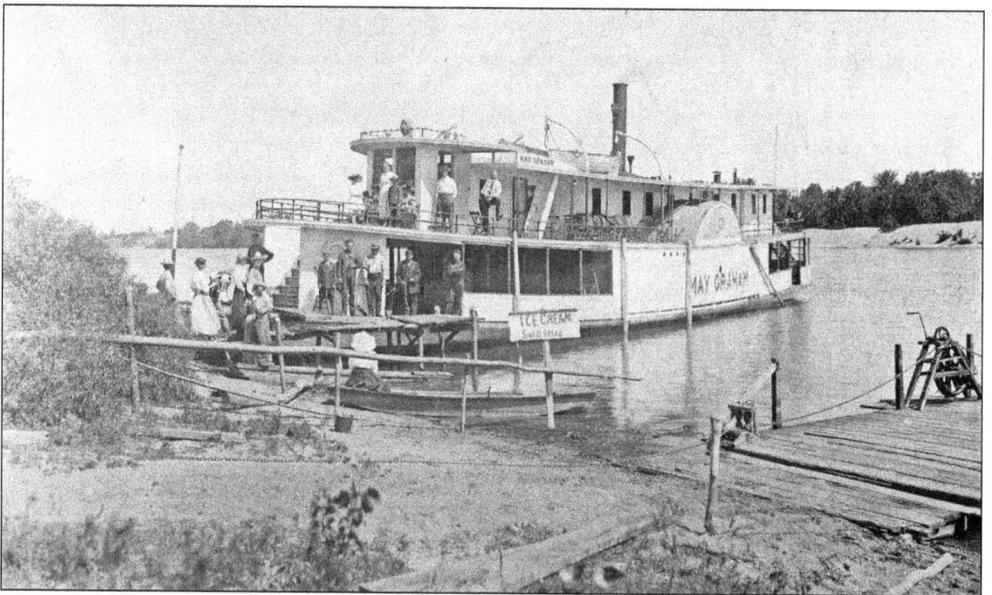

The *Mae Graham* is docked at the Eastmanville landing. The side-wheel steamboat operated on the Grand River into the 20th century. In the foreground is the bow of the chain ferry that carried passengers and wagons across the river. Like neighboring Lamont, Eastmanville was once a center of much activity. At its peak, the village had a store, steam sawmill, schoolhouse, and a hotel.

14

In most cities, horse-drawn streetcars preceded electric cars. In 1882, a Muskegon company began operating a horsecar line in that city. In this view of Laketon Avenue in the Lakeside district, the narrow-gauge rails run along the side of the road. A horsecar is visible in the distance. The car line pictured here connected the downtown area with the lakeshore at Bluffton. Another line connected the downtown to the railroad depot, which was located near the mouth of the Muskegon River.

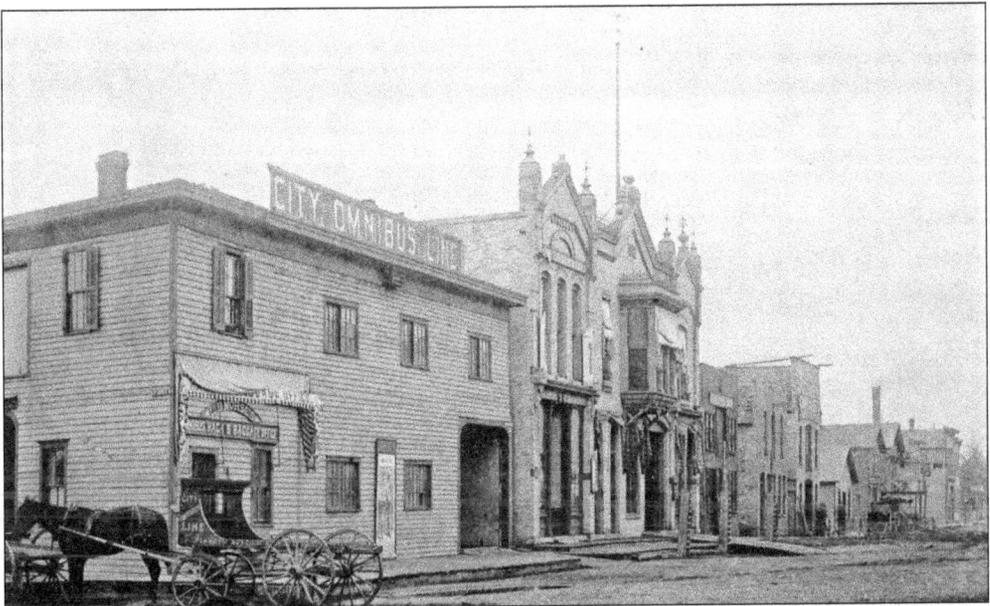

Horse-drawn bus lines also served Muskegon. L.B. Morse established the Muskegon City Omnibus and Hack Line in 1871. This photograph shows the line's carriage barn and stable, located on Market Street.

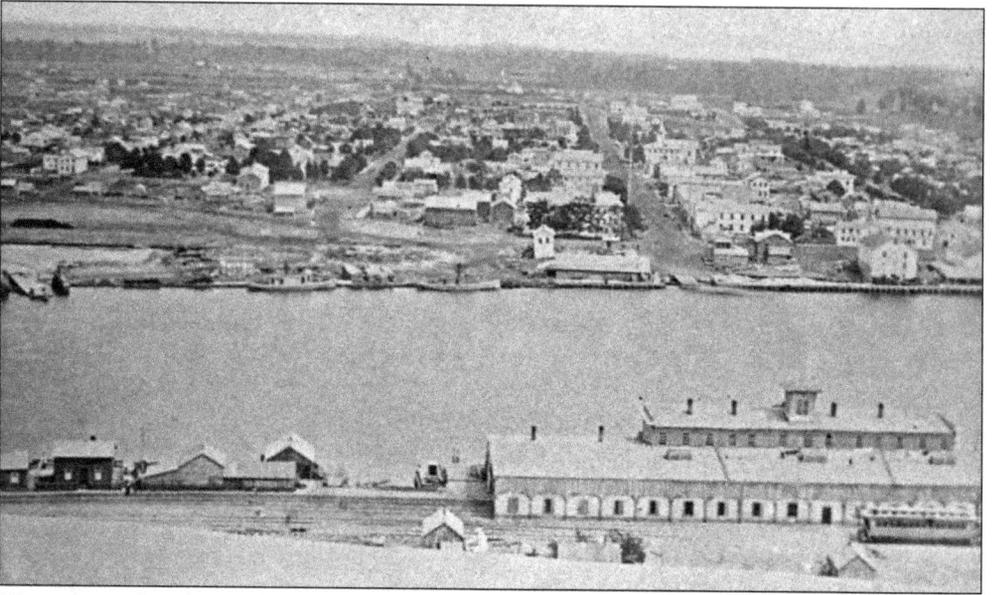

The steam railroad arrived in west Michigan in 1858, when the Detroit and Milwaukee Railroad completed its line to Grand Haven. The company built this depot and hotel on the west bank of the Grand River, across from the town, to avoid the cost of a bridge over the river. Passengers completed their journey to Milwaukee by boat. When the line was completed, the editor of the Grand Haven newspaper proclaimed that Grand Haven would surely become "the Milwaukee of Michigan."

A second steam railroad connected Grand Haven and Muskegon with Chicago in the early 1870s. These two steam locatives are pictured at Holland, Michigan, and are typical of the early locomotives in the area. The wide smokestacks with spark arresters show that these locomotives burned wood rather than coal. The couplers on the locomotives were link and pin, which required a brakeman to insert a pin to couple the cars.

16

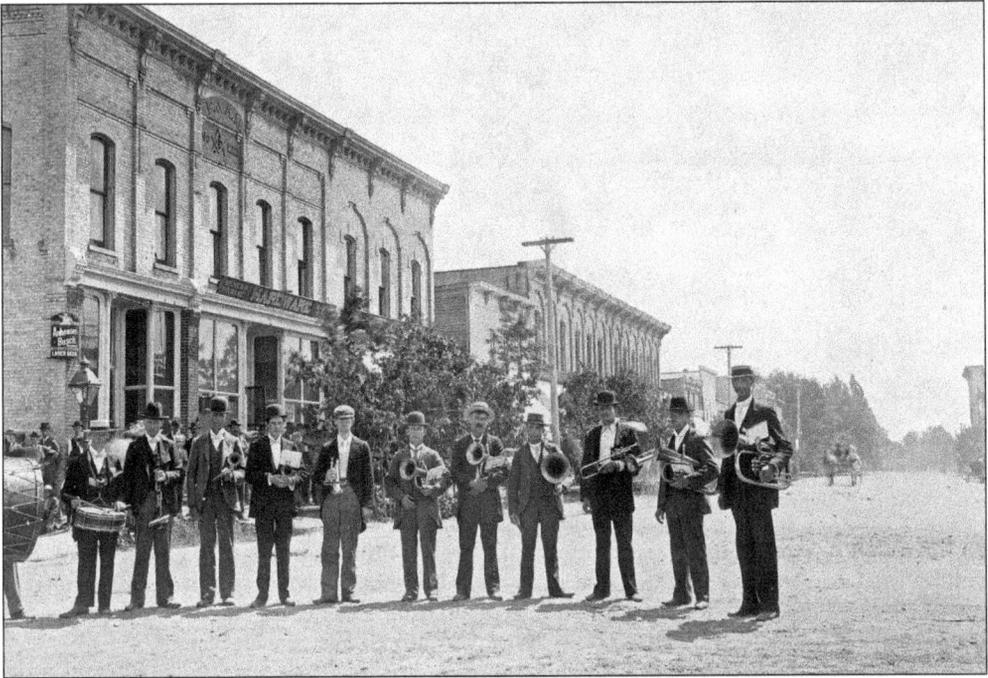

A brass band stands in Coopersville's Main Street. The arrival of the railroad provided a important stimulus to the town's growth. Within a few years, Coopersville grew from a small village along the banks of Deer Creek into one of the largest commercial centers between Grand Rapids and Muskegon.

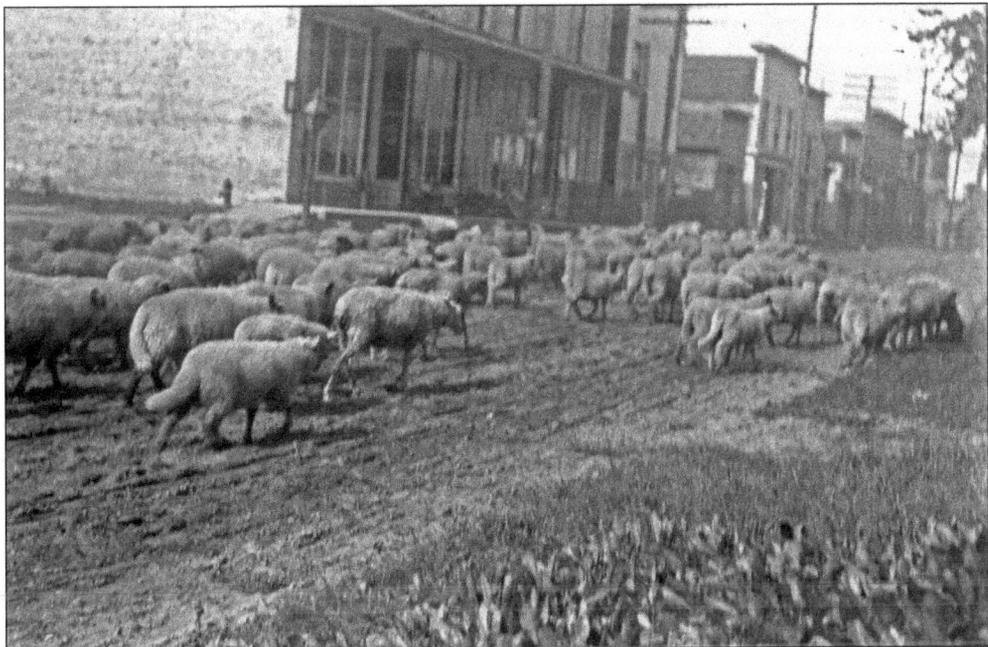

Early streets served multiple purposes in a small town. Here a farmer drives a herd of sheep up Coopersville's Main Street towards the train depot. The railroad greatly expanded the market for local farmers. Note that these sheep have not had their tails bobbed, giving them the appearance of curly-haired dogs.

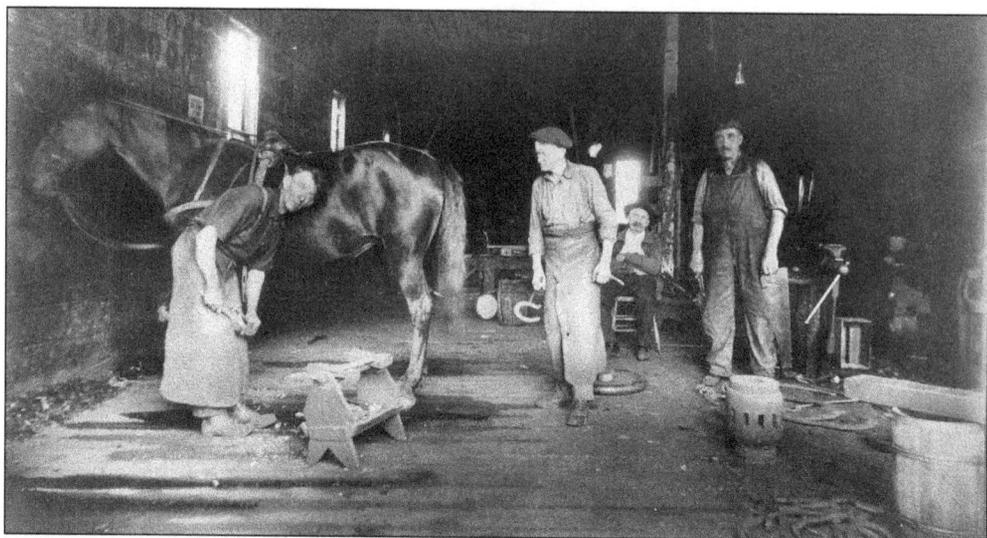

For hundreds of years, human transportation had relied on horses. Horses were for riding and pulling carts and wagons on paths and early roads. Services to support horse transportation, such as livery stables and blacksmith shops, were a fixture in cities and towns. In this image, a Coopersville blacksmith is shoeing a horse to get the animal in shape for service.

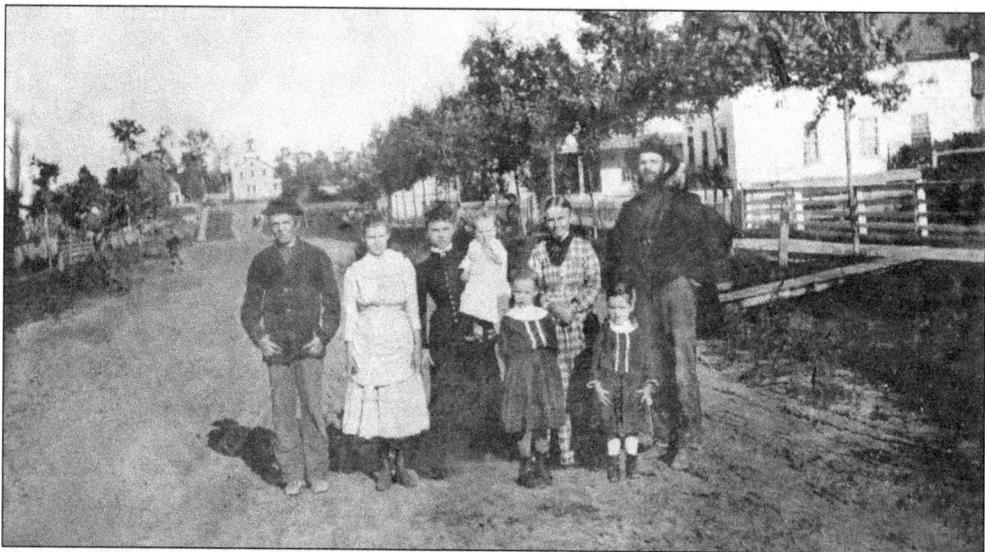

Before the interurban, most businesses were owned locally. They served local markets and employed local people. Warren Lillie and family are pictured in this early tintype. Lillie owned the planing mill in Coopersville, also on Main Street. The steam railroad provided Lillie with a means to ship his products beyond the local area. The interurban also allowed residents to commute to other communities for work. Both developments changed the dynamics of business in west Michigan.

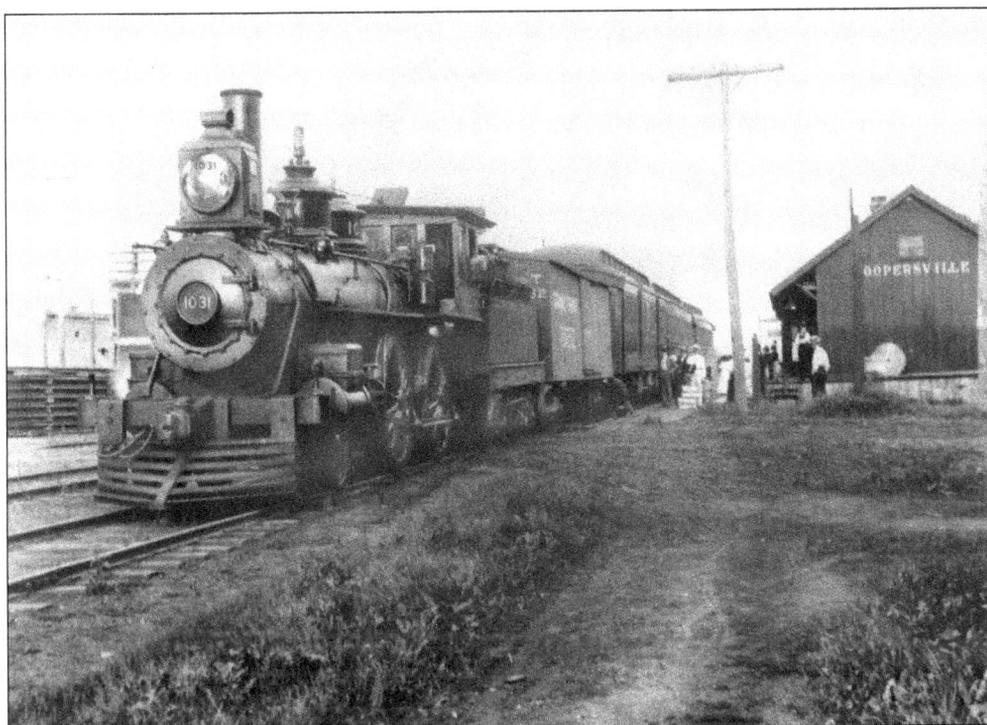

A passenger train stands in the station in Coopersville. During the 1890s, four passenger trains a day ran through Coopersville, connecting Durand and Grand Haven. The locomotive in this photograph has an older, oil-burning headlamp.

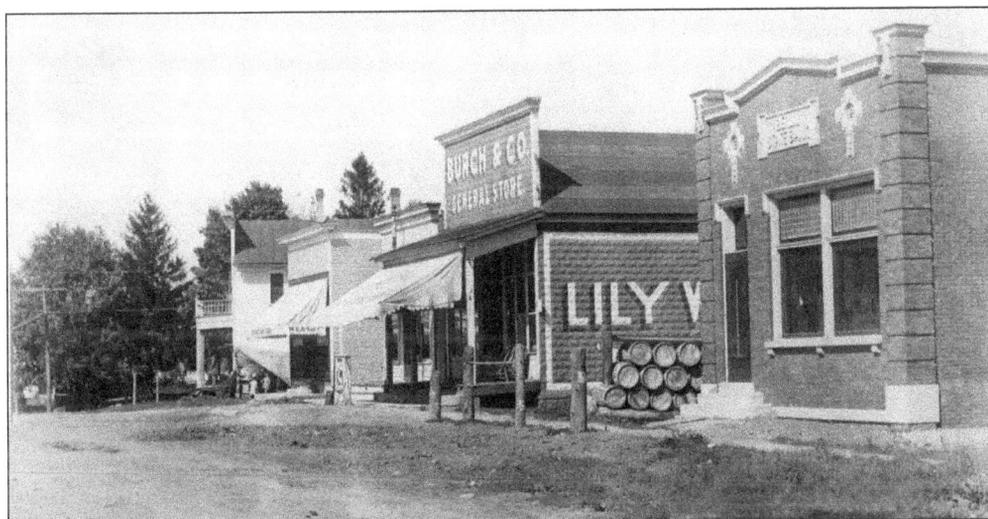

Berlin, Michigan, was another small community that felt the impact of the railroad. The Detroit and Milwaukee Railroad arrived in the 1850s, giving the small community increased importance as a railhead. In this photograph, a typical collection of businesses and hotels line State Street, the town's principal street. At the end of World War I, the community changed its name to Marne to avoid association with the German city.

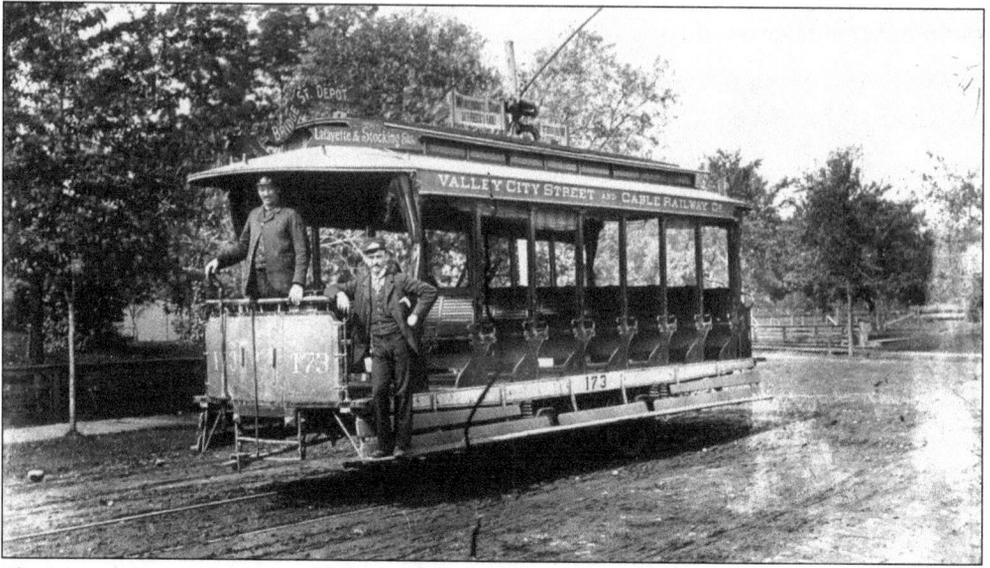

Electricity began powering street railways in the early 1890s, but horsecars began operating in Grand Rapids at the end of the Civil War. In 1885, the Valley City Street and Cable Railway started operating a cable car system on the steep hills of Grand Rapids and expanded its system to include horsecars as well. By the early 1890s, the company had discontinued the expensive cable operation and had electrified its lines. Finally, in 1891, the Valley City system merged with the rival Street Railway of Grand Rapids, leading to the creation of Grand Rapids Railway.

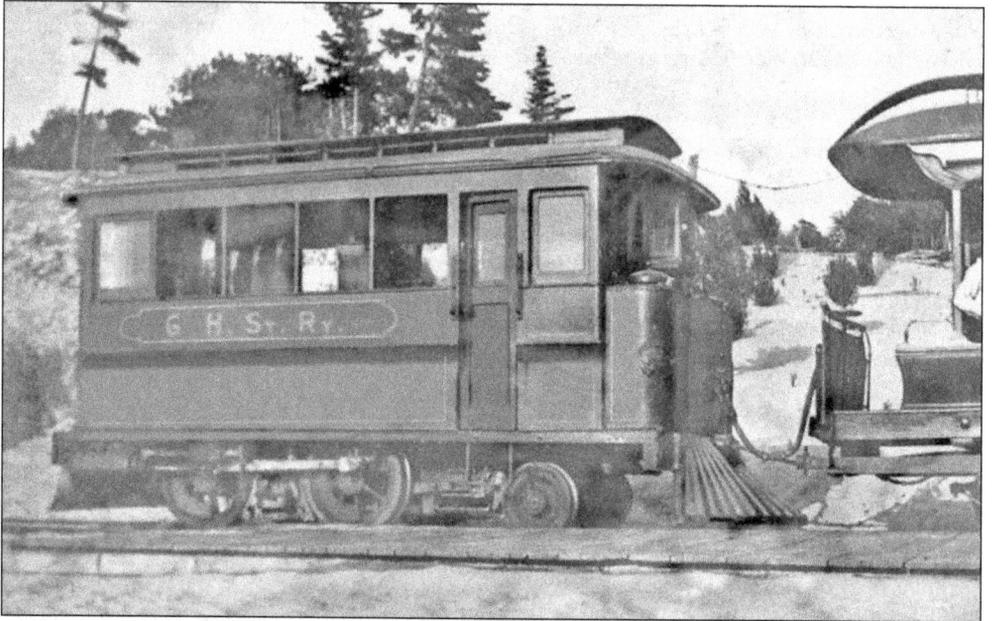

In Grand Haven, the street railway used steam locomotives instead of electricity. In 1895, local businessmen organized a street railway company in Grand Haven. Passenger coaches pulled by this small dummy locomotive made the trip between downtown Grand Haven and the beaches at Highland Park during the summer months. Most cities replaced their dummy locomotives with electric cars during the 1890s, but Grand Haven Street Railway continued to operate its locomotive until 1903.

Two

THE BEGINNING

The promoters of the Grand Rapids, Grand Haven & Muskegon Railway were so anxious to begin building that they started grading in the fall of 1901 without even waiting for the Westinghouse, Church, Kerr & Company engineer who was to manage construction. When Frederick Walker, the chief construction engineer, did arrive, he found crews working in areas both south of Muskegon and east of Coopersville. He also learned that other pieces of land needed to connect these two sections had not yet been secured. Walker quickly organized two teams of canvassers to assemble the missing parcels. The company acquired the grade of an abandoned railroad, the Chicago and Michigan Lakeshore Railroad, to span the distance between Nunica and Pickands Junction, north of Fruitport.

In the cities of Grand Rapids and Muskegon, the interurban secured agreements with the local street railway companies to use their existing tracks. With these arrangements, the track actually owned by the GRGH&M officially began at the city limits of both cities.

Crews initially concentrated on the main line between Grand Rapids and Muskegon. By January 1902, cars were making test runs on short segments of the line. Regular service between Grand Rapids and Muskegon began on February 9. Crews working on the branch to Grand Haven had the line open to Spring Lake by March 6. There it stopped for over a year, as the managers of the GRGH&M and the city of Grand Haven disputed the terms of entry into the city. There were several small issues, but the primary one involved the Grand River Bridge that connected Grand Haven and Spring Lake. The city wanted the interurban company to own the bridge and operate it as a free bridge (it was then a toll bridge). The GRGH&M offered to rebuild the bridge to accommodate both electric cars and wagons, but the company thought the city should own and operate it, including the public portions. The impasse lasted until the fall of 1902. In the end, the interurban agreed to own the bridge with the city providing an annual operating subsidy.

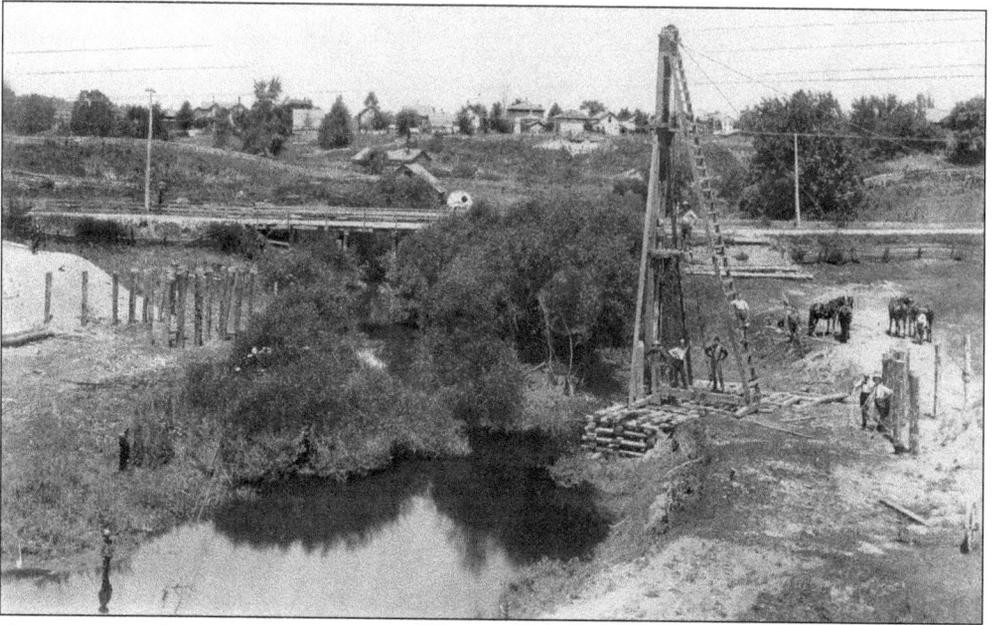

Construction of the Grand Rapids, Grand Haven & Muskegon Railway began in Coopersville, roughly the midpoint of the line, on October 20, 1901. In this photograph, a construction crew uses a horse-powered pile driver to set the pilings for the bridge across Deer Creek on the city's east side. From Coopersville, crews worked both east and west, grading the right of way and laying track.

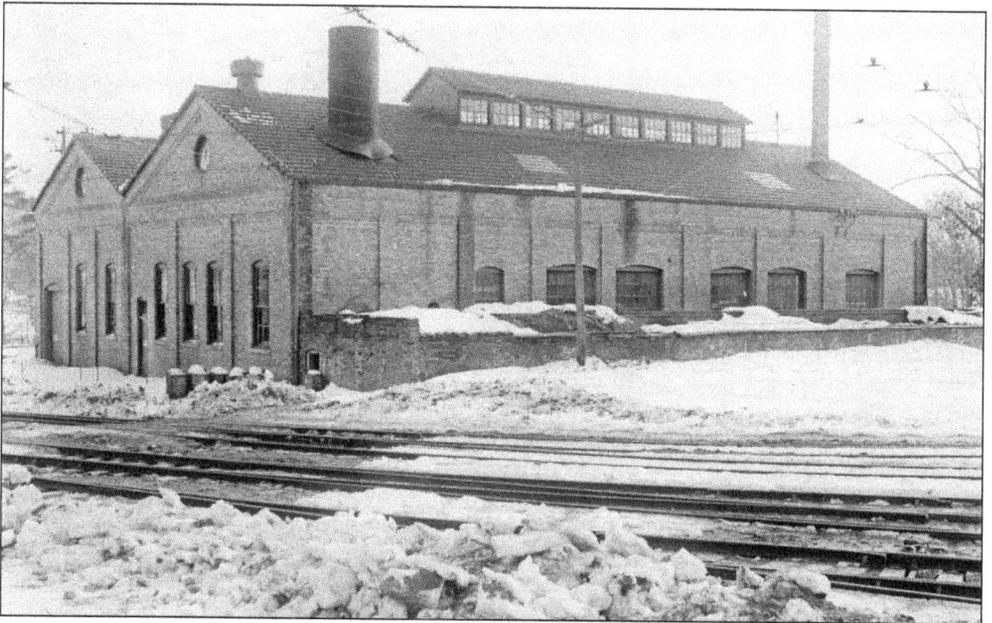

In 1901, large amounts of electric power were not readily available, so engineers from Westinghouse, Church, Kerr & Company built their own powerhouse to provide power for the line. This building was located in Fruitport, at the north end of Spring Lake. The powerhouse was used until 1906, when commercial power became available at a reasonable cost. (Courtesy of the Grand Rapids Public Library.)

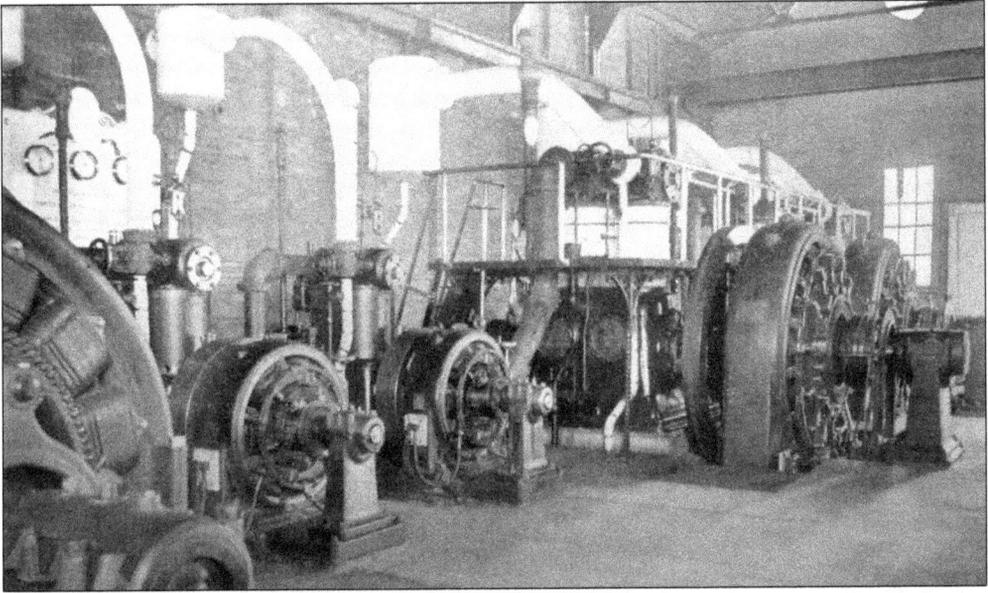

Inside the powerhouse, steam-driven generators produced 16,500-volt AC current for distribution across the entire system. But, since the motors used in the interurban cars required 650-volt DC current to operate, a series of electrical substations would be needed to convert the current to lower voltage for the cars.

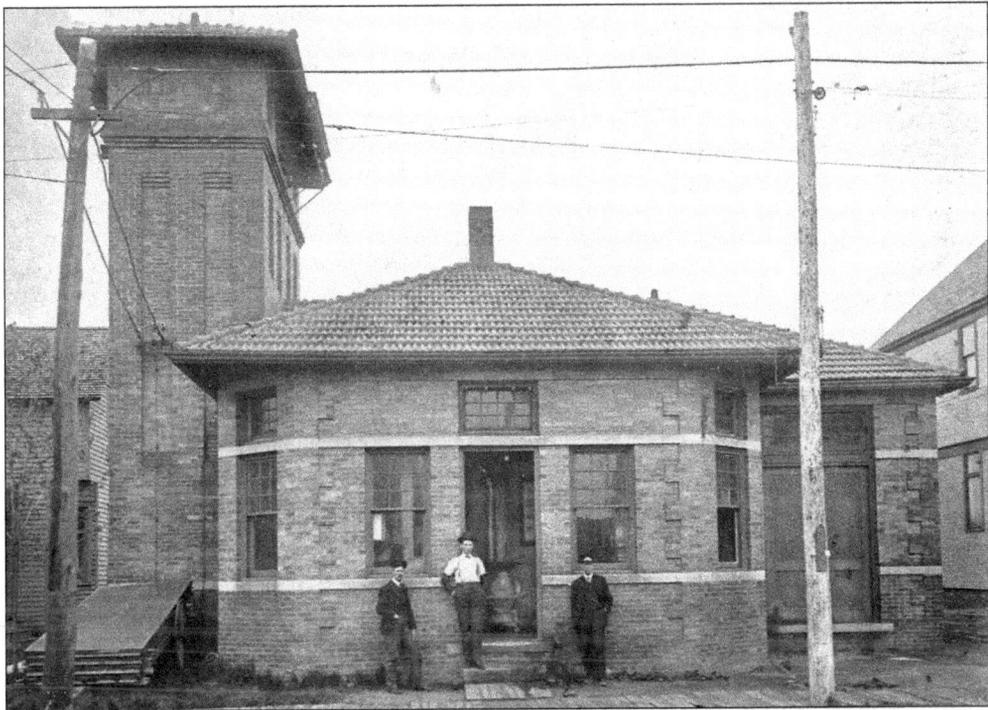

This depot and substation in Coopersville and one identical to it in Walker were built to convert the power from AC to DC. The structure served multiple purposes. A ticket office and waiting room were located in the front of the building, and the large doors on the right opened into a freight room. High-voltage AC power entered through the tower on the left.

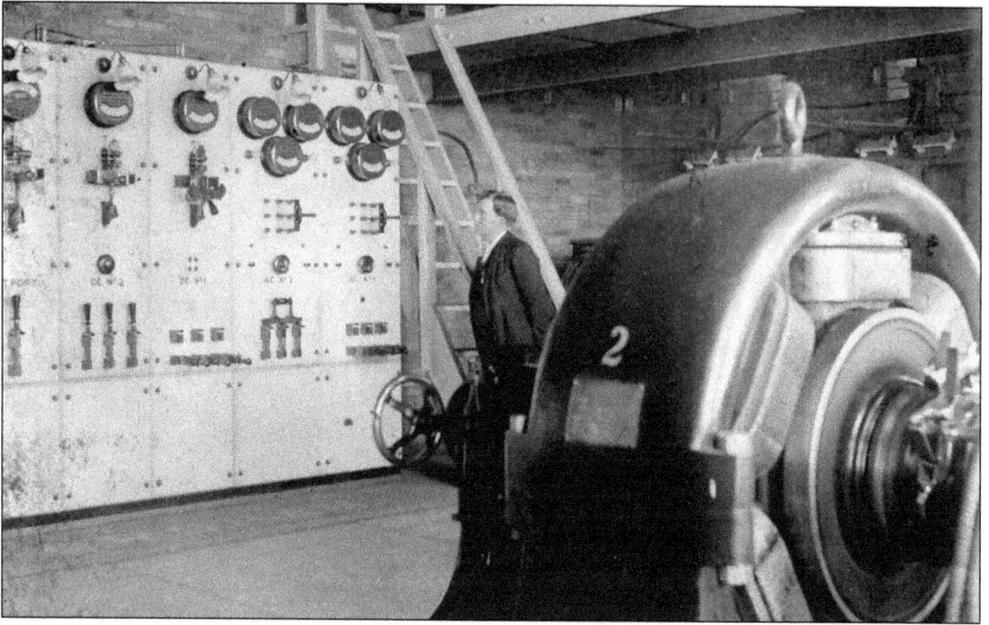

The substation equipment was located at the rear of the building. The device in the foreground is a rotary converter, which used the AC power from the powerhouse to create DC power for the cars. The control panel along the wall operated the converters and sent power to the tracks. Over the years, as more cars were added to the operation, additional substations were built in Spring Lake and Muskegon Heights to keep up with the demand for power.

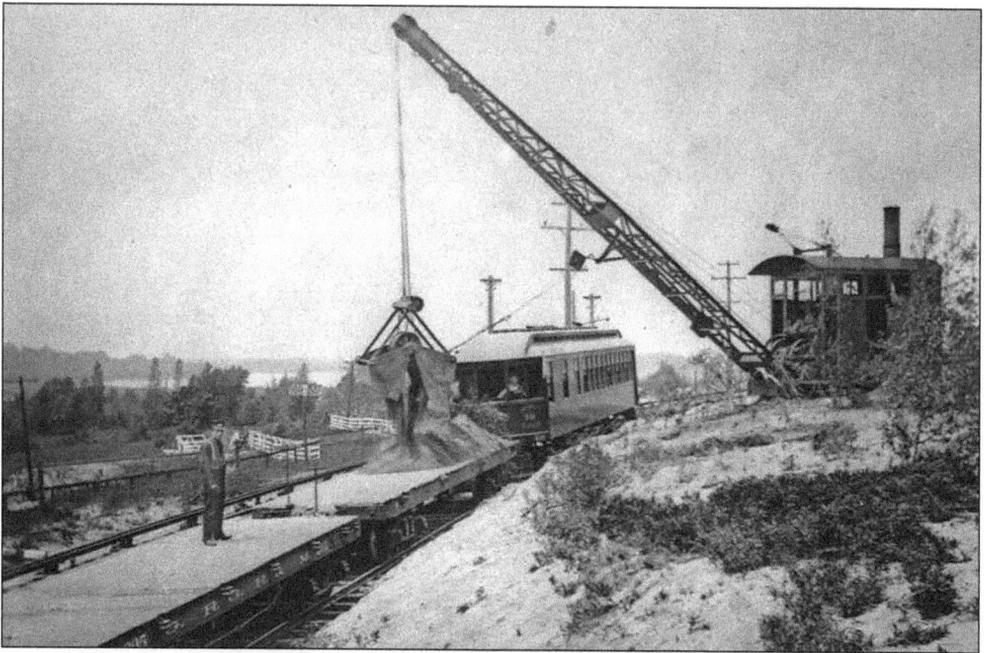

East of Muskegon at Mona Lake, engineers and crews faced the task of building a 1,500-foot trestle across the marsh at the mouth of Black Creek. A temporary connection was built to the nearby Pere Marquette Railroad to deliver a steam shovel to dig sand in order to build up an embankment supported by the trestle.

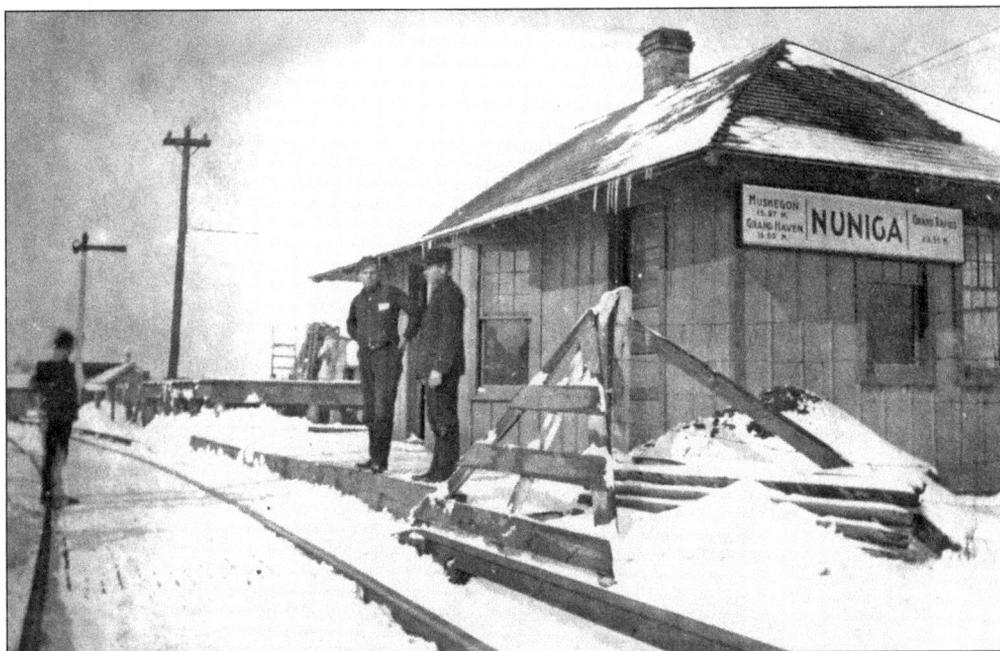

Wooden depots were built at Nunica, Berlin (Marne), and Muskegon Heights. Early on, the focus of the interurban line was passenger traffic. A freight platform is visible to the left. Over time, freight traffic grew in importance to the company, and a separate freight house was built at the location of the platform to the rear of this photograph.

In Muskegon, workers built a stone depot at Western Avenue and Seventh Street. Seen here from the wagon side, the structure housed both a passenger waiting room and a freight house. Wagons loaded and unloaded on this side of the building, and interurban cars loaded from doors on the opposite side.

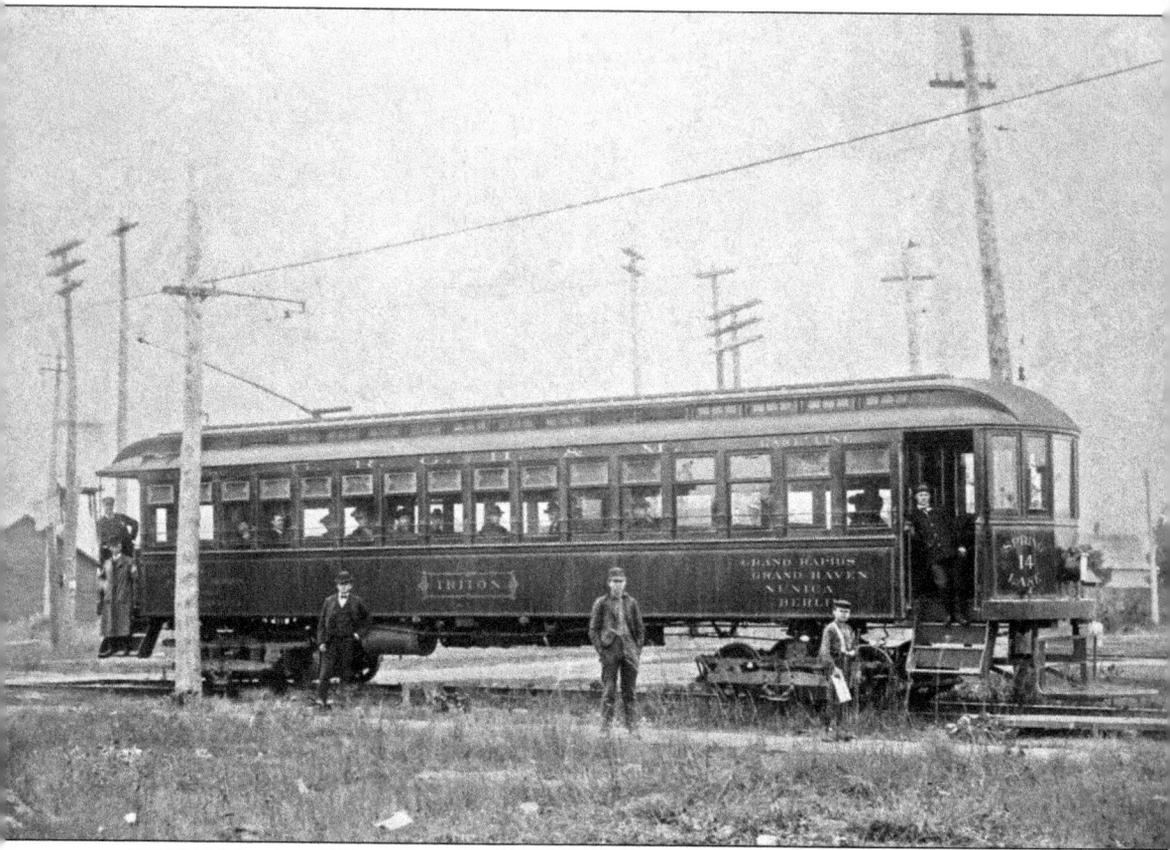

GRGH&M ordered 15 passenger coaches from the Barney and Smith Company of Dayton, Ohio. Each car was 52 feet long and had seating for 56 passengers. Two 150-horsepower Westinghouse motors provided power for each car, which was given a name as well as a number. Regular service between Grand Rapids and Fruitport began on February 1, 1902. Cars began running into Muskegon on February 9. In this early photograph, Car No. 14, *Triton*, stands on the track in Muskegon. A trip between Grand Rapids and Muskegon took nearly two hours.

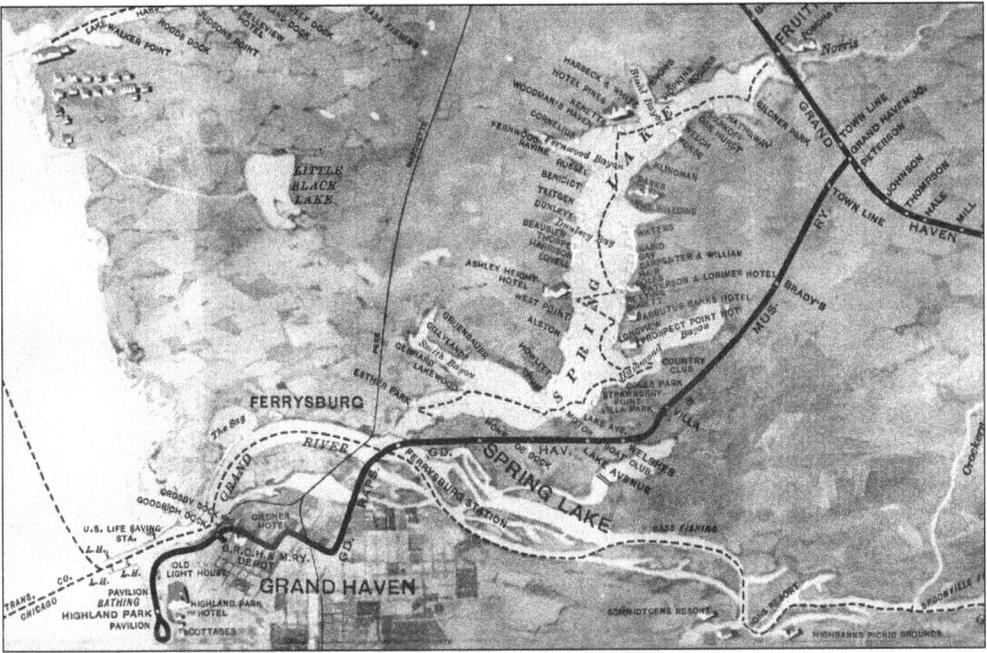

With cars running on the main line, crews began work on the branch line to Spring Lake and Grand Haven. The branch left the main line at a point dubbed Grand Haven Junction, located just east of Fruitport near the intersection of today's Apple Drive and Hickory Street.

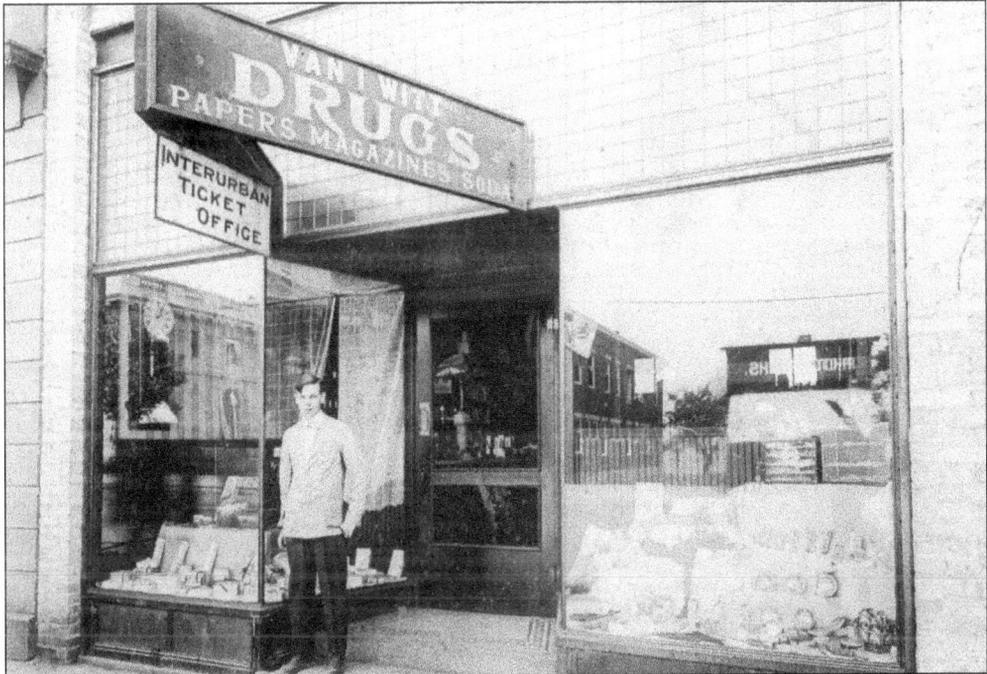

In the spring of 1901, the interurban line reached the village of Spring Lake. Before 1913, when the company built a depot in town, riders purchased tickets and boarded trains at Van Witt's drugstore.

TIME TABLE No. 17. In Effect April 21st, 1906.

MUSKEGON AND GRAND HAVEN TO GRAND RAPIDS.

	AM	AM	AM	AM	AM	And hourly thereafter until	PM	PM	PM	PM	PM	PM
Muskegon.......... (Occidental Hotel)	Ltd.	5.10	6.35	7.35	8.35		4.35	5.35	6 35	7.35	9 35	11.35
Muskegon Hts....	See	6.54	7.54	8.51		4 51	5.54	6 54	7.54	9.54	11.54
Mona Lake........	Foot	...	6.55	7.56	8 56		4.56	5.56	6.56	7.56	9.56	11 56
Fruitport........	note	5.25	7.06	8.06	9.06		5 06	6 06	7.06	8.06	10 06	12.06
Grand Haven..... (Cutler House)	5 25	...	6.50	7.50	8.50		4.50	5.50	6.50	7.5)	9.50	11 50
Spring Lake	5.32	6.58	7.58	8.58		4 58	5 58	6.58	7.58	9.58	11.58
G. H. Junction ..	5.41	5.25	7.10	8.10	9.10		5.10	6.10	7.10	8.10	10.10	12.10
Nunica	5 35	7.18	8 18	9.18		5 18	6.18	7.18	8 18	10.18	
Coopersville	5.47	7.33	8.33	9.33		5.33	6 33	7.33	8 33	10.33	
Berlin............	5 57	7.47	8.47	9.47		5.47	6 47	7.47	8.47	10.47	
Walker	6.05	7.55	8.55	9 55		5.55	6.55	7 55	8.55	10.55	
Grand Rapids (Pantlind Hotel)	6.30	6.30	8.15	9.15	10 15		6 15	7.15	8.15	9.15	11.15	
	AM	AM	AM	AM	AM		PM	PM	PM	PM	PM	AM

NOTE.—5:25 a.m. train out of Grand Haven will run Sundays, Wednesdays and Fridays ONLY
To signal a car at a road crossing at night, display a light ; in day time, wave your arm.

Shown here is an early GRGH&M timetable. In the late spring of 1902, the company issued its first full schedule, with complete hourly service on both branches. Although Grand Haven is listed as the destination, the electric cars actually stopped at the edge of the Grand River. A dispute

TIME TABLE No. 17. In Effect April 21st, 1906.

GRAND RAPIDS TO GRAND HAVEN AND MUSKEGON.

	AM	AM	AM	AM	AM	And hourly thereafter until	PM	PM	PM	PM Ltd.	PM	PM		
and Rapids..... ('81 Lyon Street)	6.10	7.00	8.06	9.00		5.00	6 00	7.00	7.45	9.10	11.15
alker	6.35	7.26	8 26	9.26		5.26	6.26	7.26	...	9.26	11.37
rlin 	6 42	7.34	8.34	9 34		5 34	6.31	7.34		9.34	11.42
opersville	6.50	7.45	8 45	9 45		5.45	6.45	7.45	8.35	9.45	11.52	.. .	
nica......	7.01	7.59	8 59	9.59		5.59	6.59	7.59		9 59	12.02
H. Junction ..	5.42	7.10	8.10	9.10	10.10		6 10	7.10	8 10	See	10 10	12.10
uitport 	7.13	8.13	9 13	10 13		6.13	7.13	8 13	Foot	10.13	12.13
ona Lake..	5 54	7.23	8.23	9.23	10.23		6 23	7.23	8.23	note	10.23	12.23
uskegon Hts ..	5.56	7 25	8.25	9.25	10 25		6.25	7.25	8 25	10 25	12 25
askegon.........	6.15	7.40	8.40	9.40	10.40		6 40	7 40	8 40	...	10.40	12.40
oring Lake......	7.19	8.19	9.19	10.19		6.19	7.19	8.19	9.02	10.19	12.19
rand Haven..... ('Cutler House')	7.25	8.25	9 25	10 25		6.25	7 25	8 25	9.10	10.25	12.25
	AM	AM	AM	AM	AM		PM	PM	PM	PM	PM	AM		

NOTE.—The 7:45 p.m. train out of Grand Rapids will run Sundays, Mondays, Wednesdays and ridays ONLY.

with the town of Grand Haven prevented the cars from crossing the river, so riders completed the trip by horse-drawn omnibus.

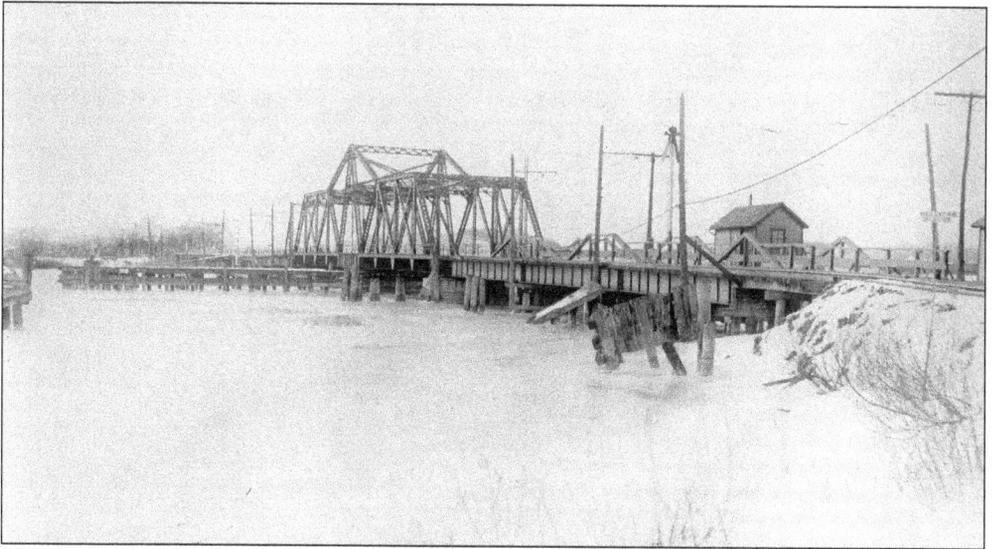

In the fall of 1902, an agreement was reached between the city and the company, and this bridge was rebuilt to accommodate interurban cars. The 947-foot structure carried both wagon traffic and the interurban cars. The center section was a swing span, which turned to allow boats to pass up and down the river. (Courtesy of the Grand Rapids Public Library.)

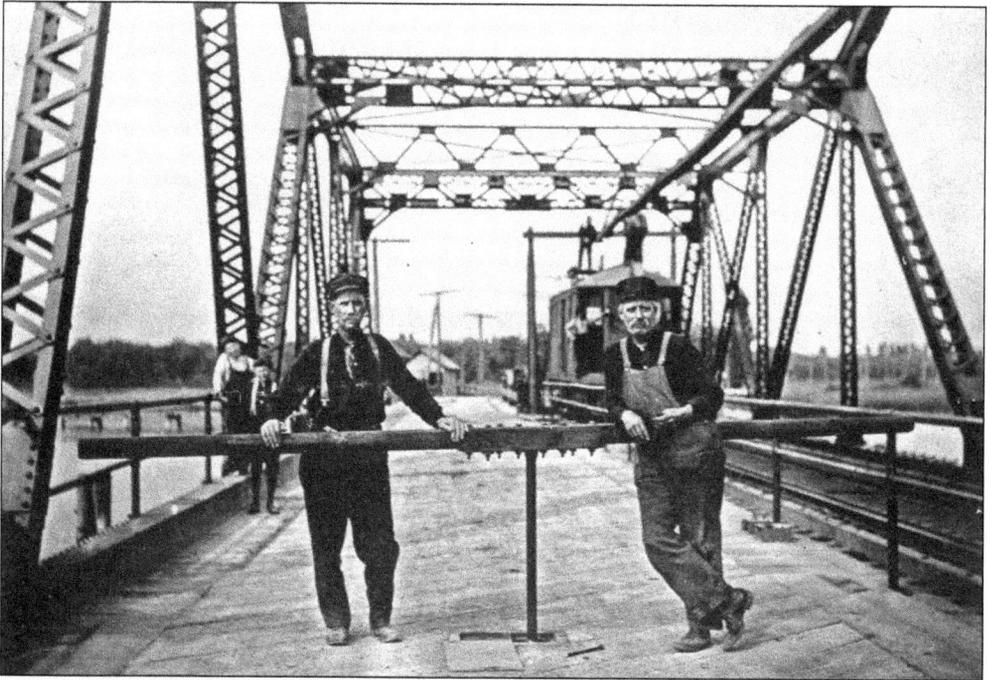

The Grand River Bridge was swung by hand and required two men turning this capstan to open and close it. Ed Gustafson is the bridge tender on the right; the other person is unidentified. In the background, workers stand on top of Car No. 99, the company's maintenance car, working on the overhead trolley wire. Interurban traffic shared the bridge with wagons and pedestrians.

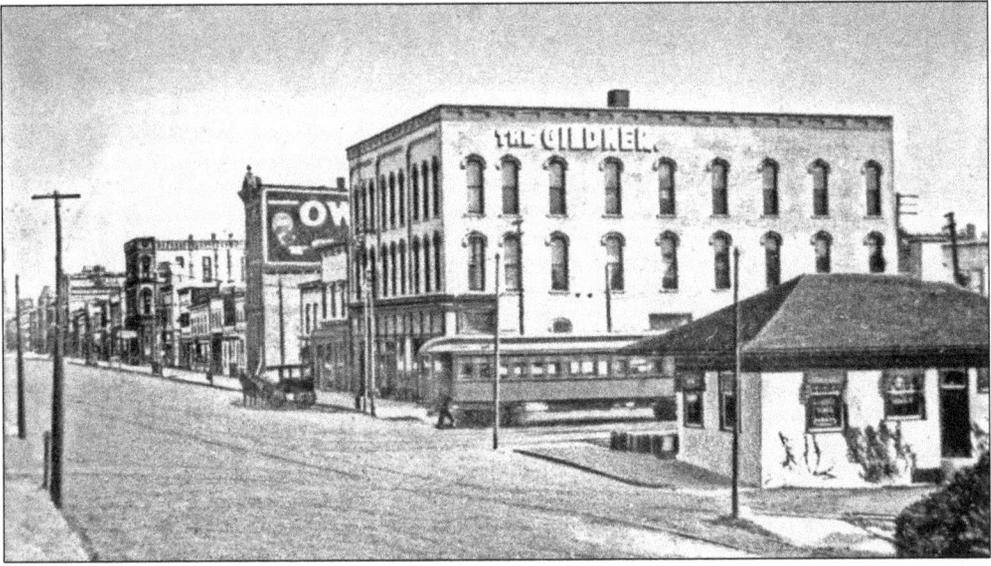

Service into Grand Haven officially began on June 18, 1903. In this photograph, a passenger car is about to turn the corner from Water Street (Harbor Drive) onto Washington Street as it begins the trip to Grand Haven Junction.

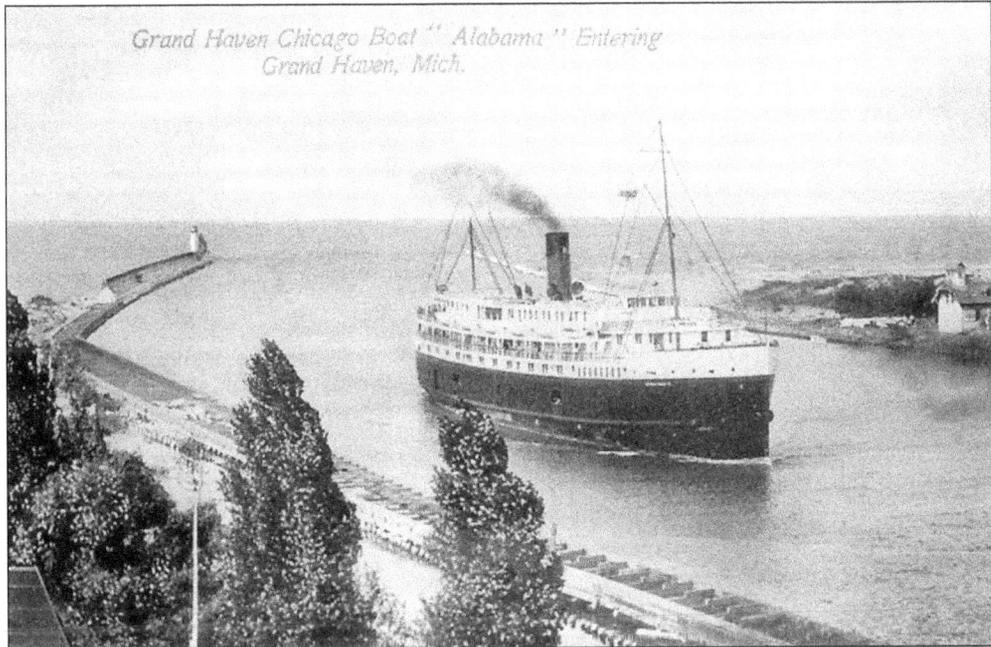

The Grand Haven branch was important to the interurban company for two reasons. First, it connected with the direct steamship service between Grand Haven, Chicago, and Milwaukee. The *Alabama*, pictured here, was one of the Goodrich Line ships that provided daily overnight service between west Michigan and Chicago. Boats of the Crosby Line provided a similar service to Milwaukee.

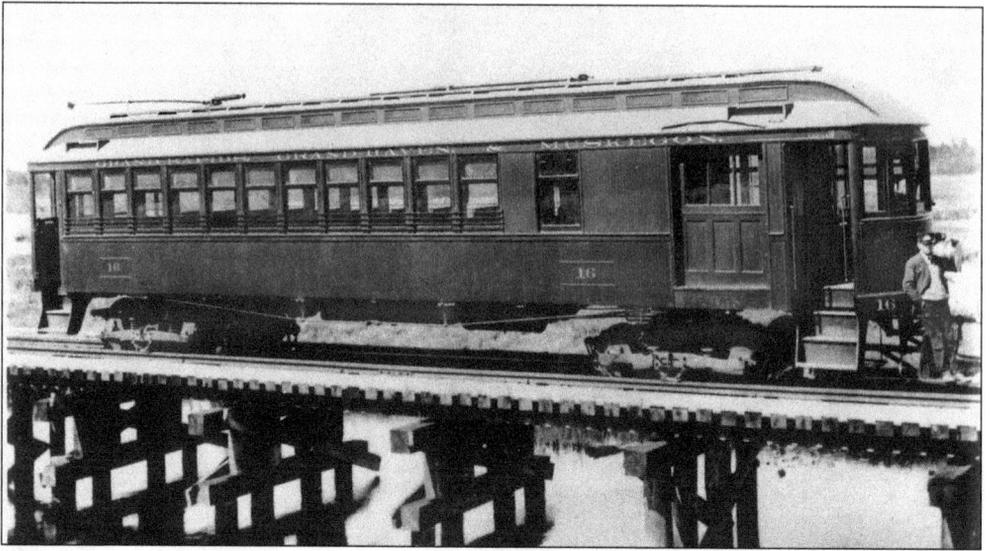

With the completion of the GRGH&M in Grand Haven, the company began to coordinate cars with the Goodrich boat schedule to Chicago. Combination passenger-freight cars with additional space for baggage were acquired for the Chicago service.

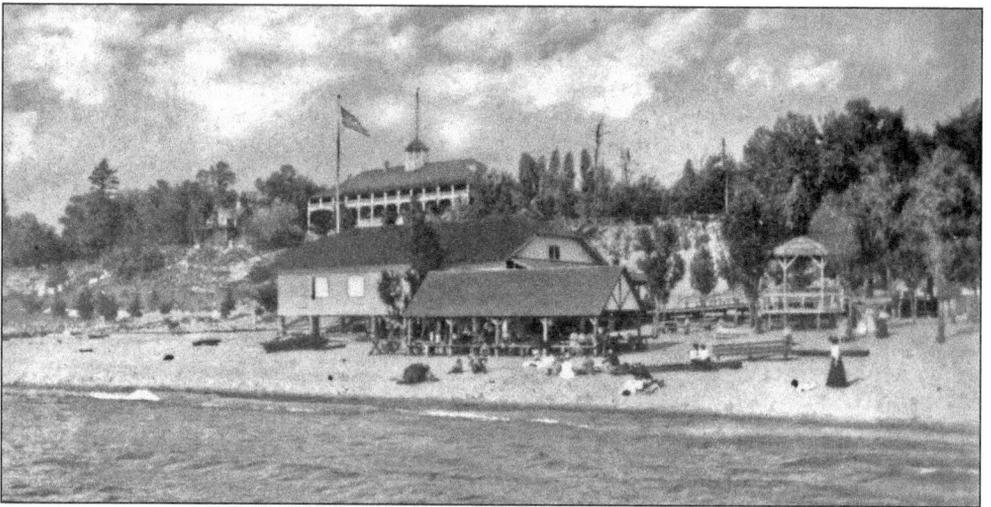

The second reason for Grand Haven's importance was the Lake Michigan beach at Highland Park, just west of the town. The beach was a popular destination during the summer. A thriving cottage community had developed during the 1890s, and a large hotel was built atop the dunes. The beach was lined with concessions and pavilions, which offered concerts and dancing in the evening. A trip by interurban to the beach was a popular way for Grand Rapids citizens to beat the summer heat.

Three

RIDING THE INTERURBAN

In 1907, a round trip from Grand Rapids to Muskegon cost $1.05; each leg of the trip took one hour and 40 minutes in a local car. The slightly shorter trip to Grand Haven took one hour and 25 minutes, and a round-trip ticket cost 90¢. With each passing year, both ridership and revenues were growing. The key to the GRGH&M's success was frequency. Most of the steam railroads offered two or three trains to Muskegon or Grand Haven each day, but during the summer months, the interurban cars ran hourly. In addition, the cars stopped at frequent roadside crossings to pick passengers up or let them off. In short, interurban travel was convenient and easy, and west Michigan residents adapted quickly.

In its advertisements, the GRGH&M referred to itself as the "Lake Line" to emphasize the connection to Lake Michigan with its beaches and the overnight connection between Grand Haven and Chicago. Passengers could check their baggage until 7:45 p.m. in Grand Rapids and purchase a through ticket to Chicago. Boats left Grand Haven at 9:15 p.m. The boats were equipped with staterooms and berths, so passengers could sleep during the voyage. The cost was $2, one way (without a stateroom).

The night boat from Chicago arrived at dawn, and an interurban car left immediately for Grand Rapids. Passengers were delivered to the Grand Trunk and Grand Rapids Union stations in time to catch the morning trains for other destinations. Passengers who waited for the first Grand Trunk train between Grand Haven and Grand Rapids would not arrive until mid-morning and would have connected to later trains.

The GRGH&M did not build a passenger station in Grand Rapids. Instead, the company used a ticket office and waiting rooms in existing commercial buildings. From 1902 until 1912, the waiting room was located at 81 Lyon Street. In 1912, the location was moved to new quarters in the Houseman Building at the corner of Lyon and Ionia Streets.

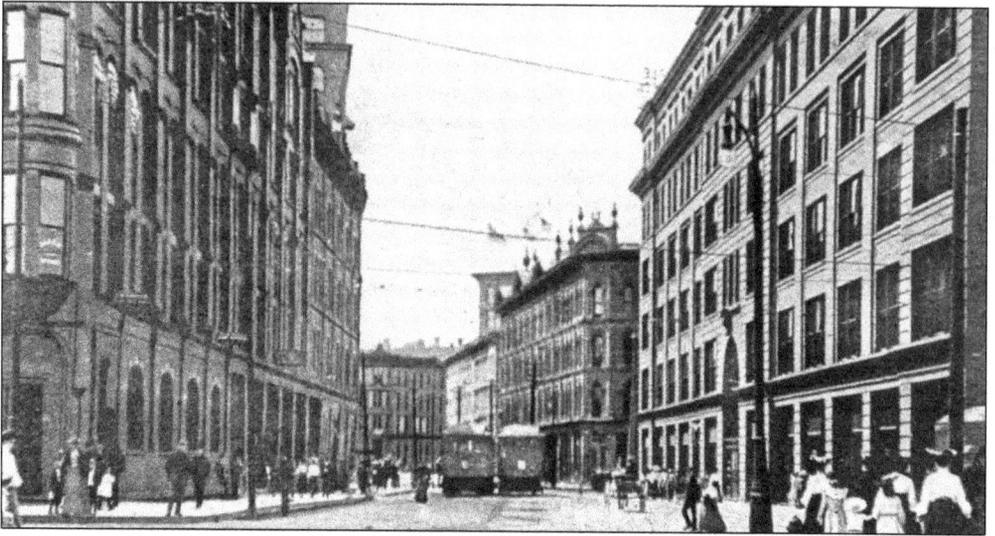

Two cars wait on Ottawa Street for the start of their runs. On the left is the Houseman Building, which housed the waiting room after 1912. From here, cars would travel along Lyon Street to Monroe Street and then turn north toward Bridge Street. Cars arriving from the west would continue south on Monroe Avenue to Ionia Street in order to loop back to this starting location.

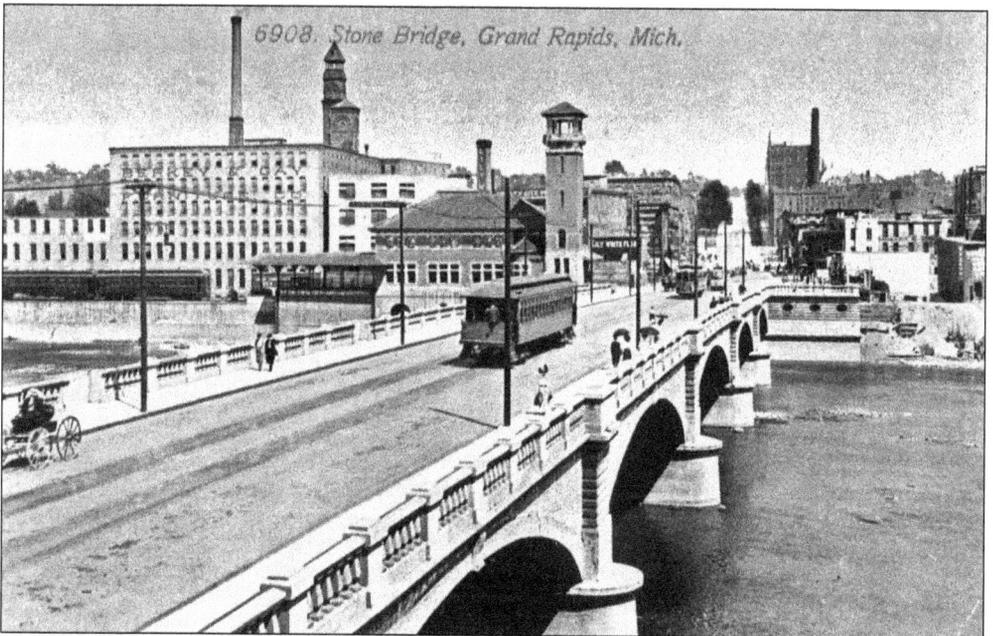

Interurban cars used the track of the Grand Rapids streetcar system to enter and leave Grand Rapids, leaving the city by Leonard Street on the northwest side of town. Here, a GRGH&M car is crossing the Bridge Street bridge on its way out of the downtown area. The Grand Trunk depot is in the background, along the east bank of the Grand River.

34

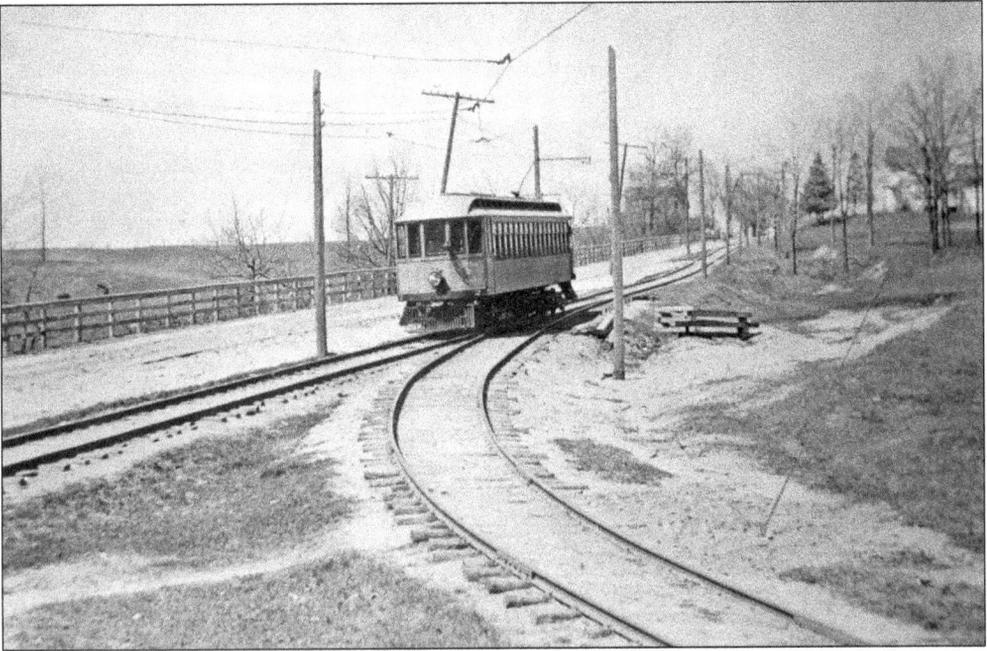

At the city limits, interurban cars left the city system and entered the GRGH&M-owned tracks along the north side of Leonard Street. This photograph shows Car No. 2 approaching the city limits from the west at Walker Road. The spur track leads to a gravel pit the company had operated to furnish ballast for building the railroad.

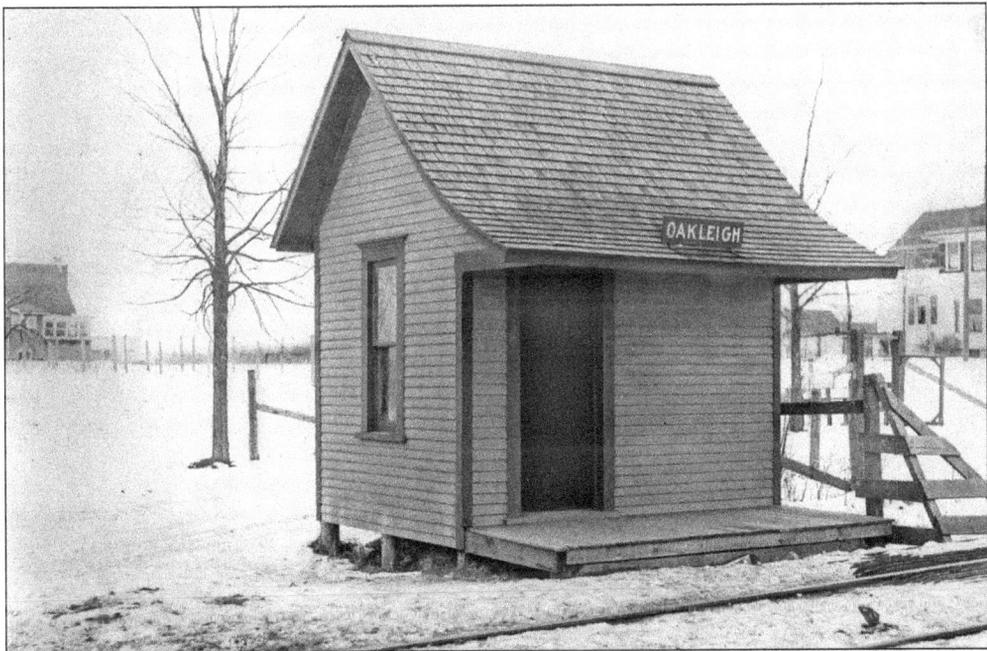

This waiting shelter stood at the corner of Leonard Road and Oakleigh Avenue. It was common for the interurban company or local residents to build similar shelters at main road crossings. The shelters gave the passengers a place to wait away from the elements. Windows in the sides let them watch for an approaching car. (Courtesy of the Grand Rapids Public Library.)

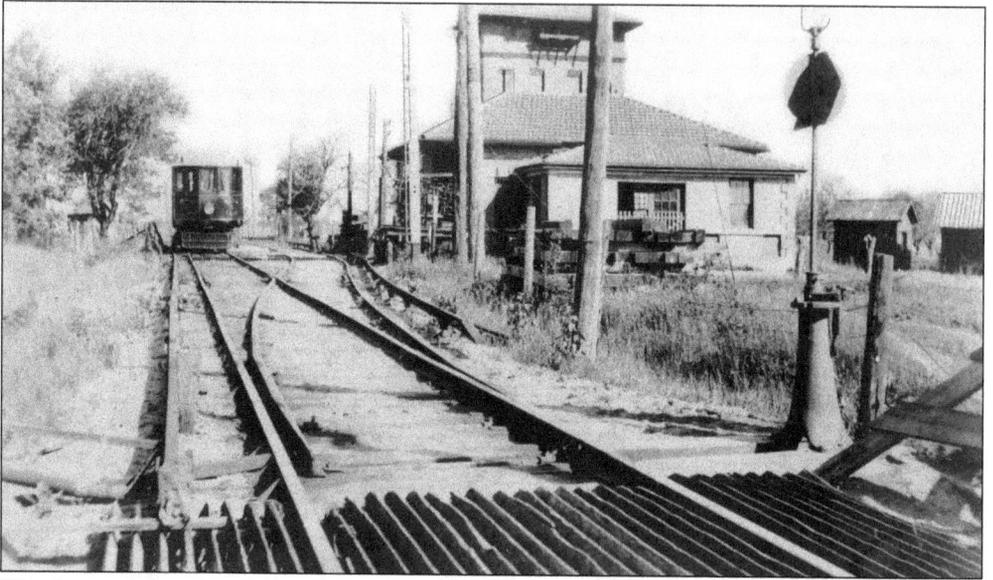

The first station west of Grand Rapids was the depot and substation at Walker, located at the intersection of Remberance Road, Kinney Avenue, and Richmond Street. Interurban cars took power from overhead wires in cities and towns, but in rural areas, cars were powered from electric "third rails" that ran alongside the track. Third rails are visible here along the side of both tracks.

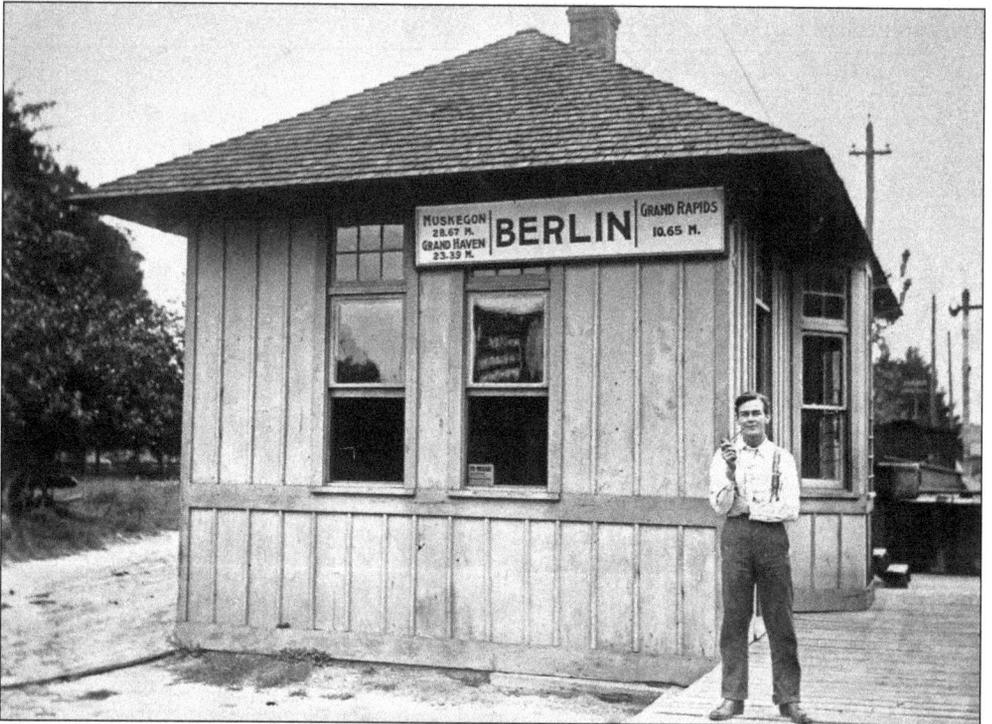

Berlin (now Marne) was the next town west of Walker. This board and batten wooden depot was built in 1902. Here, the station agent stands in front of the depot, which was located in the southeast corner of town.

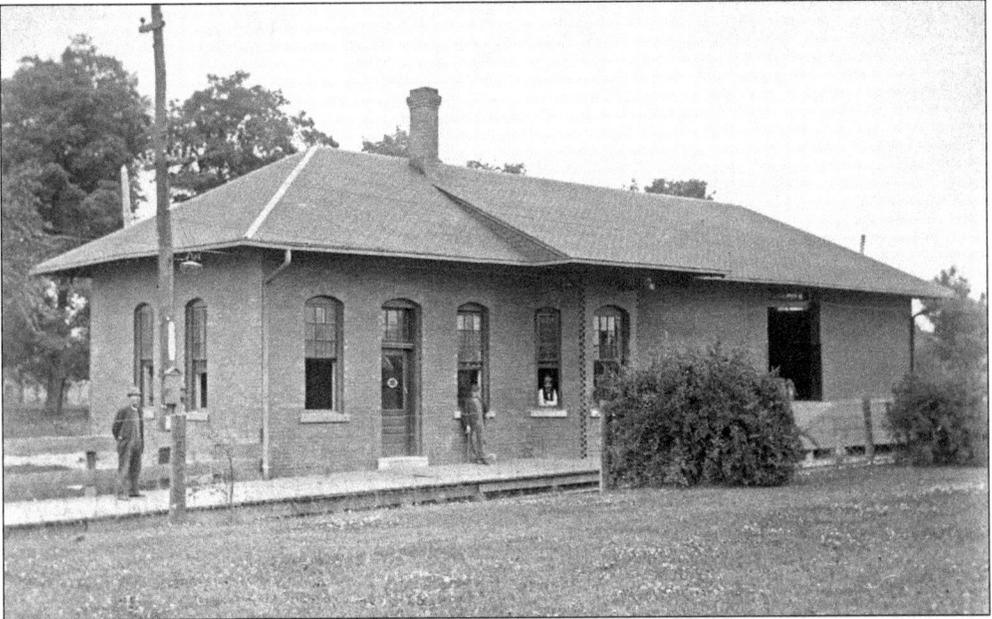

The first Berlin depot burned in 1913 and was replaced by this brick structure. Seen here from the trackside, the ticket office and waiting room were in the left-hand side of the building, and freight was handled at the raised platform and large door to the right. The station agent is visible in the bay window near the center of the depot.

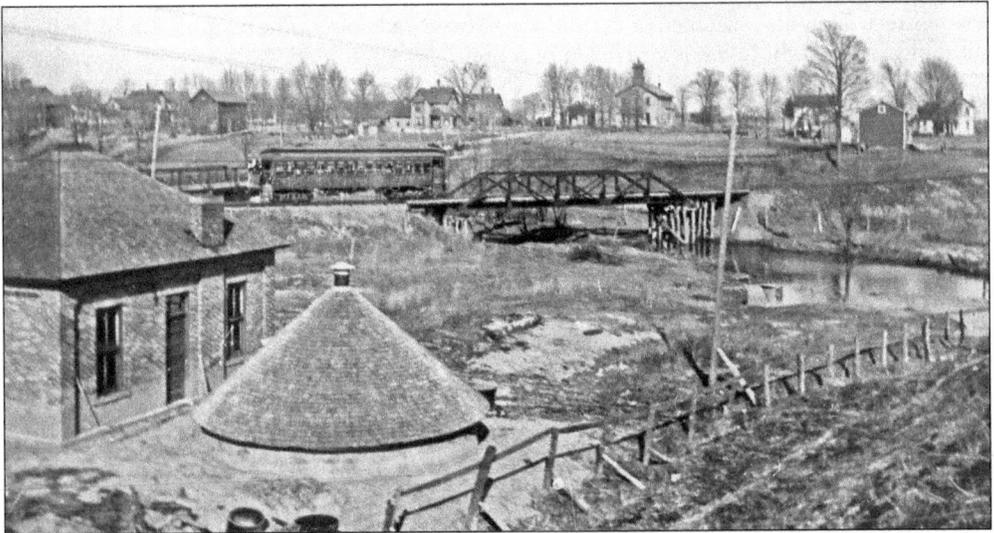

A passenger car crosses the Deer Creek Bridge on the eastern edge of Coopersville. In a view that emphasizes the transition from rural to urban, the background shows a mixture of both environments: a high school and residences mixed with farm buildings. In the foreground is the town's water treatment plant.

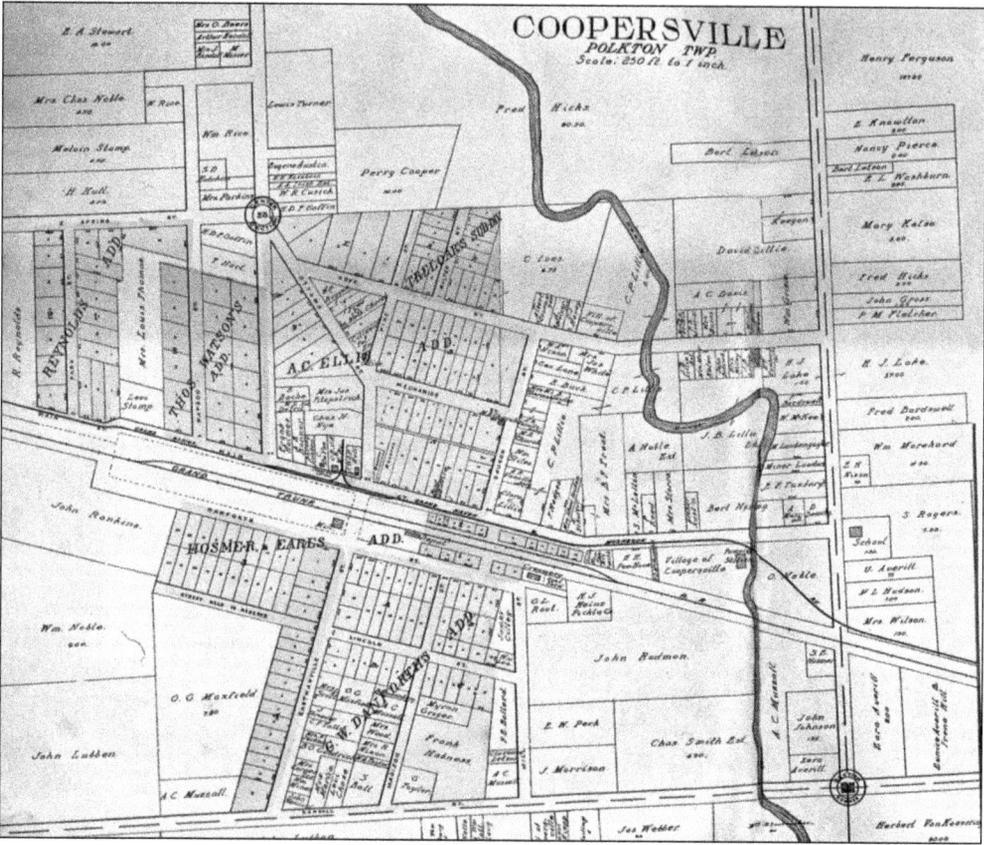

This plat map of Coopersville shows the routes of the Lake Line and the steam railroad through the town. Just past the Deer Creek Bridge, cars left the company's private right of way and entered Main Street. They also switched from third-rail to overhead power. The turning wye at the depot substation and freight house is visible left of center.

In this Coopersville street scene, a freight motor travels along Main Street, heading east. Lillie's General Store is on the left. The GRGH&M's freight operations were built around express and less-than-carload items. It succeeded by offering same-day or next-day service between the communities along its routes.

Crowds have gathered in Coopersville for a celebration. Peanut vendors line the street, and a tent has been erected behind Odd Fellows Hall, the large building across the street. In the background, the interurban depot and substation is visible, and a freight motor sits on the freight house wye.

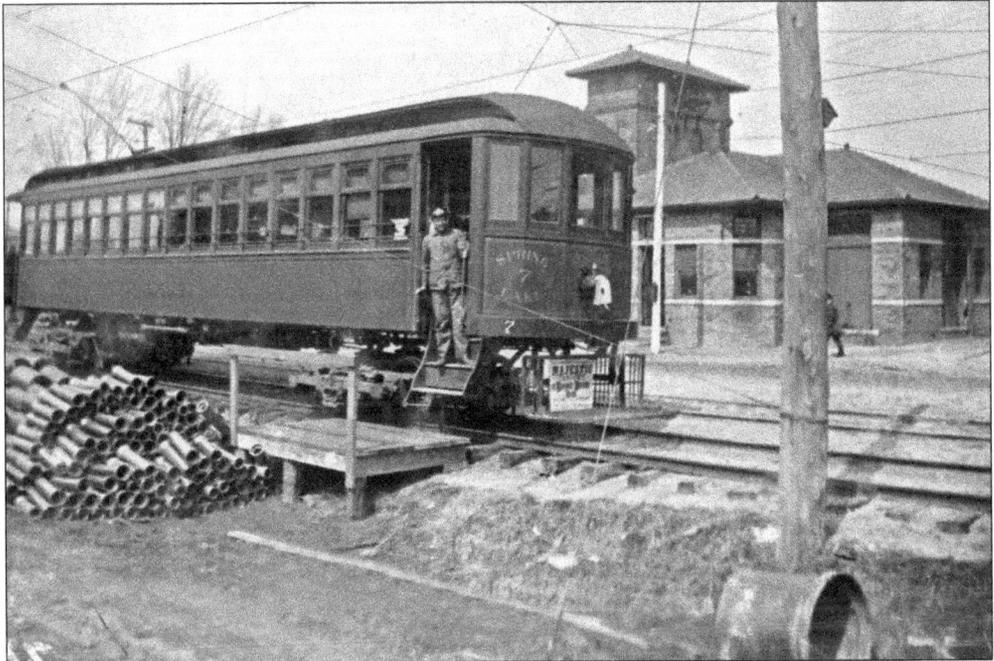

The motorman stands on the steps of Car No. 7 in front of the Coopersville depot. During the summer season, cars passed through Coopersville bound for Grand Rapids or the lakeshore every hour during the day. In the winter, the service was reduced to a car every hour and a half. There was also a commuter service that ran between Coopersville and Grand Rapids each morning and evening.

Malone's Crossing was at the intersection of the interurban right of way and Eighty-eighth Avenue. Cars stopped here if someone was waiting or wanted to get off. The man in the photograph is sitting on a platform built to handle baggage and freight. Across the street from the stop was St. Michael's Catholic Church. Each week, a priest took a car from Grand Haven to the church to say the mass.

40

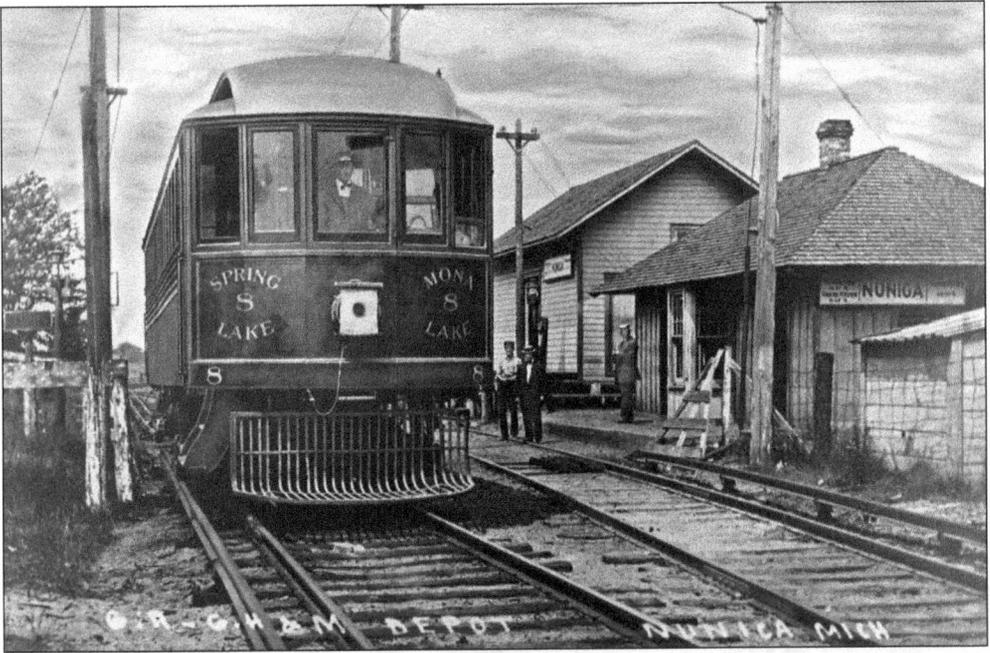

Car No. 8 stands in front of the station in Nunica. Since the interurban cars passed through Nunica on private right of way rather than using the city street, the cars did not switch from third rail to overhead power. The third rails are evident on both the main line and on the station siding. Sidings were used at stations and other locations to allow cars to pass or to unload freight without blocking the main line.

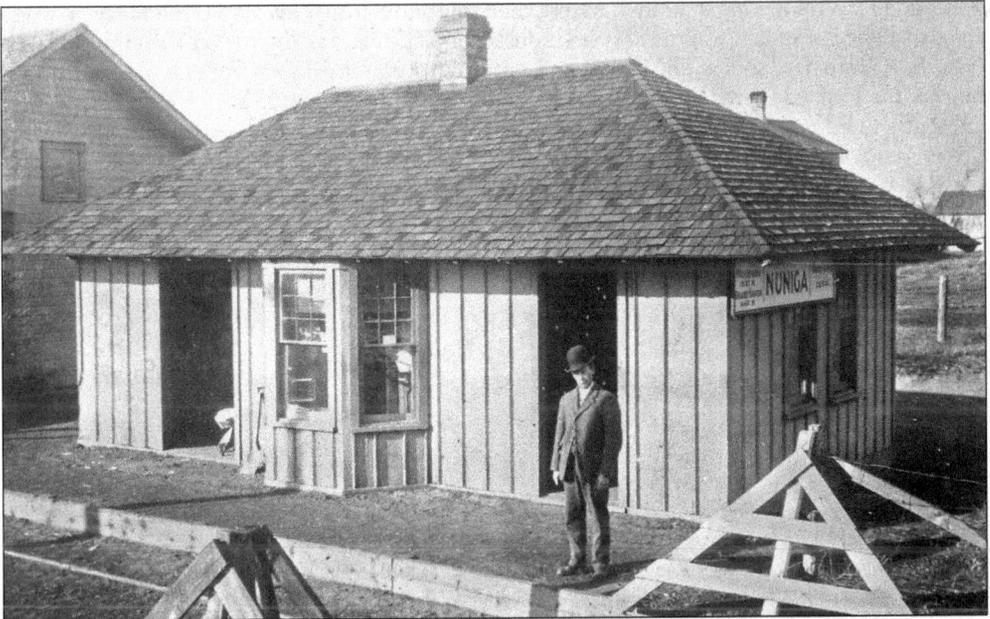

Clarence Bond, the station agent, stands at the Nunica depot. At the beginning of the interurban era, Nunica was a farming community served by the railroad. The hourly interurban trains opened the door to commuting. Area residents began to travel to Muskegon to work in the factories or to the neighboring town of Coopersville for shopping.

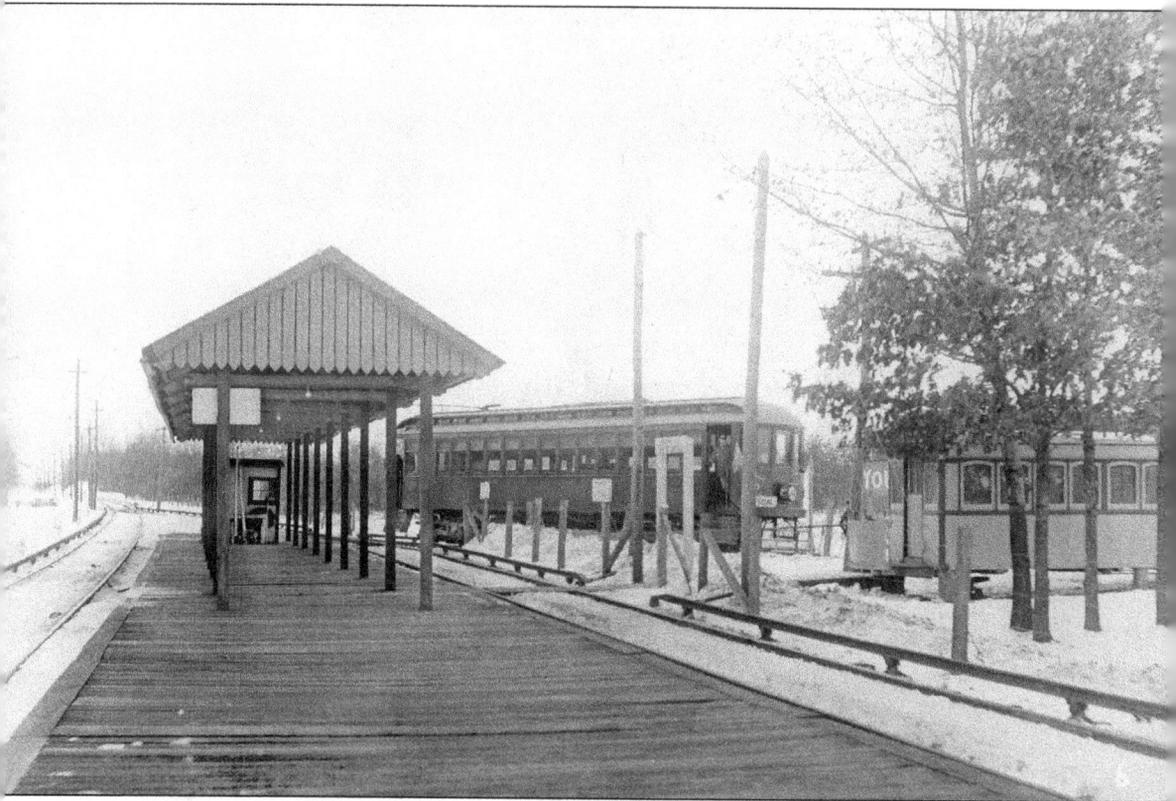

At Grand Haven Junction, a branch line headed south to Spring Lake and Grand Haven, while the main line continued to Fruitport and Muskegon. The car at center is on the Grand Haven branch, ready to head south. The junction was a focal point of the railway's operations. Every train on the line stopped there. Each hour, three trains would meet: one headed west to Muskegon, another headed east to Grand Rapids, and the third traveled back and forth to Grand Haven. Passengers could make connections for any destination without a long wait. An old streetcar body, seen at right, served as a dispatching office during the summer when traffic was at its peak. (Courtesy of the Grand Rapids Public Library.)

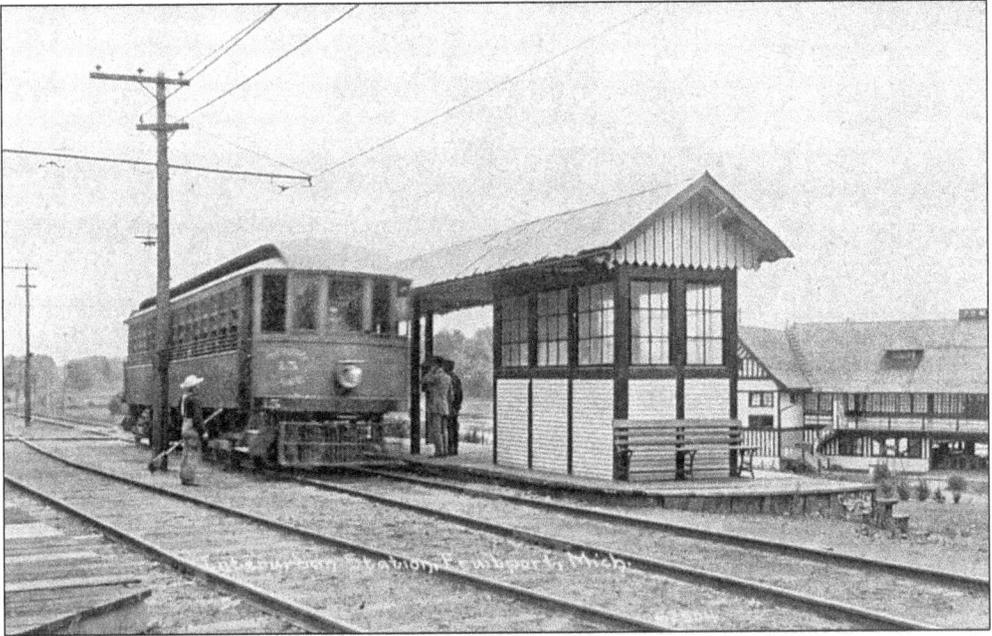

In Fruitport, cars stopped at a station by Pomona Pavilion, a resort operated by the interurban company. The company built the pavilion as a destination for summer activities such as picnics and boating. Groups could charter a car for the trip to the pavilion. Car No. 15 stands on the station track, and the pavilion is in the background on Spring Lake.

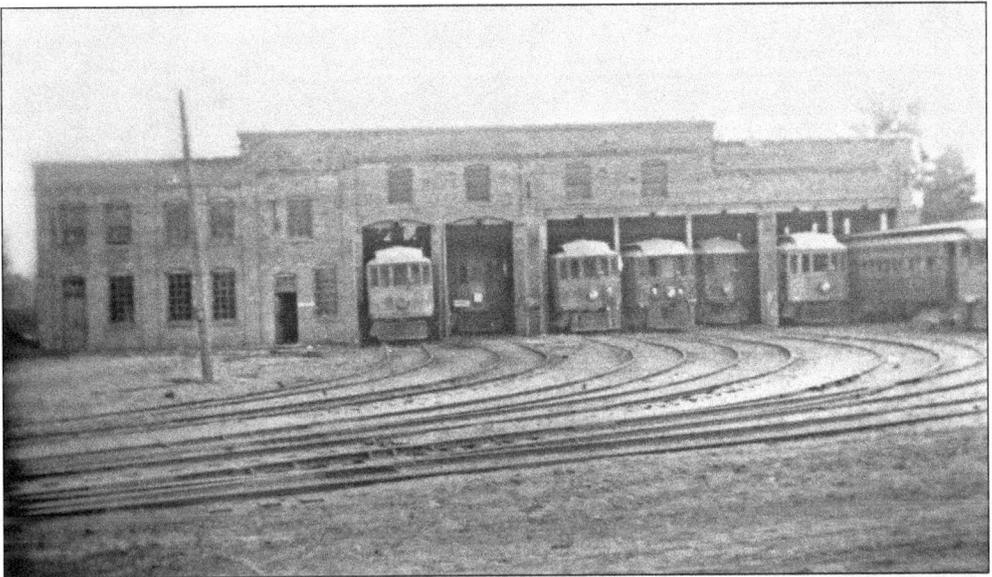

Fruitport was also the site of the line's carbarn and shop building. The first two tracks from the left are the shop tracks. This section of the building housed cars undergoing maintenance and repair work. The five sets of track on the right were storage tracks, where cars were kept out of the weather when they were not in use.

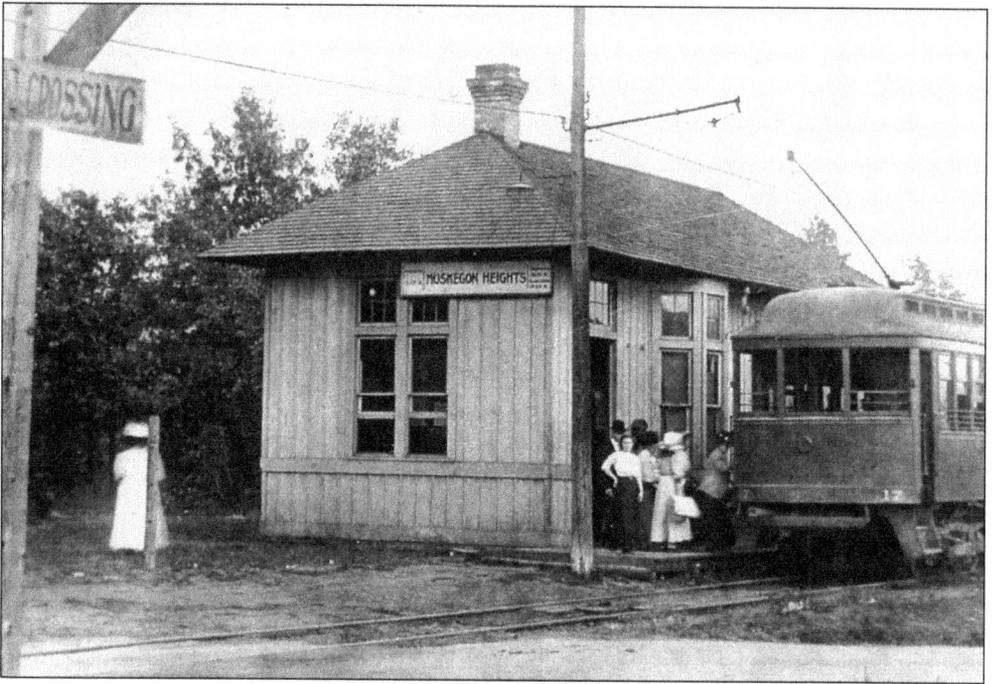

In Muskegon Heights, cars stopped at a depot located on Peck Street, a block south of McKinney (now Broadway). A few hundred feet beyond this point, they entered the tracks of the Muskegon Traction and Lighting Company for the remainder of the trip. In this photograph, passengers are boarding Car No. 17, a passenger-baggage combination car, headed east toward Grand Rapids.

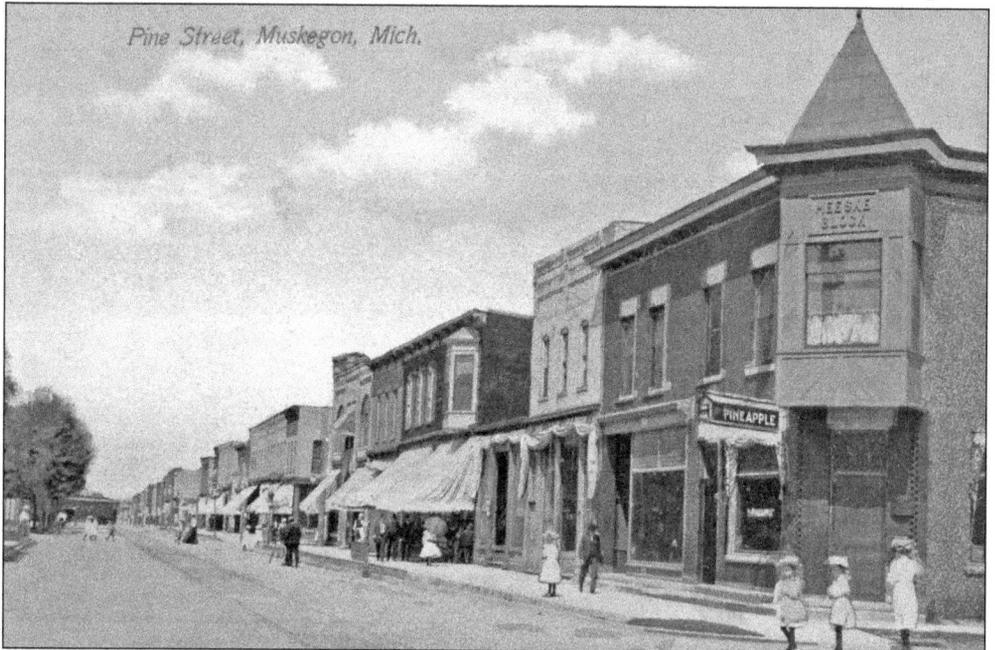

In Muskegon, cars approached the downtown on Pine Street. The view in this postcard scene is looking north on Pine Street from the intersection with Apple Avenue. In the distance, an interurban car is approaching from West Walton Avenue to turn north and continue to Western Avenue.

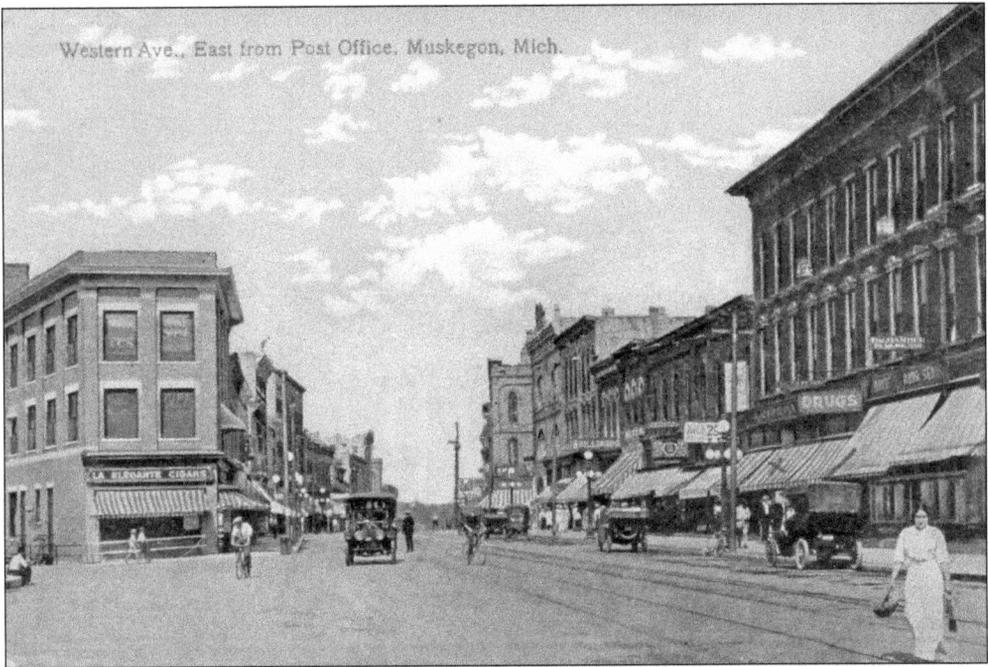

Western Ave., East from Post Office. Muskegon, Mich.

Lake Line cars followed the city streetcar track along Western Avenue, between Pine Street and the GRGH&M depot on the corner of Seventh Street. This postcard view shows the block between Jefferson and First Streets.

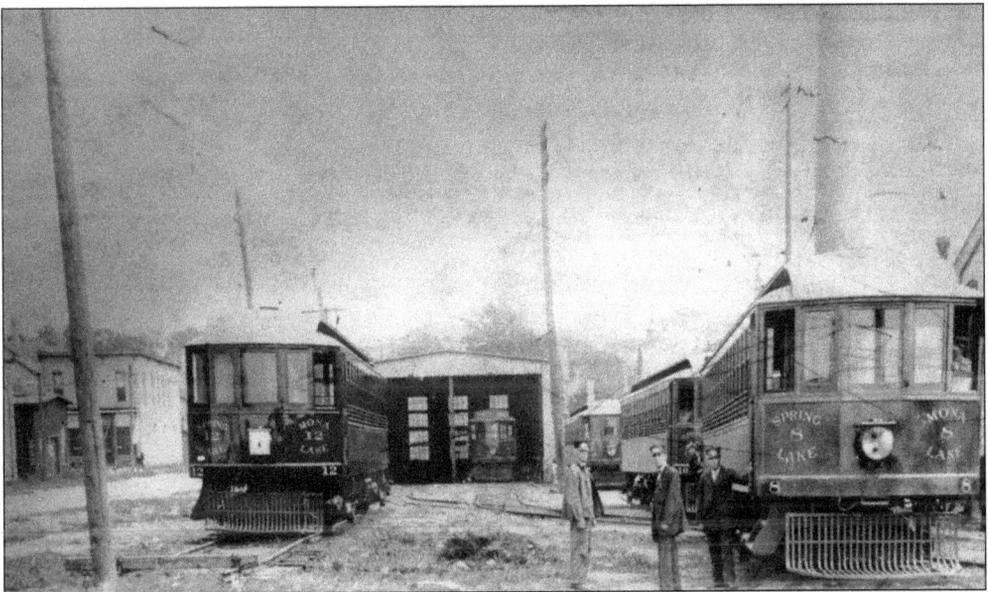

Trips to Muskegon ended in the depot yard on Seventh Street and Western Avenue. Cars were stored here between trips. In the distance is the Muskegon shop building, which was used to inspect cars and make minor repairs. Substantial repairs were always made at the main shop building in Fruitport.

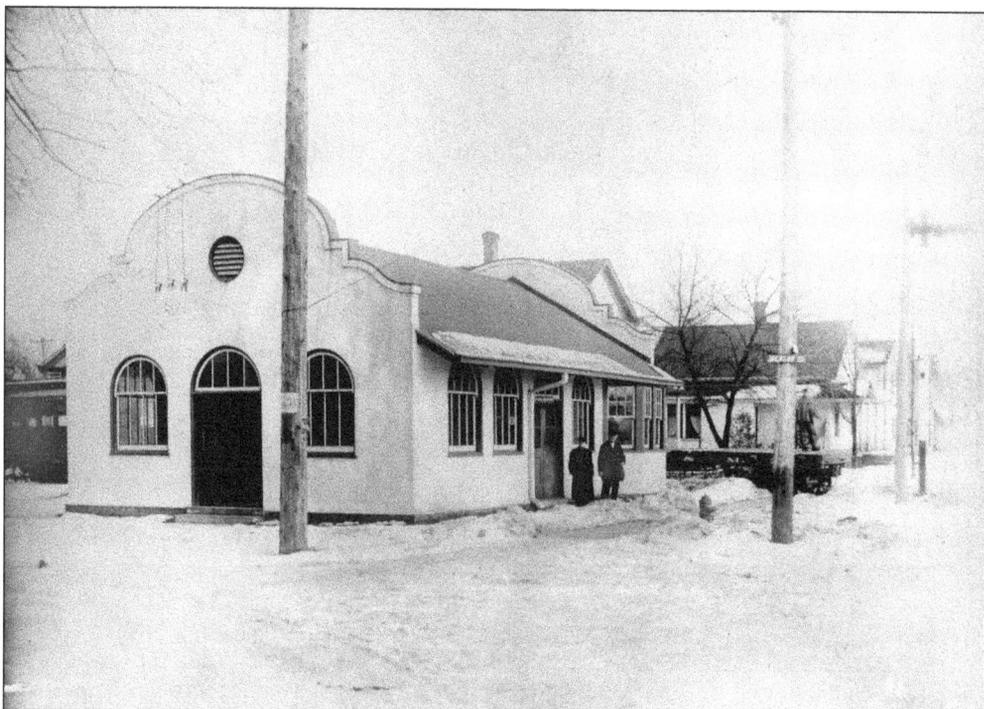

In 1913, the GRGH&M built a station in Spring Lake. The stucco building stood at the corner of Jackson and Savage Streets. A separate freight house, not visible in this image, stood behind the building. In 1917, the company installed a substation in the freight house to help balance the power on the branch. New automated substation technology allowed the equipment to function automatically and did not require an operator.

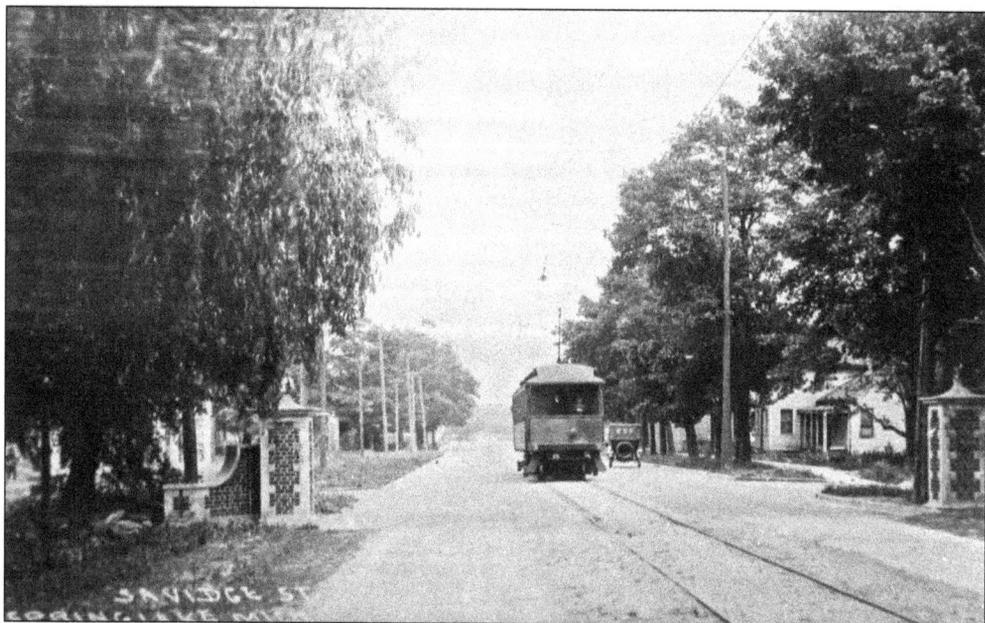

A combination passenger-freight car is traveling east along Savidge Street in Spring Lake. The larger interurban car dwarfs an early automobile sharing the road with it.

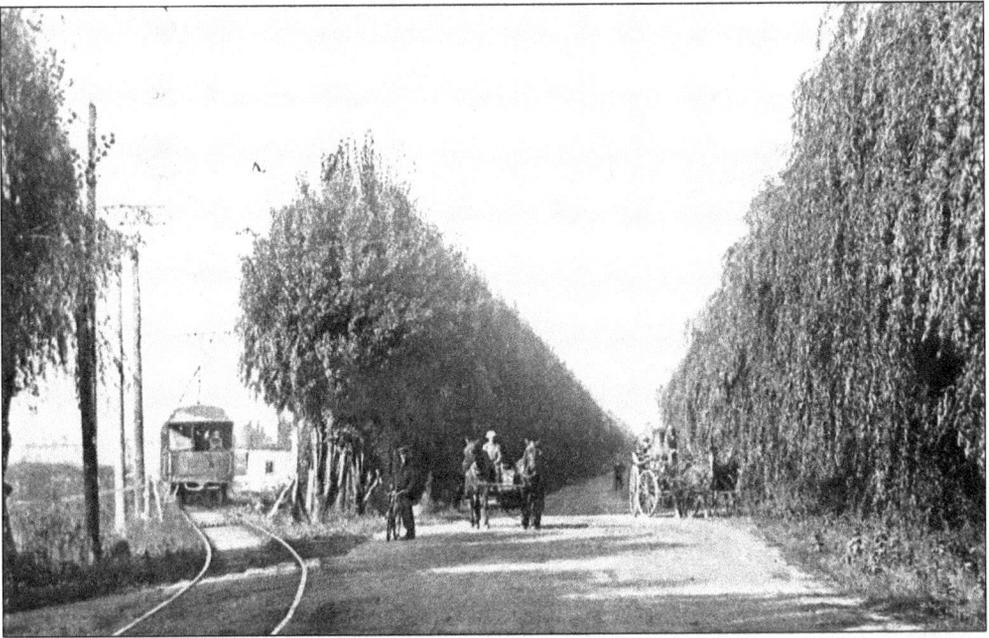

This section of the road between Spring Lake and Ferrysburg was known as "the willows," for the trees that lined each side of the road. Instead of following the road farther west, the interurban line angled southwest to the bridge, crossing the Grand River at Mill Point. The waiting shelter at the bridge is visible in the background, to the right of the car.

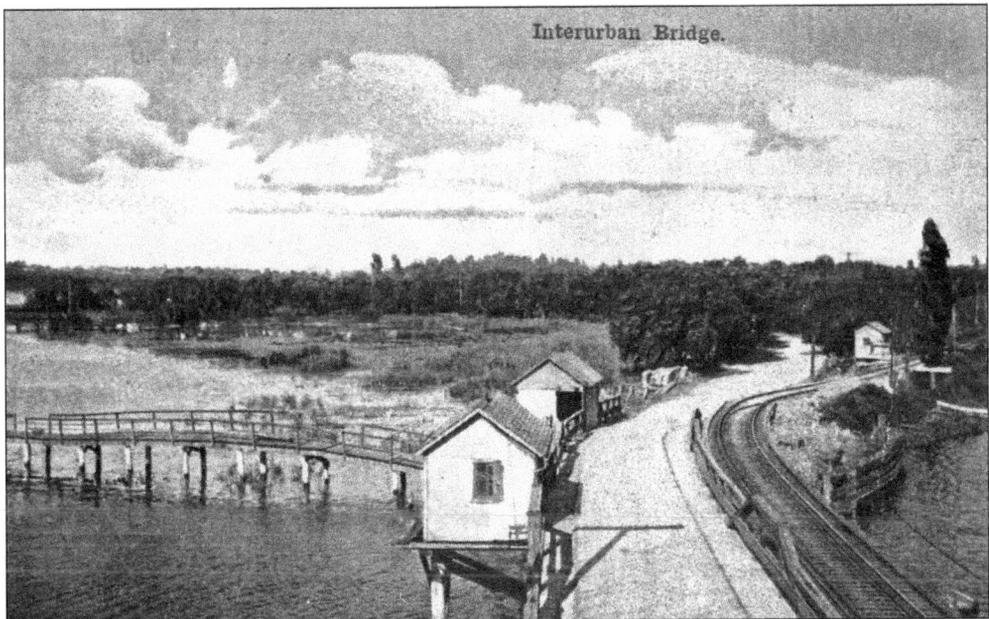

Interurban Bridge.

This postcard view shows the north approach to the Grand River Bridge. The buildings in the foreground housed the bridge operators and stored equipment. In the background along the track is a waiting shelter for passengers.

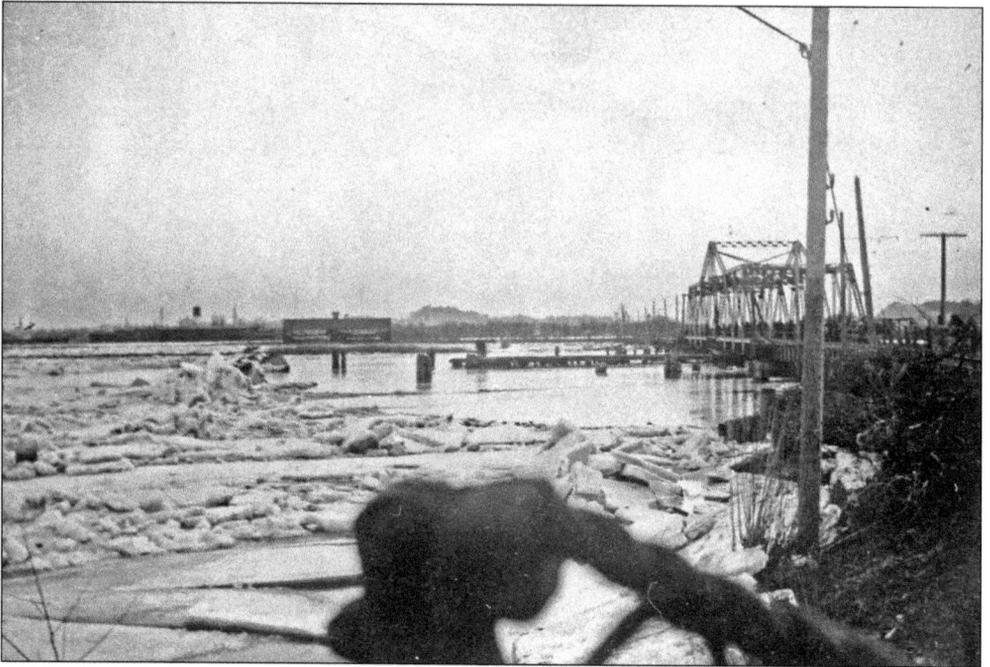

The Grand River Bridge is seen here from the north approach, looking toward Grand Haven. Ice has formed along the shore. Ice on the river was a constant danger to the interurban. An ice jam above the bridge could force river ice to back up and cause serious damage to the structure.

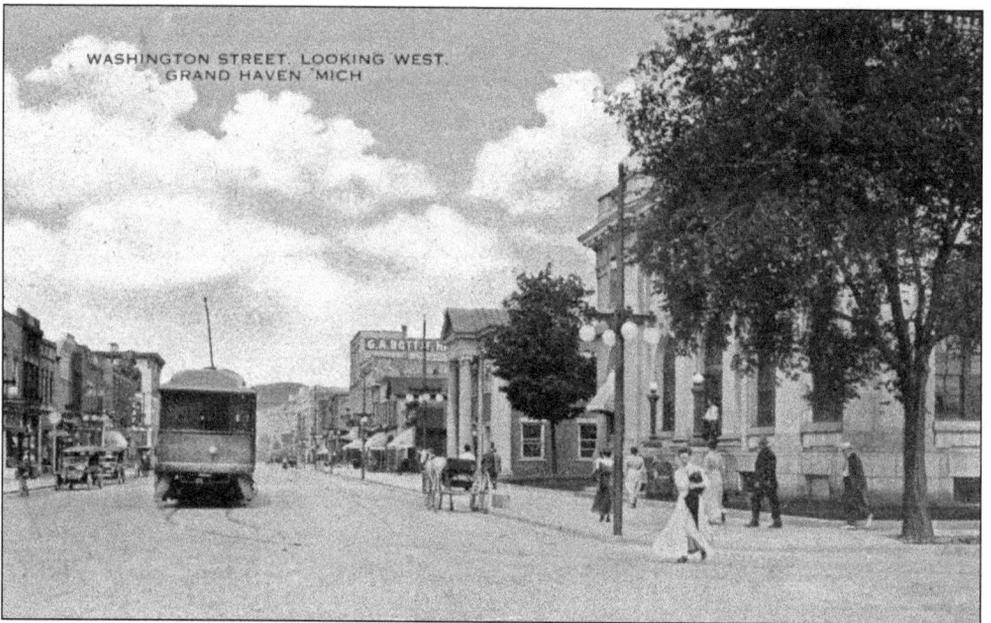

WASHINGTON STREET. LOOKING WEST.
GRAND HAVEN MICH

An interurban car has just turned onto Washington Avenue from Third Street, headed into downtown Grand Haven. In Grand Haven, cars traveled down Fulton Street from Seventh to Third Street, then on Third to Washington Street, and Washington to Water Street (now Harbor Drive).

48

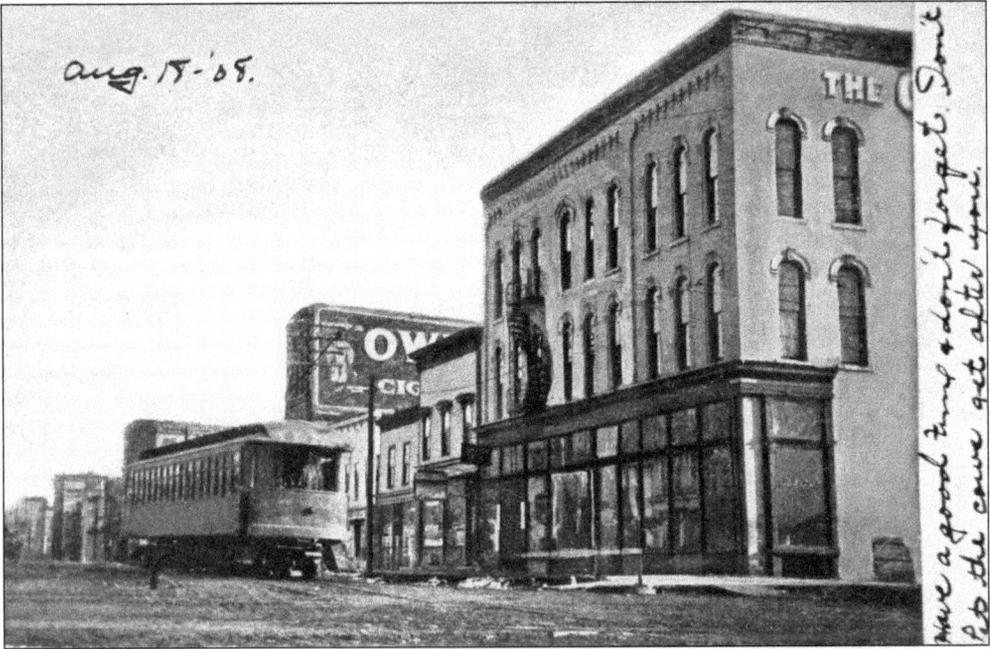

aug. 15-'08.

Have a good time & don't forget. Don't let the cane get after you.

A passenger car is heading east on Washington Street, near the intersection with Water Street (today's Harbor Drive). The building on the corner is the Gildner House, one of the main hotels in Grand Haven. Cars left Grand Haven every hour to make the trip to the junction and the connections to Grand Rapids and Muskegon.

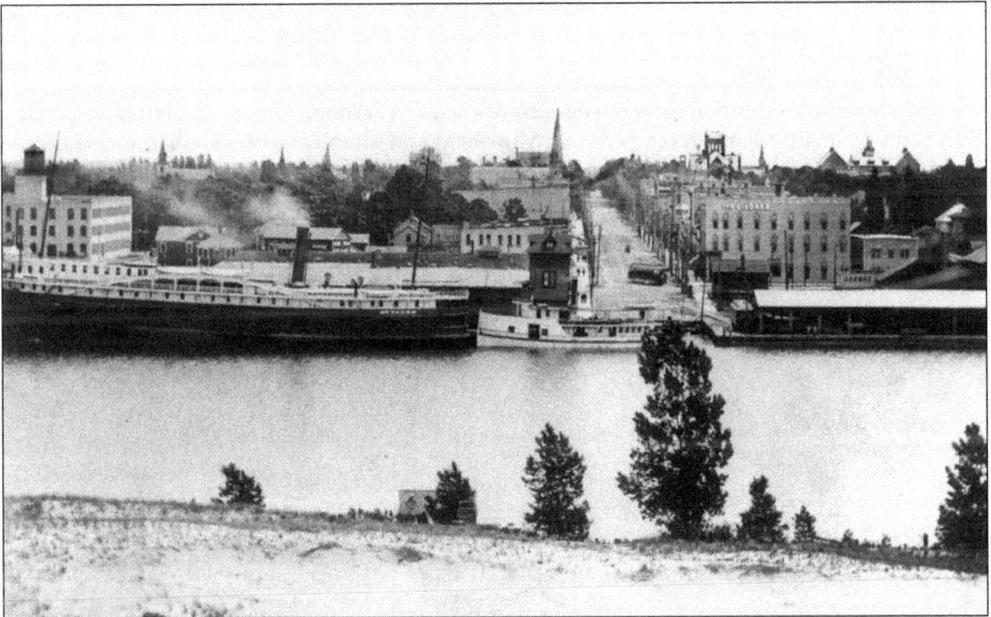

This postcard view shows an open interurban car turning the corner at the foot of Washington Street in Grand Haven. The Goodrich dock is on the right, with an interurban freight motor on the dock siding. The dock on the left is the Grand Trunk dock. The boats at the Grand Trunk dock are the *Nyack*, the Crosby line's steamer that ran between Michigan and Milwaukee, and a river packet.

Map of the
Grand Rapids, Grand Haven & Muskegon Ry.
To Rosedale Park

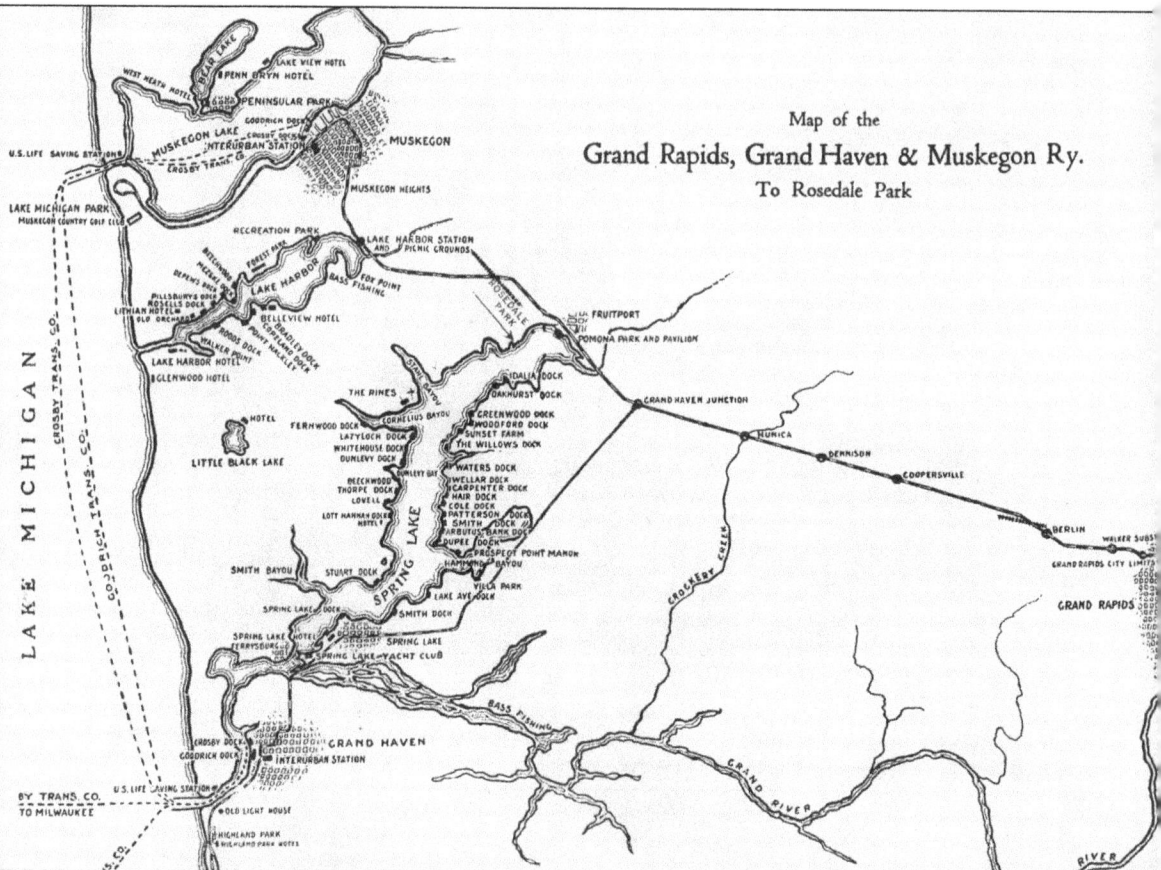

LAKE MICHIGAN

LAKE VIEW HOTEL
PENN BRYN HOTEL
WEST HEATH HOTEL
PENINSULAR PARK
GOODRICH DOCK
MUSKEGON LAKE
INTERURBAN STATION
MUSKEGON
CROSBY TRANS.
U.S. LIFE SAVING STATION
MUSKEGON HEIGHTS
LAKE MICHIGAN PARK
MUSKEGON COUNTRY GOLF CLUB
RECREATION PARK
FOREST PARK
LAKE HARBOR STATION AND PICNIC GROUNDS
BASS FISHING
FOR POINT
INTERURBAN
MEDBAL
DEPEW'S DOCK
PILLSBURY'S DOCK
ROSELL'S DOCK
LITHIAN HOTEL
OLD ORCHARD
LAKE HARBOR
BELLEVIEW HOTEL
McBRADLEY'S DOCK
CORNWELL DOCK
WALKER DOCK POINT
NICKELL DOCK
LAKE HARBOR HOTEL
EGLENWOOD HOTEL
ROSEDALE PARK
FRUITPORT
POMONA PARK AND PAVILION
HOTEL
LITTLE BLACK LAKE
THE PINES
FERNWOOD DOCK
CORNELIUS BAYOU
LAZYLOCH DOCK
WHITEHOUSE DOCK
DUNLEVY DOCK
BEECHWOOD
THORPE DOCK
LOVELL
LOTT HANNAH DOCK
HOTEL
TULLEY GUT
IDALIA DOCK
OAKHURST DOCK
GREENWOOD DOCK
WOODFORD DOCK
SUNSET FARM
THE WILLOWS DOCK
WATERS DOCK
WELLAR DOCK
CARPENTER DOCK
HAIR DOCK
COLE DOCK
PATTERSON DOCK
SMITH DOCK
ARBUTUS BANK DOCK
DUPEE DOCK
PROSPECT POINT MANOR
HAMMOND BAYOU
VISTA PARK
GRAND HAVEN JUNCTION
NUNICA
DENNISON
COOPERSVILLE
BERLIN
WALKER SUBST.
GRAND RAPIDS CITY LIMITS
GRAND RAPIDS
CROCKERY CREEK
SMITH BAYOU
STUART DOCK
LAKE AVE DOCK
SMITH DOCK
SPRING LAKE
SPRING LAKE DOCK
SPRING LAKE HOTEL
FERRYSBURG
SPRING LAKE YACHT CLUB
CROSBY DOCK
GRAND HAVEN
GOODRICH DOCK
INTERURBAN STATION
BASS FISHING
GRAND RIVER
BY TRANS. CO. TO MILWAUKEE
U.S. LIFE SAVING STATION
OLD LIGHT HOUSE
HIGHLAND PARK
HIGHLAND PARK HOTEL
RIVER
CROSBY TRANS. CO.
GOODRICH TRANS. CO.

West Michigan was resort country at the turn of the 20th century. During the latter part of the 19th century, major resorts developed near Muskegon and Grand Haven. Smaller resorts dotted Spring Lake, drawing visitors from throughout the region. Cool breezes along the lake offered a break from the summer heat farther inland. From mid-May until after Labor Day, there was an influx of resorters and tourists. The GRGH&M capitalized on the increased business. The frequency of trains increased from once each hour and a half during the winter months to once an hour during the summer.

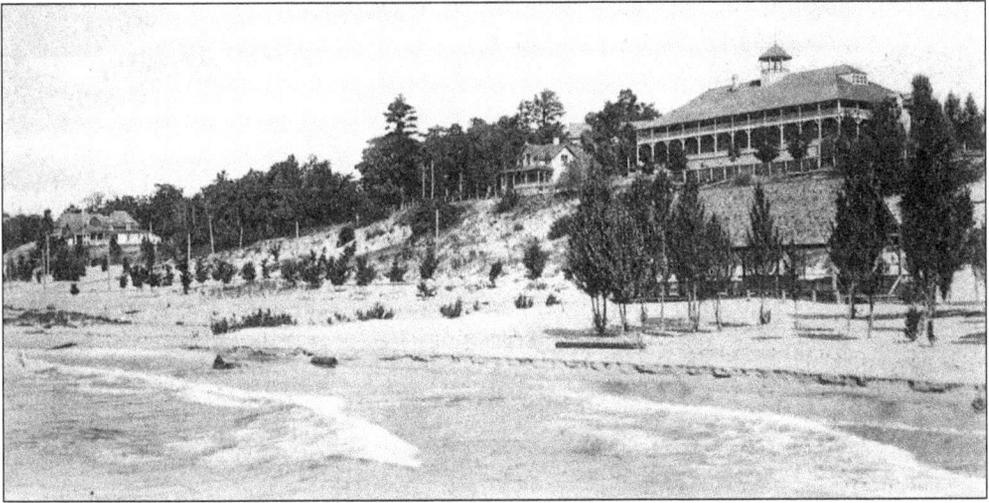

During the 1890s, a resort community had developed along the Grand Haven dunes at Highland Park. The large Highland Park Hotel, pictured here, was an overnight journey from Chicago and Milwaukee and a popular destination during the summers.

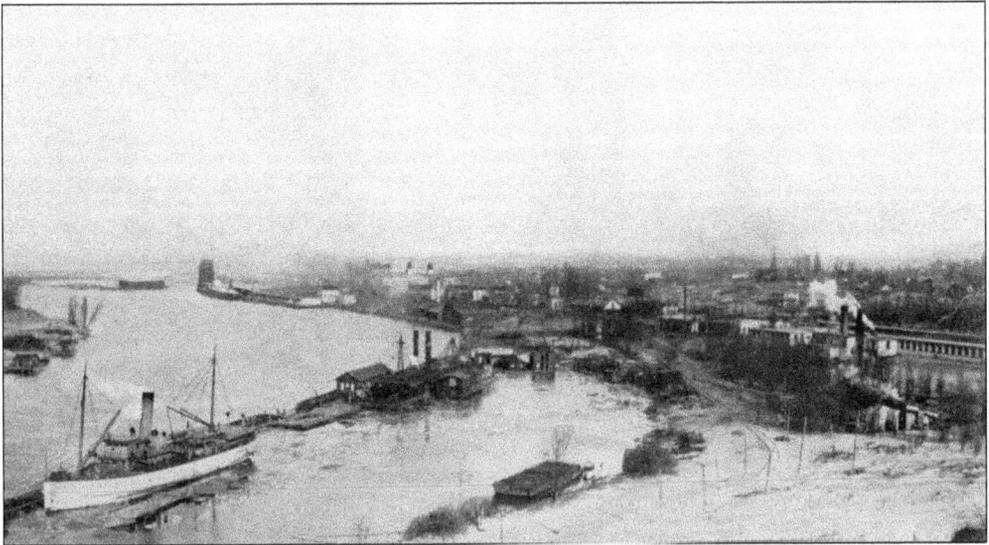

In 1902, the GRGH&M purchased the Grand Haven Street Railway, which had served Highland Park during the summers, and re-laid the tracks to the beach so they could support the larger interurban cars. The tracks to the lake ran along Water Street (now Harbor Drive) and continued into the dunes west of town. The tracks and line poles are visible in this postcard view.

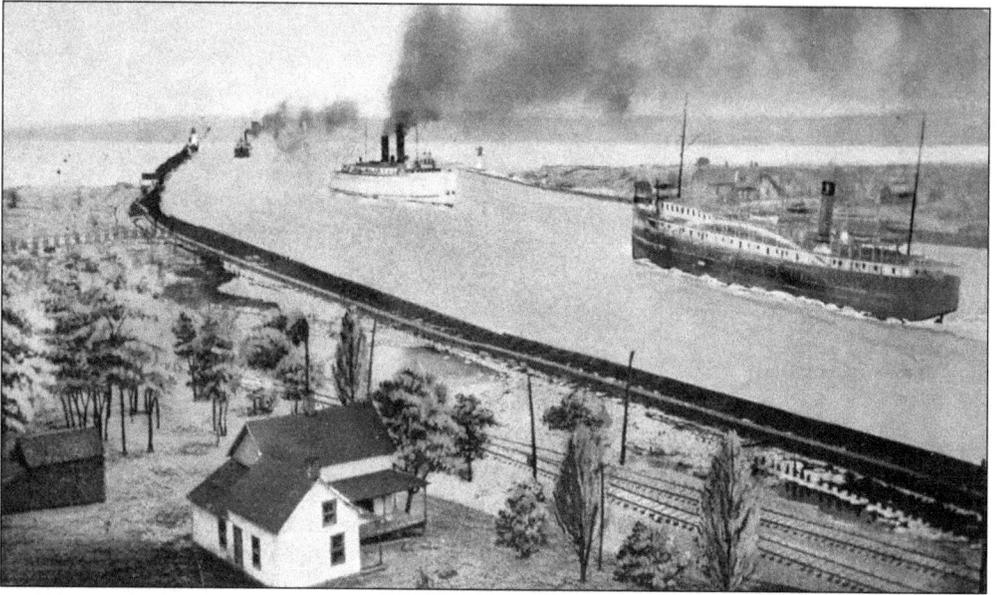

The interurban tracks continued along the south side of the river to its mouth at Lake Michigan and then turned south along the beach. Between the lake steamers, shown here, and the railroad car ferries of the Detroit and Milwaukee (Grand Trunk), the port of Grand Haven was a busy place, especially in the summer.

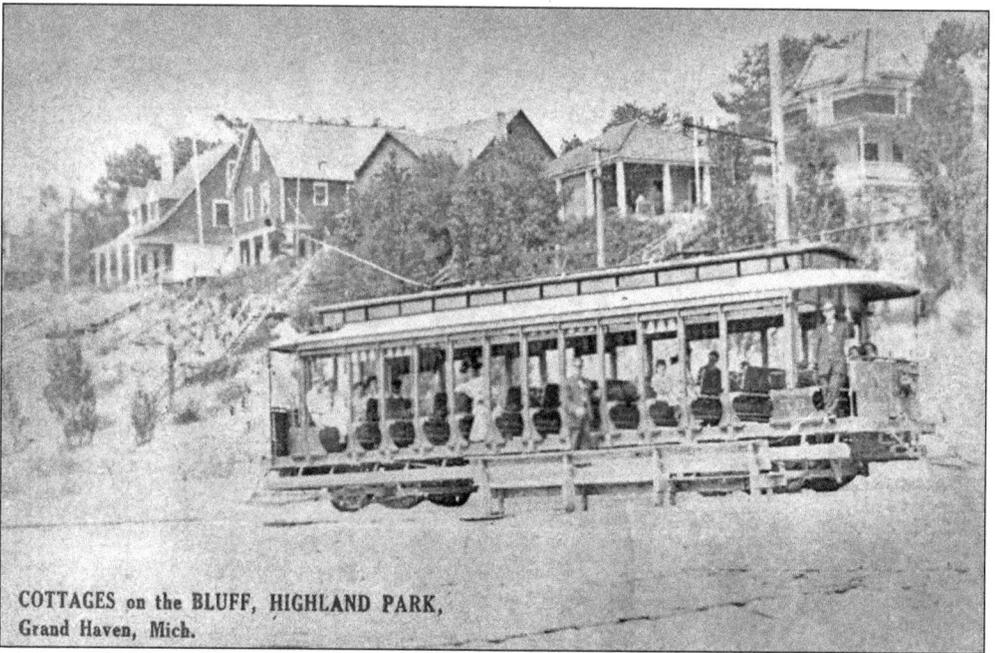

COTTAGES on the BLUFF, HIGHLAND PARK,
Grand Haven, Mich.

The Lake Line acquired a pair of open cars from the Brill Manufacturing Company to provide service to the beach. This photograph shows Car No. 56 running along the beach, with a few of the elaborate Highland Park cottages on the top of the dunes. In the minds of the public, the open cars became an iconic part of summers at Grand Haven.

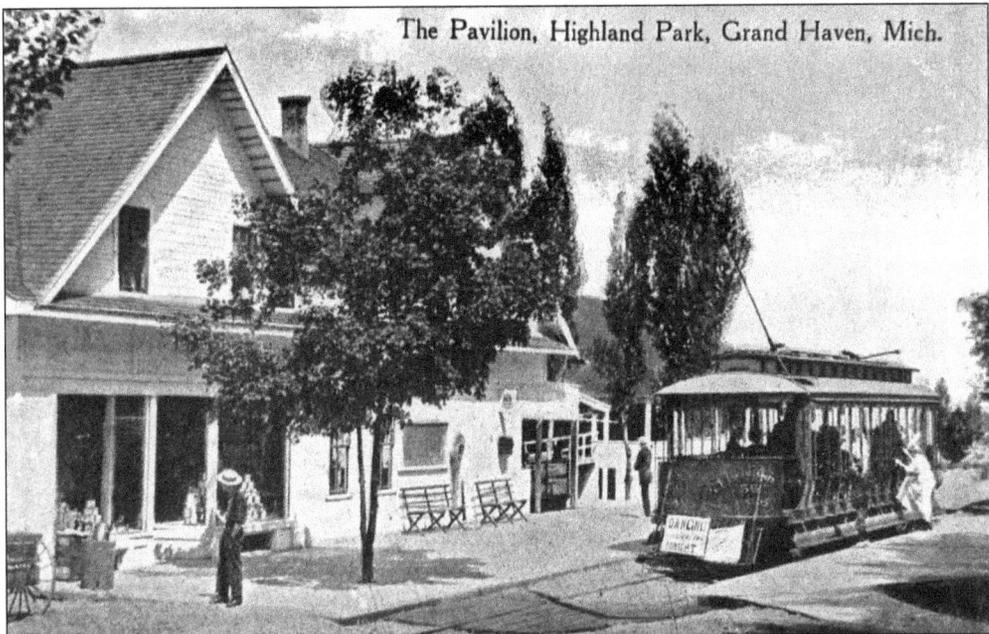

The Pavilion, Highland Park, Grand Haven, Mich.

On the beach below the hotel, a series of pavilions and shops developed to serve the summer trade. This store on the beach also served as the interurban ticket office and waiting room. Dancing in the pavilion behind the streetcar was a popular way to spend summer evenings along the shore of Lake Michigan.

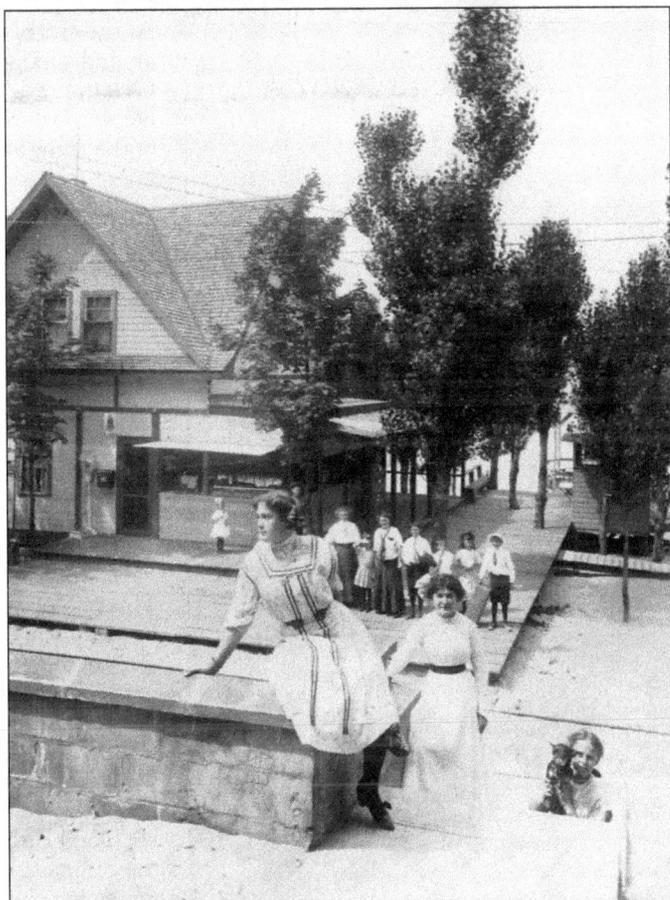

A group of young girls poses on the stairs leading from the pavilions to the hotel. Below them, several passengers wait on the platform at the store for the next car. Even in the middle of the resort season, the interurban tracks are nearly covered with sand.

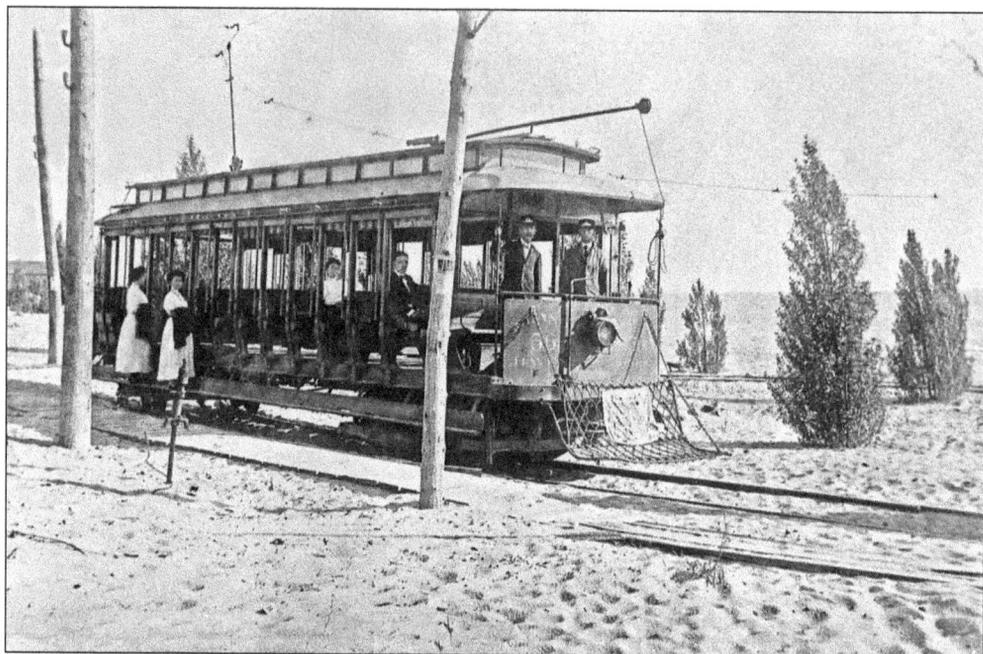

At the end of the line, cars traveled around a loop to turn them for the trip back to town. The loop was located just below the dune at Stickney Ridge, south of the main Highland Park community. Longtime residents and visitors referred to this location as the "Indian Village" because of a collection of cottages some thought were reminiscent of teepees.

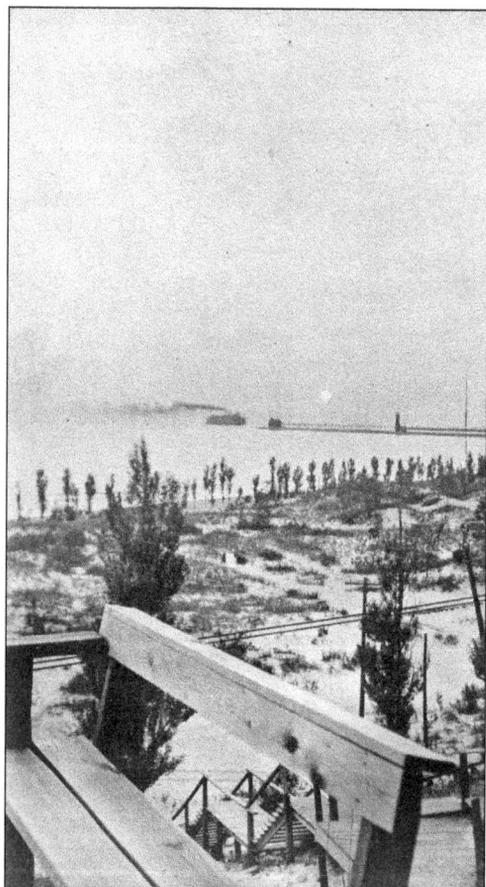

This photograph was taken from the boardwalk at the top of the dunes, and the interurban tracks are visible along the beach. In the background, a Grand Trunk railroad car ferry is approaching the pier and lighthouse at the mouth of the Grand River. During the summer, the GRGH&M ran a daily resorter's special between Highland Park and Grand Rapids to ease the commute for businessmen spending the summer at the lake with their families.

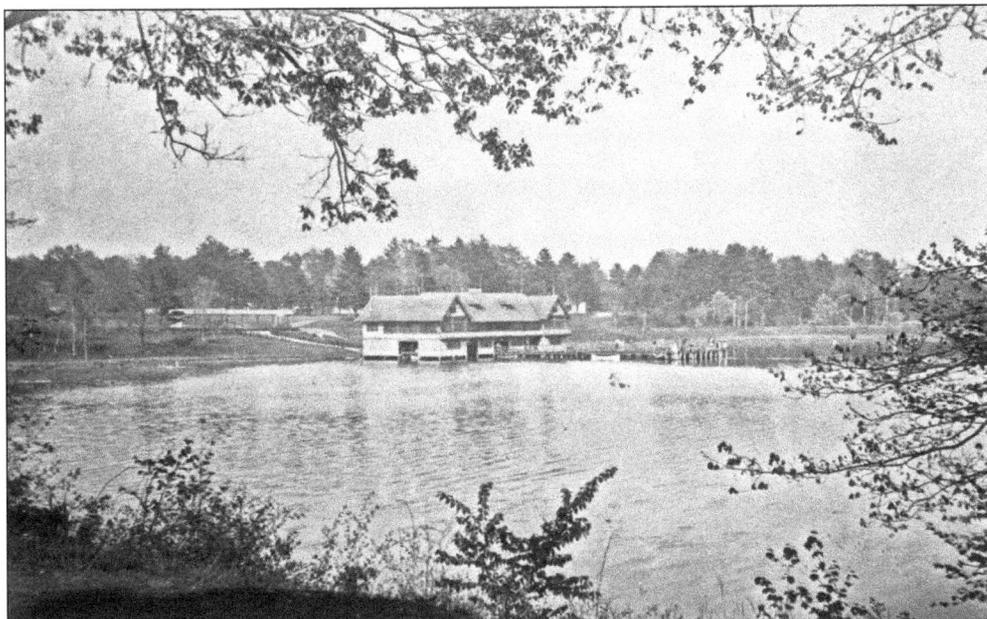

The GRGH&M created its own summer destination when it built Pomona Pavilion along the shores of Spring Lake at Fruitport. The building was actually built out over the lake and attached to the shore.

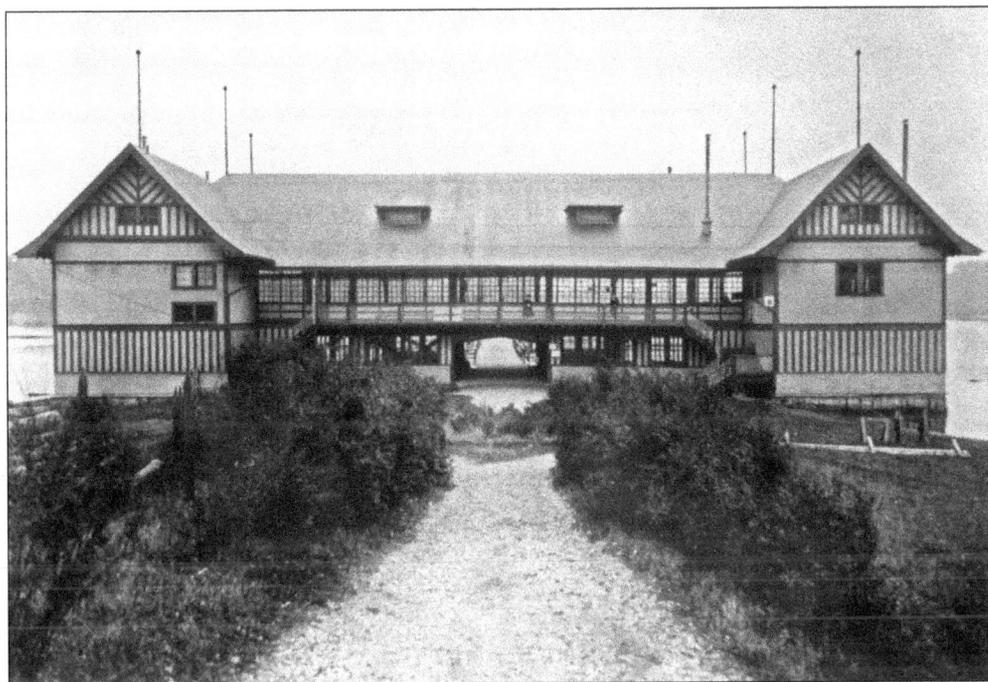

This view shows the front entrance to the pavilion, standing empty in the offseason. The center section housed a large dance hall, and there was also a restaurant and other concessions.

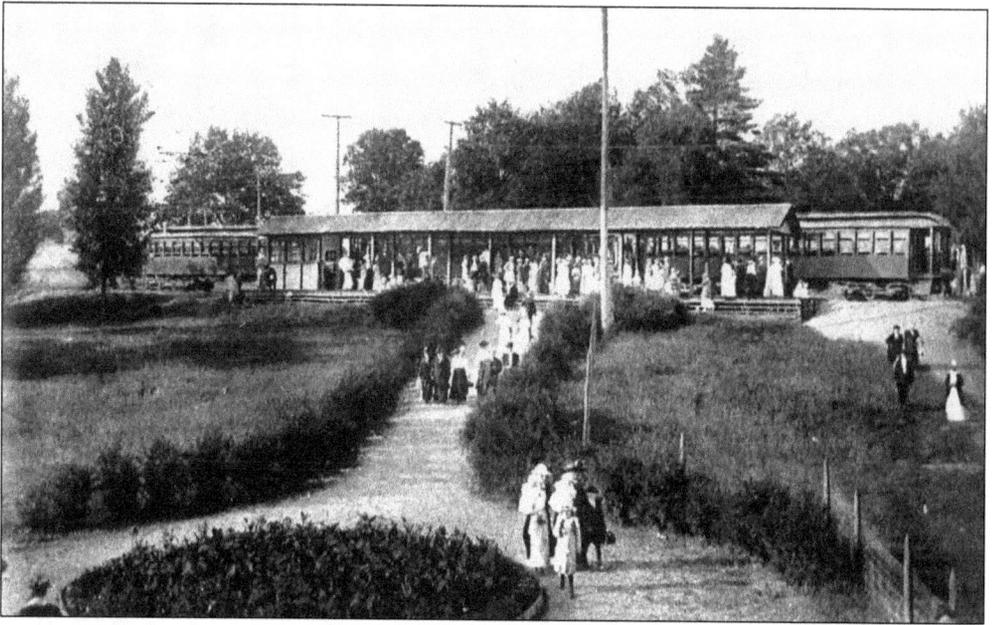

Summer crowds are arriving at the pavilion station. The pavilion and surrounding grounds were a popular destination for group charters during the summer. Groups could charter one or more cars for the trip from Grand Rapids, Muskegon, or Grand Haven. Charters were popular with churches, businesses, and fraternal groups. They were also an important source of income for the interurban company.

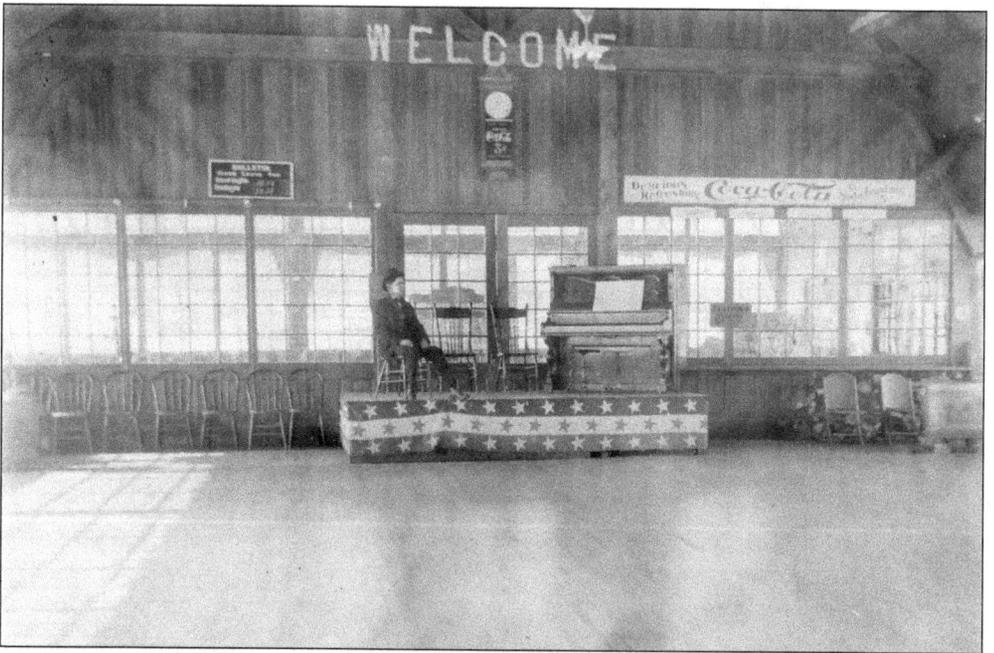

The dance floor and bandstand at Pomona Pavilion are waiting for dancers to arrive. Dance bands were a fixture on the lake during the days of the interurban as well as after the Lake Line quit. During the years the pavilion was owned by the GRGH&M, is was operated as a dry facility. Those wishing for a drink stronger than a cola would need to go elsewhere.

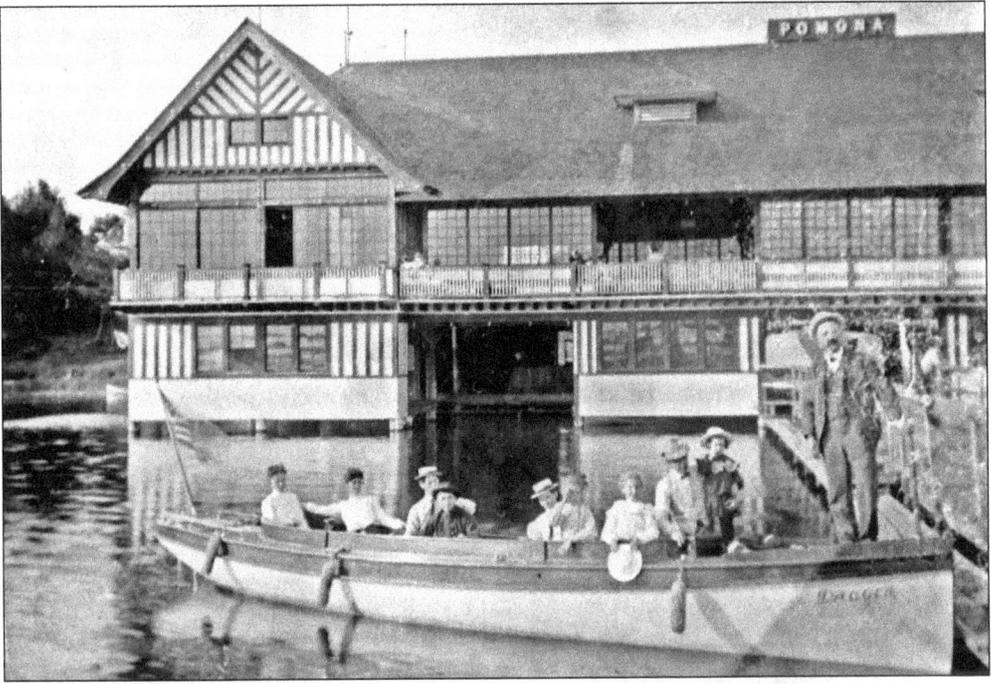

In this view, a group of boaters is alongside the dock at the Pomona Pavilion. Guests could arrive at the pavilion in their own launch or rent a rowboat from one of the concessions. The photograph clearly shows that both the pavilion and the dock are built out over the water.

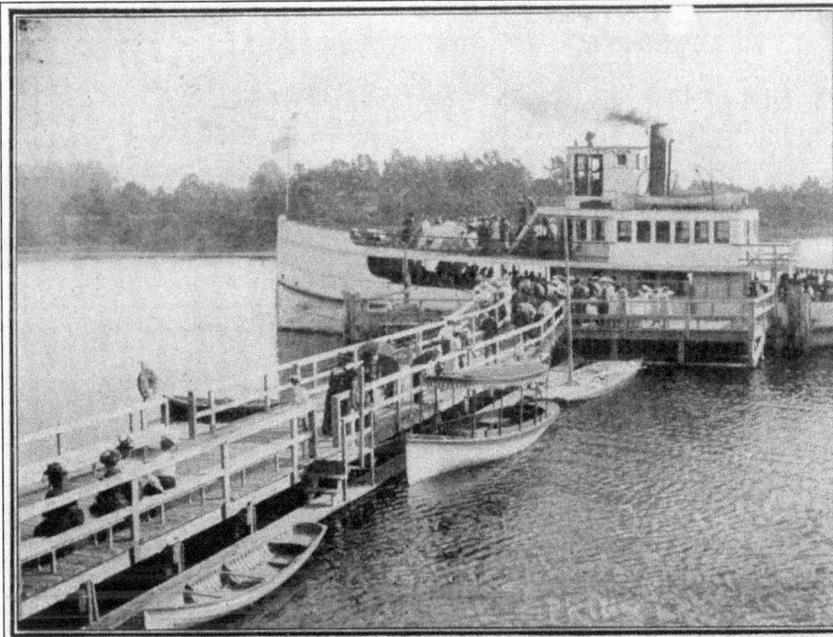

Steamer
Leaving
Fruitport
Pavilion

The steamer *Ottawa* takes on passengers at the pavilion dock. The GRGH&M promoted excursions from Grand Rapids that included a trip to Fruitport on the interurban, then a cruise on the lake to the Spring Lake Hotel and back, followed by a return trip to Grand Rapids. The cost was $1.15 per person round trip, with the boat ride included.

A Loop the Loop Trip

Interurban and Boat

FOR PARTIES OR INDIVIDUALS

Ride the Interurban to Muskegon then the Goodrich Transit Company's palatial ships, S. S. Alabama or S. S. Grand Rapids, out through Muskegon Lake with an hour and one half ride on Lake Michigan to Grand Haven where you are again met by Interurban and brought back to Grand Rapids. This trip can be taken any day or late afternoon from Grand Rapids or start as early as party desires with stop off for day's outing at Mona Lake or spend the day at Lake Michigan Park, Muskegon.

During the summers, the GRGH&M advertised various "loop the loop" trips. One of the most popular was possible because the Goodrich lake boats began their Chicago-bound trips in Muskegon and then made a final Michigan call in Grand Haven. Riders took an interurban from Grand Rapids to Muskegon, boarded a steamer from Muskegon to Grand Haven, and caught an interurban car back home.

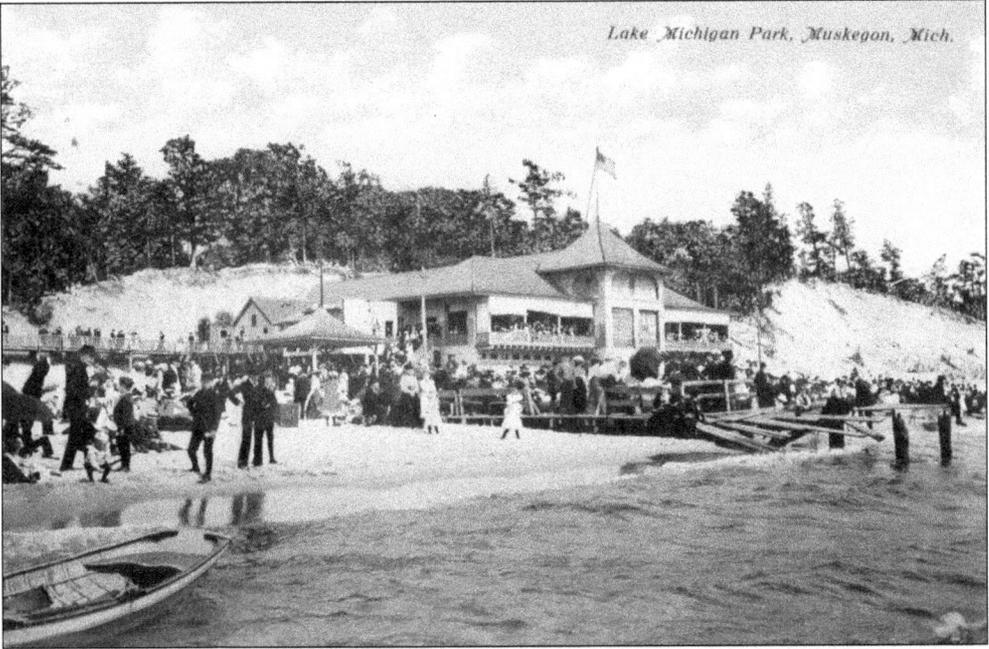

Lake Michigan Park, Muskegon, Mich.

Although the GRGH&M did not serve the Muskegon beaches directly, they were readily available via the cars of the Muskegon Traction and Lighting Company. The street railway company operated this pavilion on Lake Michigan near Bluffton. Besides the pavilion, there was a large amusement park, complete with a roller coaster and other attractions.

Grand Rapids had its own attractions during the summer, including John Ball Park, Reeds Lake, and North Park, all accessible via the streetcars of the Grand Rapids Railway.

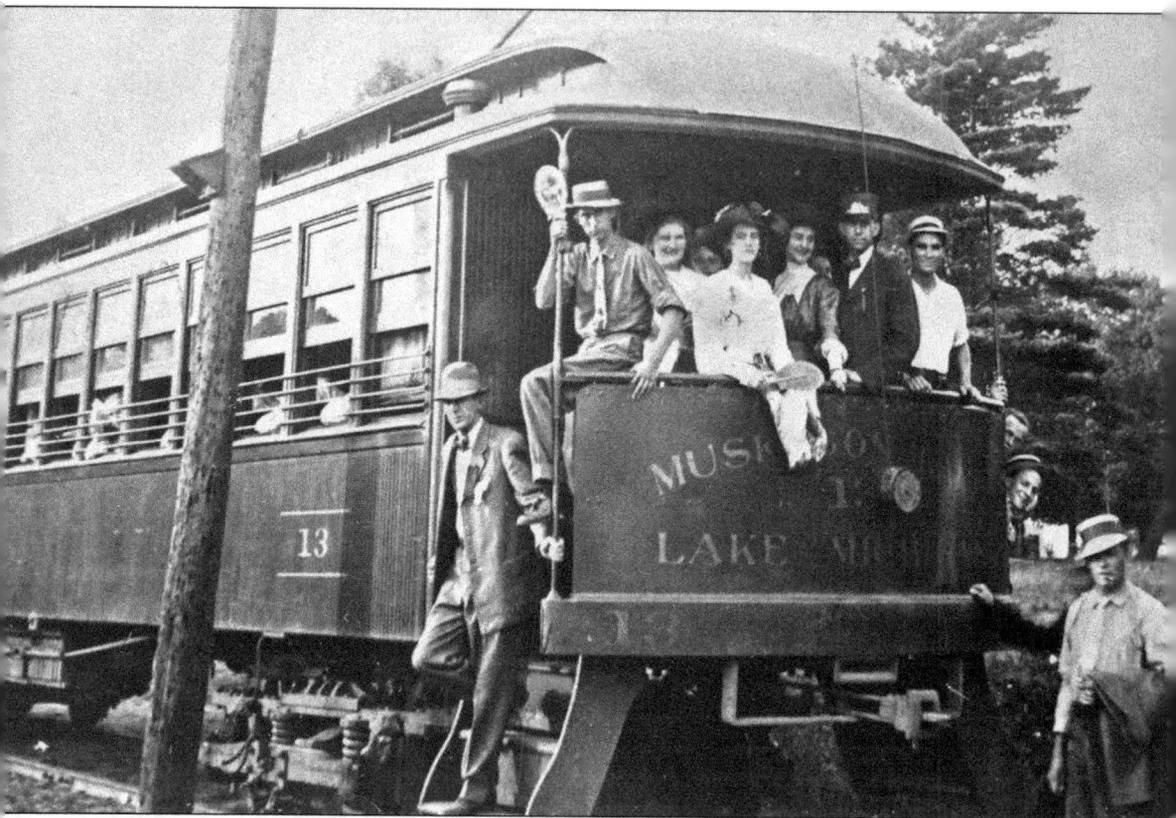

A carefree group pauses for a picture on Car No. 13. Summertime brought revelers out in force. These partygoers, along with the summer tourists and residents just wanting to get out of doors or dance at a lakeshore pavilion, were an important part of the GRGH&M's attraction during the life of the Lake Line.

Four

FACILITIES FOR FREIGHT

From the beginning, the focus of the Grand Rapids, Grand Haven & Muskegon Railway was on passenger traffic. When operations began, the line possessed 15 passenger cars but only four freight motors. Freight facilities were lacking as well. In Grand Rapids, the company rented space for freight in a building on Lyon and Canal Streets. Other depots along the line had minimal freight handling facilities as well.

The managers quickly saw that there was an opportunity in moving freight, especially less-than-carload freight. The freight motors could efficiently move barrels and crates containing industrial goods, produce, and packages between the terminal cities and the towns along its track. Furthermore, an interurban could offer same-day service to its customers. The company quickly won a contract to carry the mail between Grand Rapids, Muskegon, and Grand Haven. The slogan for freight became "Express service at freight rates," as the service was superior to that offered by the steam railroads, at a comparable price.

The freight operations quickly outgrew the leased facility. In 1904, the GRGH&M built a freight house of its own at the corner of Goodrich and Oakes Streets in Grand Rapids. Additional cars were purchased through the years until the freight fleet numbered 20 cars. Smaller, dedicated freight houses were added at Muskegon, Grand Haven, Spring Lake, Coopersville, and Nunica.

By 1910, freight traffic had outgrown even the new freight house on Oakes Street, and a second freight house was built next to it. In 1913, a third freight house was built, this one on the west side of Grand Rapids at Leonard Street and McReynolds Avenue.

Each day there were three scheduled freight runs, normally consisting of multiple cars run three minutes apart. The first cars left at 3:30 a.m., loaded with the morning newspapers and the mail for Muskegon and Grand Haven. Often, a combination passenger-baggage car was among the equipment assigned, as the early morning run was popular with fishermen and hunters.

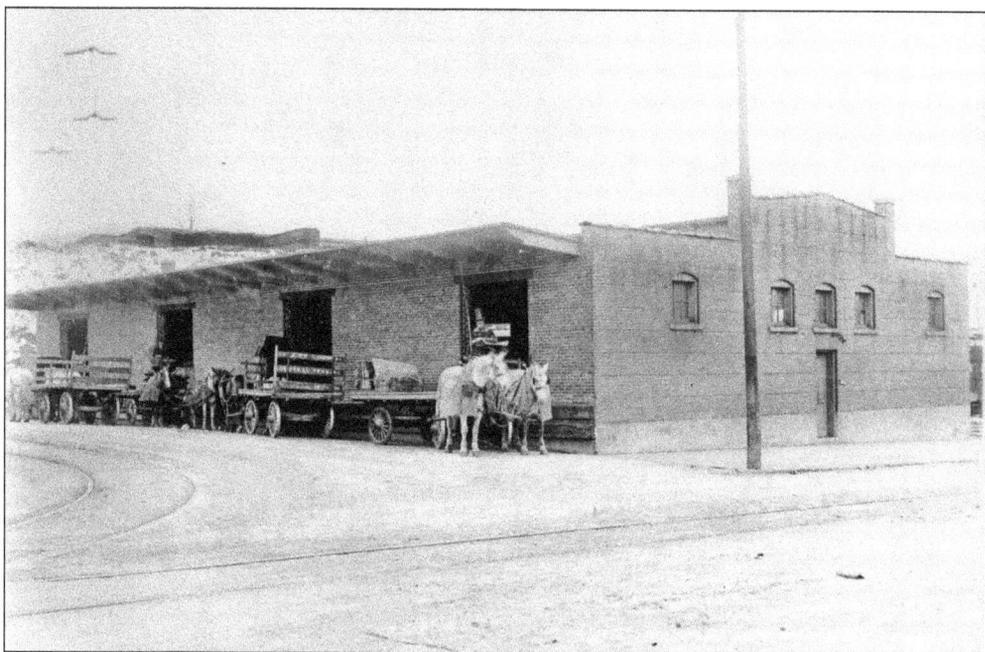

This photograph shows the 1904 freight house at Goodrich and Oakes Streets. The new brick structure had 2,400 feet of floor space, more than three times that of the previous location. Horses and drays loaded and unloaded on one side of the building, and interurban freight cars loaded on the other. (Courtesy of the Grand Rapids Public Library.)

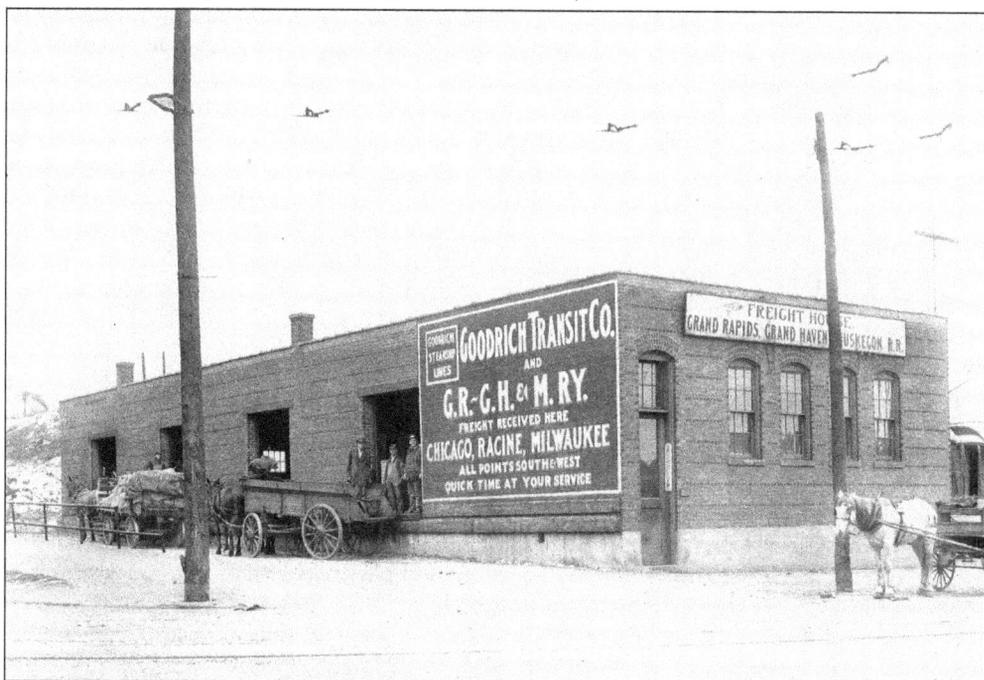

By 1910, even more space was needed, and a second freight house was built just to the east of the original building. This allowed the company to dedicate one of the houses to outbound freight and the other to inbound. (Courtesy of the Grand Rapids Public Library.)

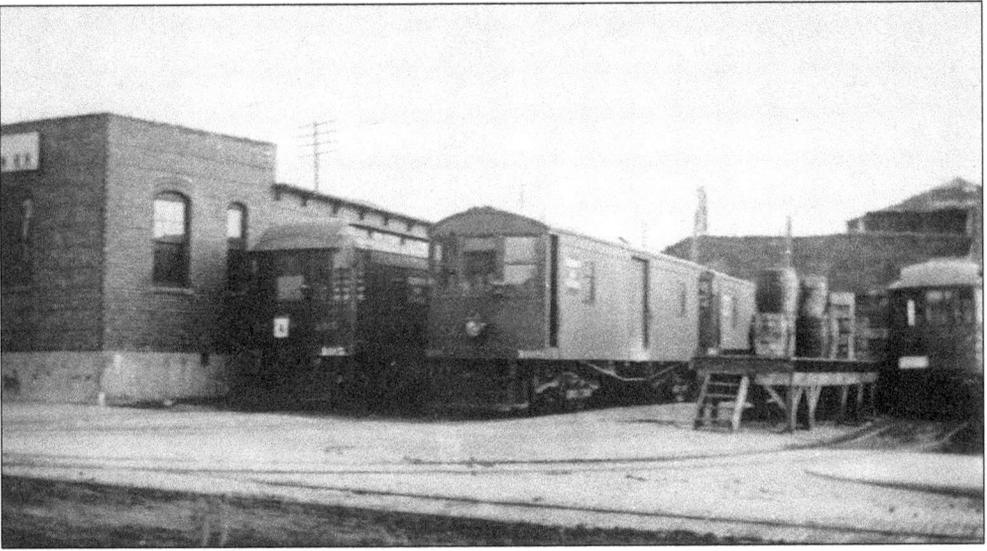

In addition to the loading docks on each building, another dock was built to allow teams to unload expedited freight directly into cars. Freight could be received as late as 5:00 p.m. and still be loaded onto the night boat to Chicago at Grand Haven.

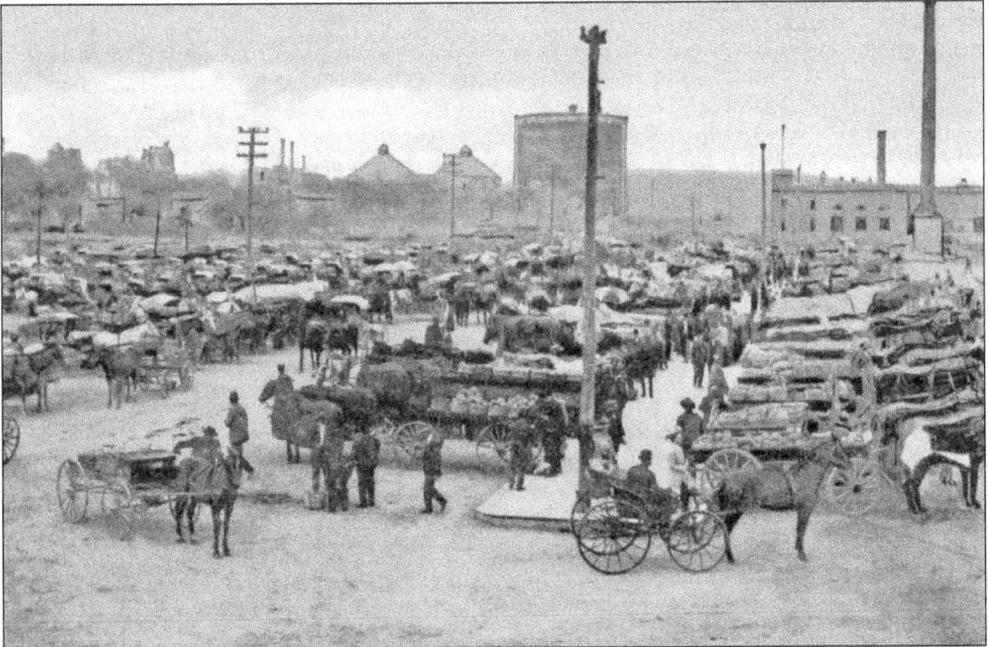

The Grand Rapids City Market was located on Market Street, just blocks away from the freight houses. The Grand Rapids Railway built tracks from the freight facilities into the market, and the interurban company constructed a produce loading dock in the marketplace itself. Fruit and vegetables could arrive at the market one day and be in warehouses in Chicago or Milwaukee by dawn the next morning.

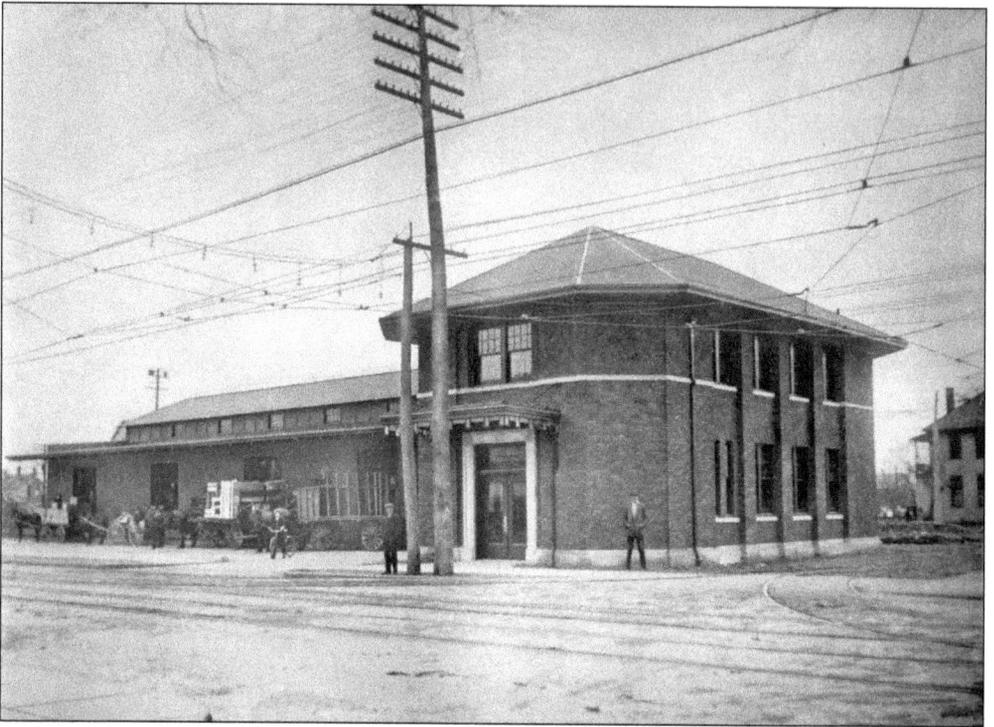

In 1913, the company managers felt additional freight facilities were needed to meet the needs of a number of businesses on the west side of Grand Rapids. The new freight house was on Leonard Street and McReynolds Avenue. As seen here, wagons loaded and unloaded from the street side of the building. A passenger ticket office and waiting room occupied the two-story structure on the right, and the second story served as living quarters for the passenger agent.

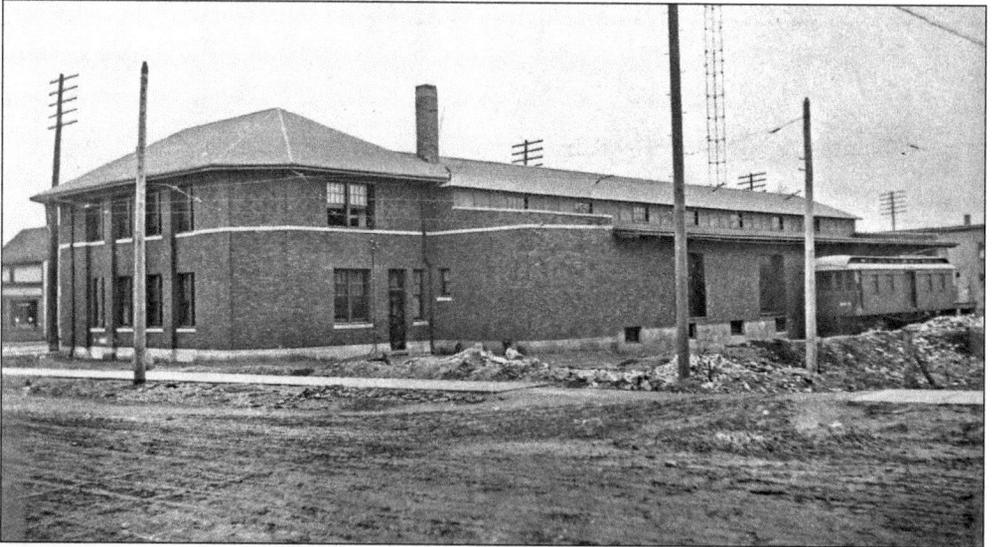

Freight motors loaded in the back of the building. The freight area contained 6,000 square feet of storage and handling space. During the 1910s, the company began to modify the freight motors so they could run as multiple car trains. Often a three-car train would be assembled at the west side freight house for the run to the lake.

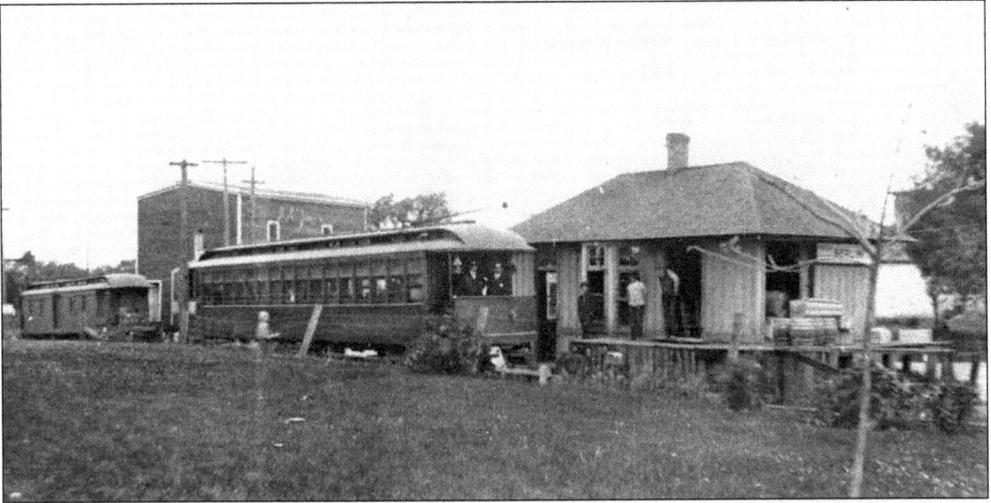

Freight service was important to the towns along the GRGH&M. This photograph shows the freight portion of the original depot at Berlin (Marne). A passenger car is at the station, and a freight motor waits on the siding. On the loading dock are barrels and crates, the typical cargo of the interurban era.

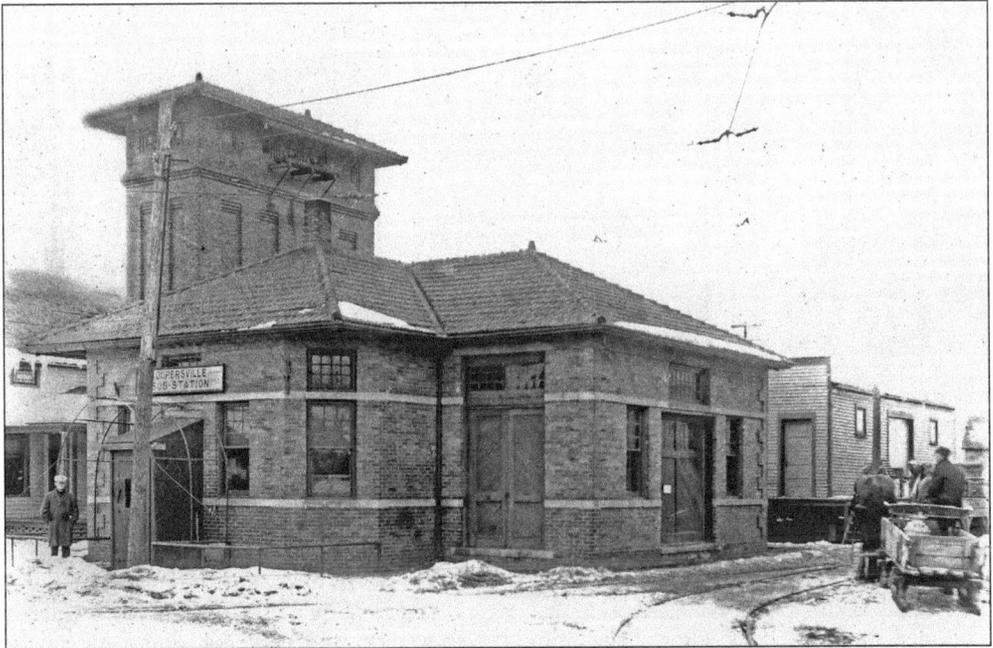

In Coopersville, the freight traffic outgrew the capacity of the original freight room, so a wooden freight house was built on the rear of the property. Here, a horse-drawn sleigh is heading through the snow towards the loading dock. (Courtesy of the Grand Rapids Public Library.)

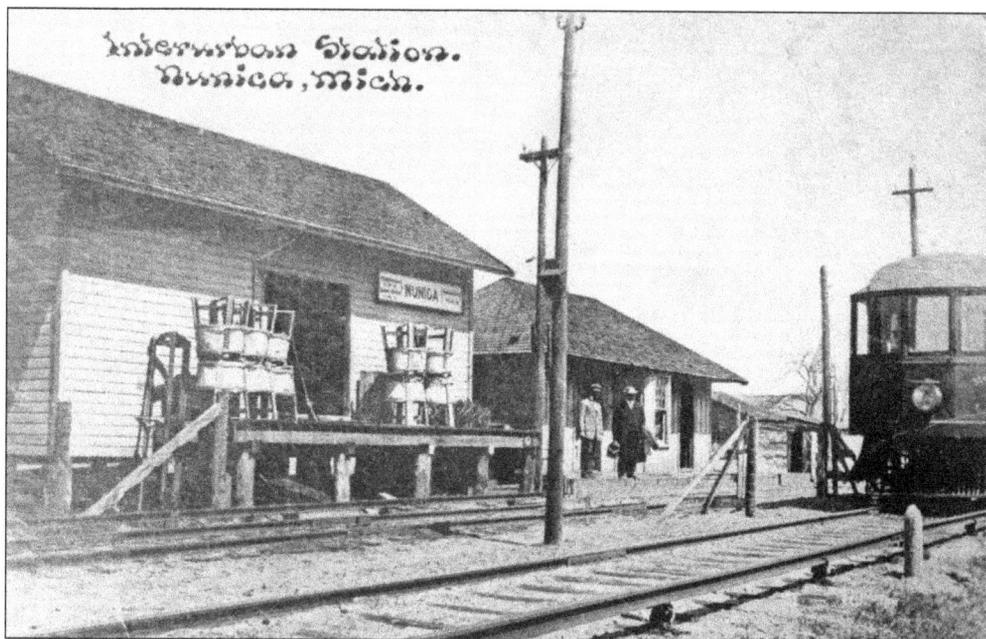

Interurban Station.
Nunica, Mich.

Washing machines stand on the platform at the Nunica freight house. During the interurban era, traveling salesmen, called drummers, used the interurban network to travel from town to town. The washing machine manufacturer has shipped a load of machines to Nunica ahead of the drummer, who will be expected to sell them once he arrives.

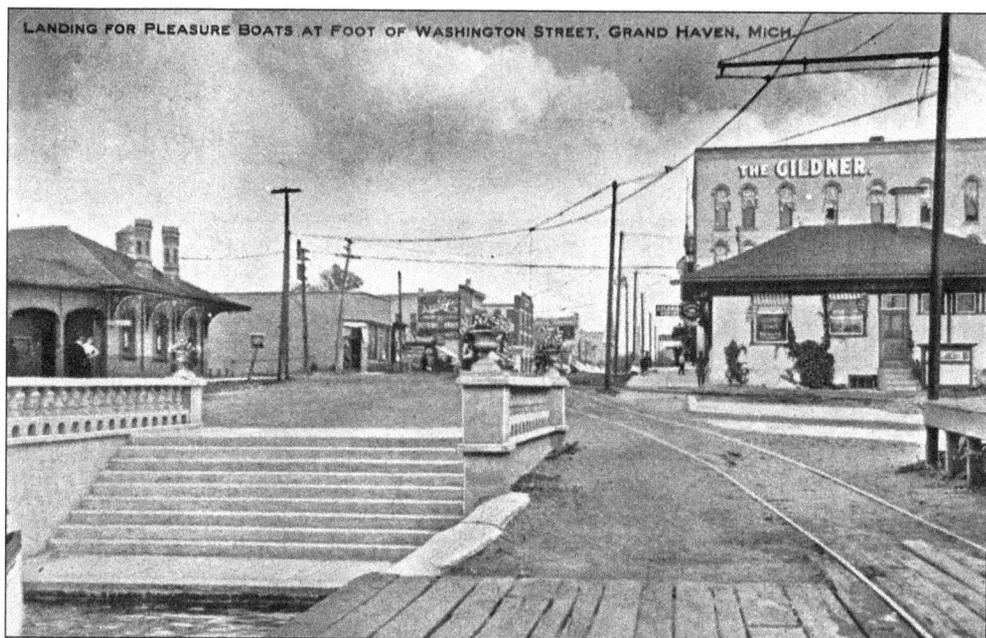

LANDING FOR PLEASURE BOATS AT FOOT OF WASHINGTON STREET, GRAND HAVEN, MICH.

THE GILDNER

This view shows the dock siding at the Grand Haven waterfront. The siding continued straight to the foot of Washington Street, where the main line turned into Water Street. Both passenger and freight cars used the siding to pull directly alongside the Goodrich freight house, just out of view. The Italianate Grand Trunk depot is on the left side of the steps.

Five

THE CARS AND THEIR WORK

The passenger and freight cars used by the Lake Line evolved over its lifetime. When interurban lines emerged from street railways in the 1890s, the cars were little more than large streetcars. But by the time that Westinghouse, Church, Kerr & Company began equipping the GRGH&M, the cars had developed to the point where they resembled a passenger car on a steam railroad. They were larger, heavier, and more comfortable than their street railroad counterparts and more suited to long-distance travel.

During construction, the company ordered 15 passenger coaches from the Barney and Smith Car Company of Dayton, Ohio. Many of these cars remained in service throughout the life of the line. The cars were made of wood and had various amenities, including electric heat, upholstered seats, and a small restroom. The additional cars were manufactured by the Jackson and Sharp Company, the Niles Car Company, and the St. Louis Car Company.

Passenger cars continued to evolve during the life of the line, becoming slightly larger and more comfortable. The technology changed, too. Improved controllers made it possible to run two or more cars together as a multiple-unit train. Cars purchased by the company in 1912 had this capability, and during the next few years, the original equipment was retrofitted for multiple-unit operation. Although capable of multi-unit operation, this feature was seldom used, especially by passenger cars other than the boat train. In general, passenger trains consisted of separate cars running at three-minute intervals. Cars also made a transition from wood to steel, and the last passenger car acquired by the company, Car No. 20, was a steel combination passenger-baggage car.

The cars that handled freight also changed over time, growing from 41 feet to 50 feet in length. Unlike several other Midwestern interurban lines, the GRGH&M did not use unmotored trailers in its operations; all the cars used in freight operations had their own set of motors, mounted below the cars on one of the trucks. Like the passenger cars, the freight motors made the transition from wooden cars equipped for single operation to metal cars that operated coupled together. Multiple-unit operation was more common among freight motors than it was with passenger cars; it was not uncommon for two- and even three-car trains to make the trip between Grand Rapids and the lakeshore.

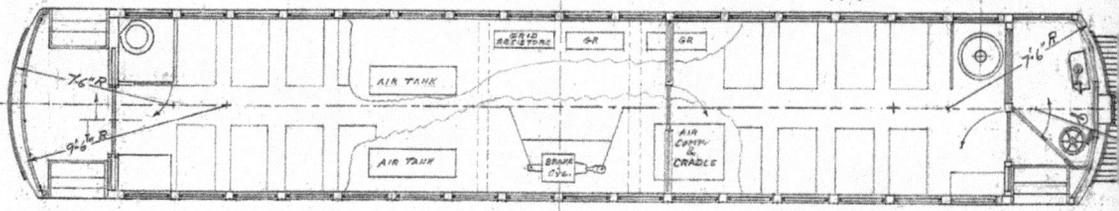

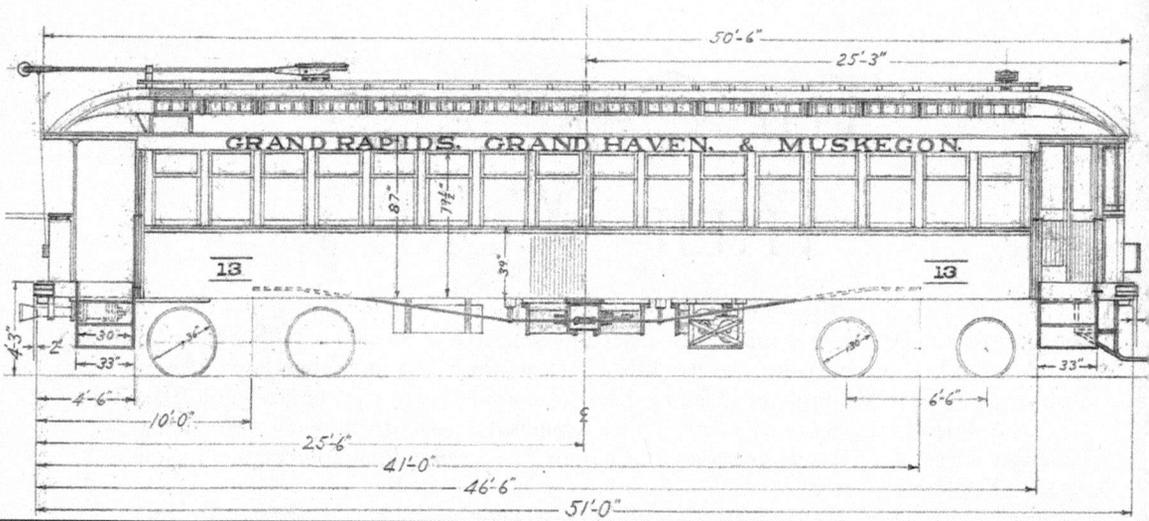

Each of the Barney and Smith cars was 52 feet long, could seat 56 passengers, and had three separate compartments. In the very front of the car was the motorman's compartment. Directly behind was the smoker, which also contained the coal heater. The rear section was the general coach, separated from the smoker by a glass partition. In the corner of the very rear was a small toilet. (Drawing by Al Krueger.)

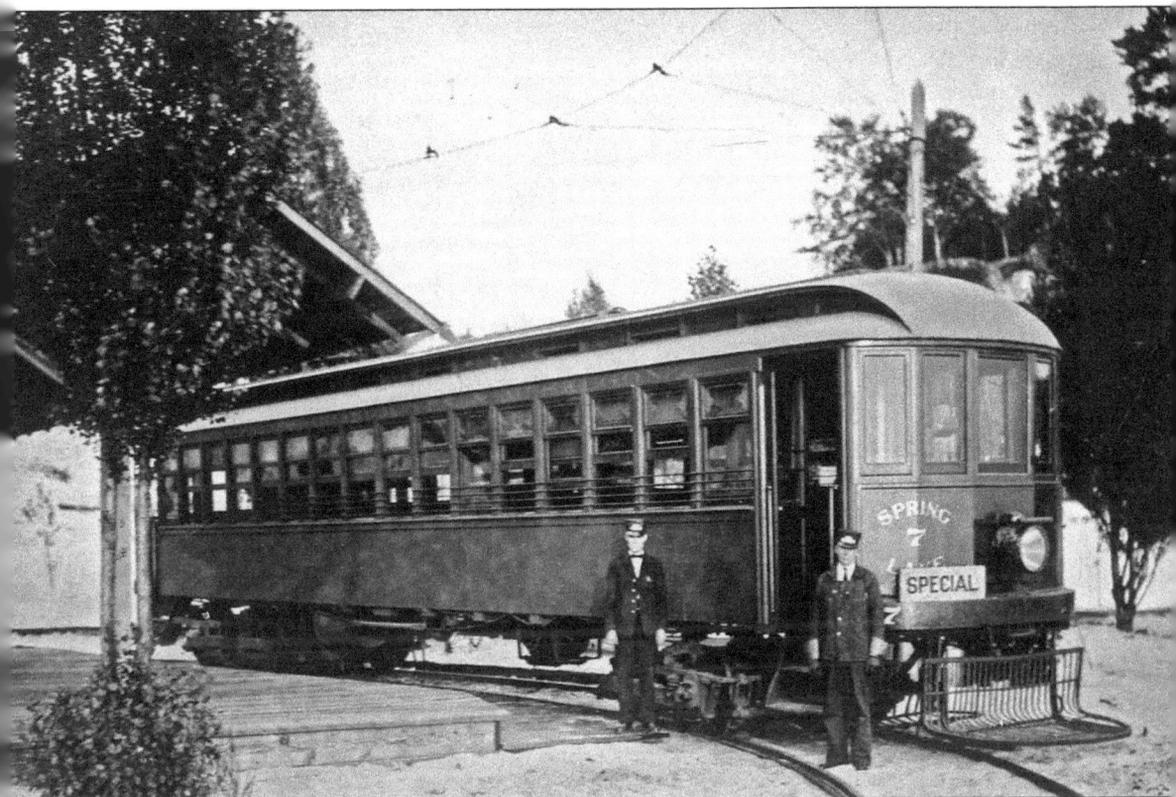

The original 15 coaches were the backbone of the passenger service for most of the GRGH&M's existence. Two Westinghouse 150-horsepower motors powered each car. Both motors were mounted on the rear wheel-set, or truck. The cars were single ended, with control equipment and an operator's compartment on the front, so the cars needed to be turned on a wye or a loop at the end of each run. The original coaches were capable of maintaining speeds of 40 to 45 miles per hour.

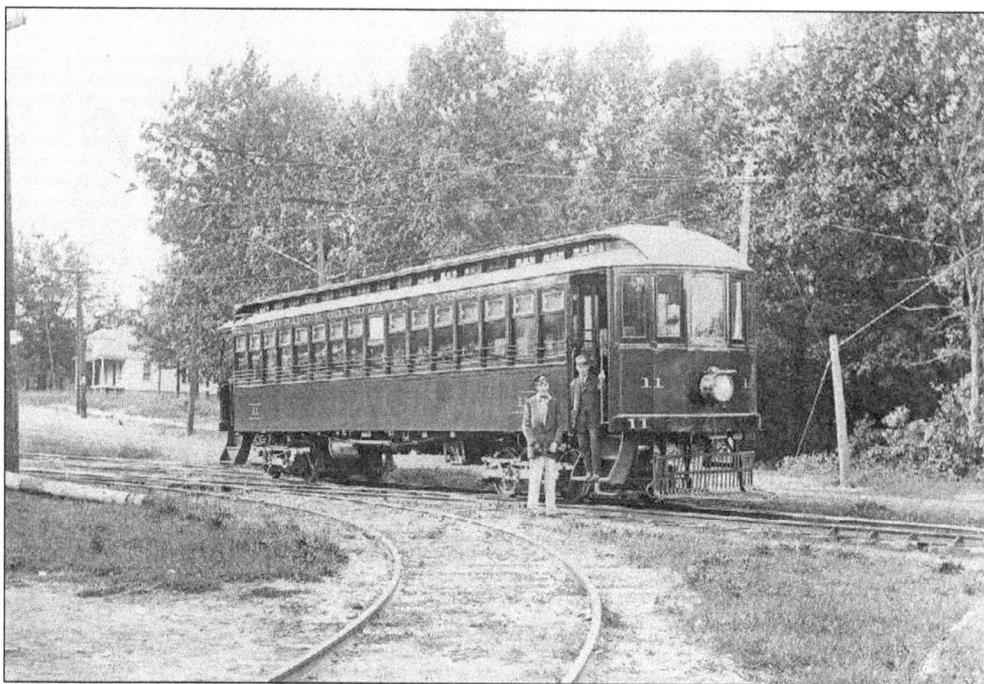

Car No. 11 is standing at the entrance to the Fruitport carbarn. West Fruitport Road is in the background. The car is now in the simplified paint scheme used on the passenger cars in later years. References to the car's name, *Nereid*, have been eliminated from its sides.

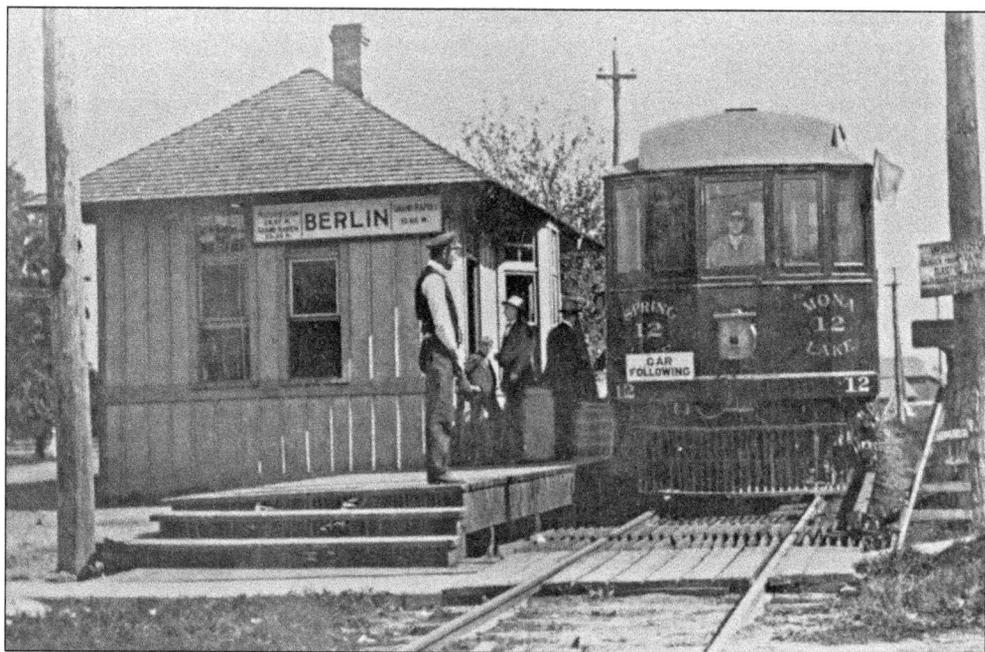

In this photograph, Car No. 12 is standing in the original Berlin depot. The depot agent (wearing a cap) is on the platform. A sign on the front of the car and a flag on the roof indicate that the car and at least one other make up a multi-section train. By the rules of the line, the second car (and any succeeding cars) must stay at least three minutes behind the one ahead of it.

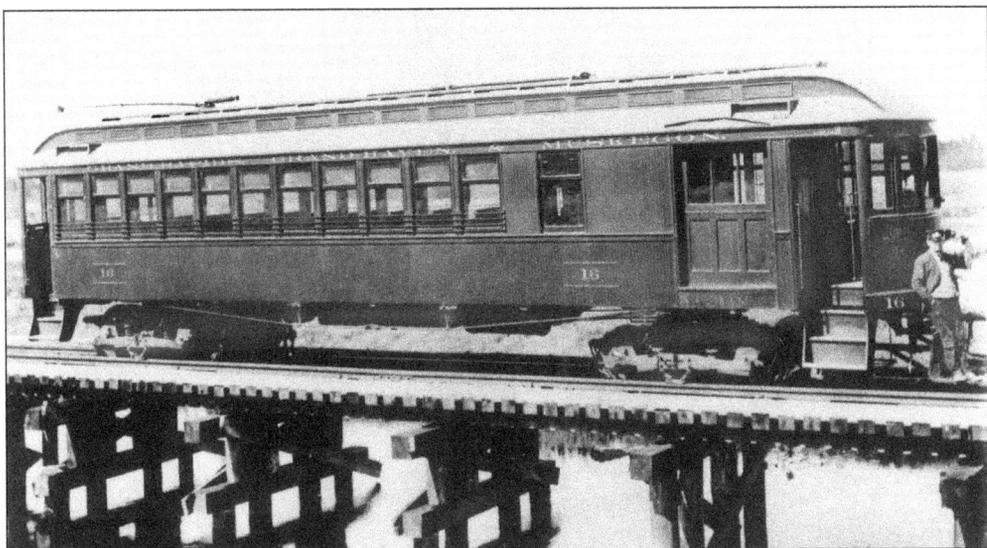

The Chicago boat service led the company to begin buying combination passenger and baggage cars in 1903. The Jackson and Sharp division of American Car and Foundry Company built the cars in this series. Car No. 16 featured an expanded baggage compartment to better accommodate luggage that accompanied the steamship travelers. Like the passenger coaches, the combines were equipped with two 150-horsepower motors. There were no separate smoking compartments on these cars.

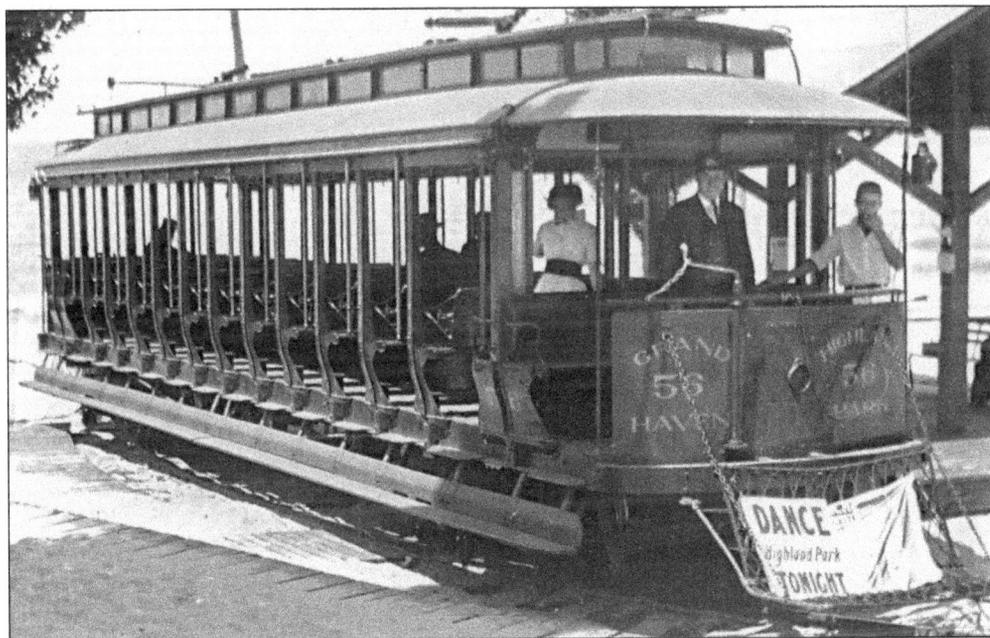

Cars No. 55 and 56 were double-ended open cars manufactured by Brill. They were mainly used for service on the Highland Park branch in Grand Haven and Spring Lake, but they were equipped with third-rail shoes and could travel on the sections of the line that were not equipped with overhead wires. Each car had 15 benches for seating, with a capacity of 90 passengers. Regular service on the Grand Haven branch ended at the depot on Water Street, so passengers would transfer to the open cars for the trip to Highland Park.

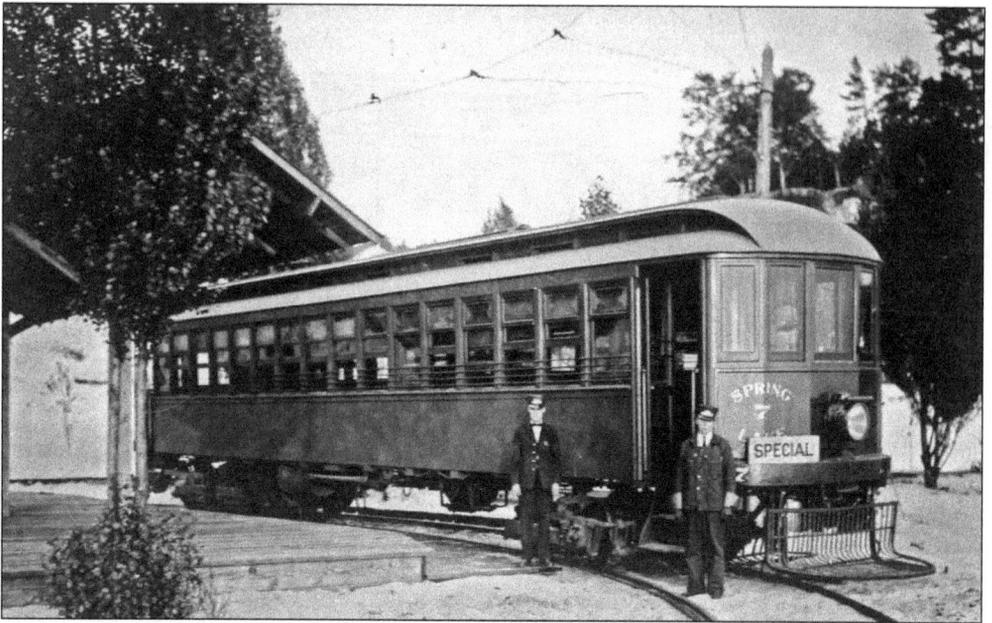

The larger passenger coaches did venture onto the Highland Park branch, especially during the summers, when they could be chartered to bring groups directly to the beach. Here, Car No. 7 waits at the Highland Park Loop before making its return trip. The passenger coaches also made daily trips during the summer to bring businessmen spending the summer at their cottages back to Grand Rapids for the workday, returning them to Highland Park in the evening.

TO THE LAKES — THE GREAT THIRD RAIL
GRAND RAPIDS, GRAND HAVEN & MUSKEGON RAILWAY

ISSUED 1913 TWO CAR TRAIN S. L. VAUGHAN, Traffic Manager
Steamboat Limited, CHICAGO and MILWAUKEE BOATS

In 1912, the United Light and Railways Company acquired the GRGH&M and began to add equipment. This two-car boat special was built by the Niles Car Company and consisted of a combination car and a coach that were designed to be run connected together as a multiple unit. This set of cars was purchased to allow a single motorman to operate higher capacity trains to and from the lake boats. The nightly boat train was designated "the car with the star" and featured a lighted star on the front end while the train was in Grand Rapids. This photograph, however, is a publicity shot; an artist has added this star to the front of the car.

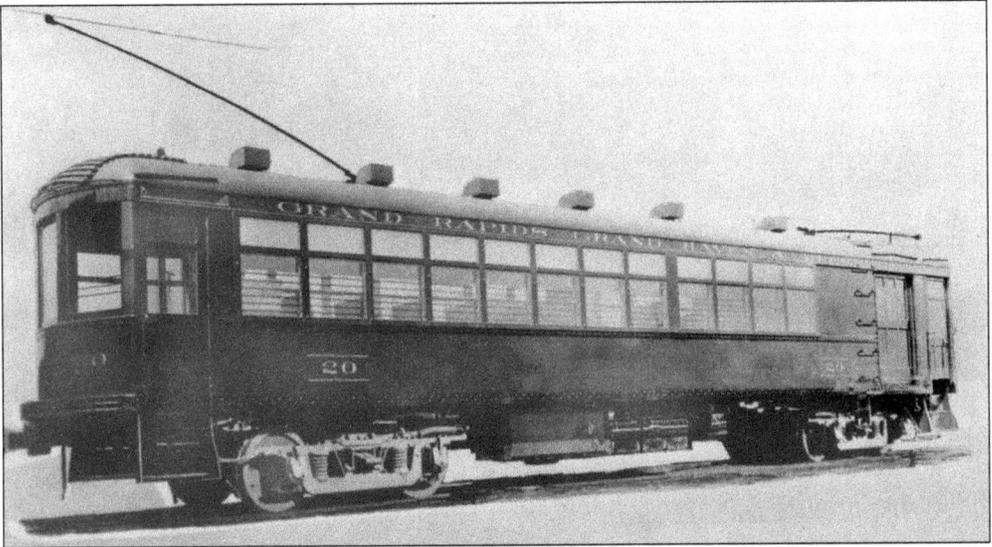

The final passenger car purchased by the GRGH&M was Car No. 20, a combination passenger-baggage car manufactured by the St. Louis Car Company in 1916. Car No. 20 was built of steel rather than wood. Measuring 60 feet in length, it was the longest car acquired by the company.

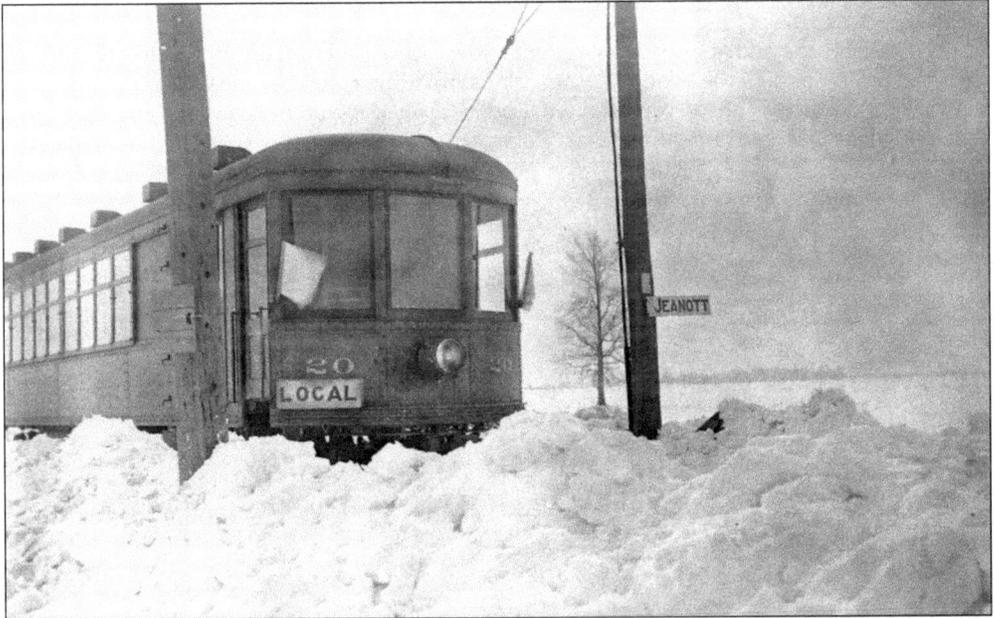

This photograph of Car No. 20 pushing through the snow was taken at Jeanott Crossing, between Muskegon and Fruitport. The flags on the car indicated that it was traveling as part of a multisection train. When traffic was heavy, an additional car (sometimes more than one) would be added to accommodate the crowds. Rather than couple the cars together, cars ran separately, spaced three minutes apart. Green flags indicated that the car was being followed by another. The last car in a train carried white flags. At night, colored lanterns were used in place of the flags.

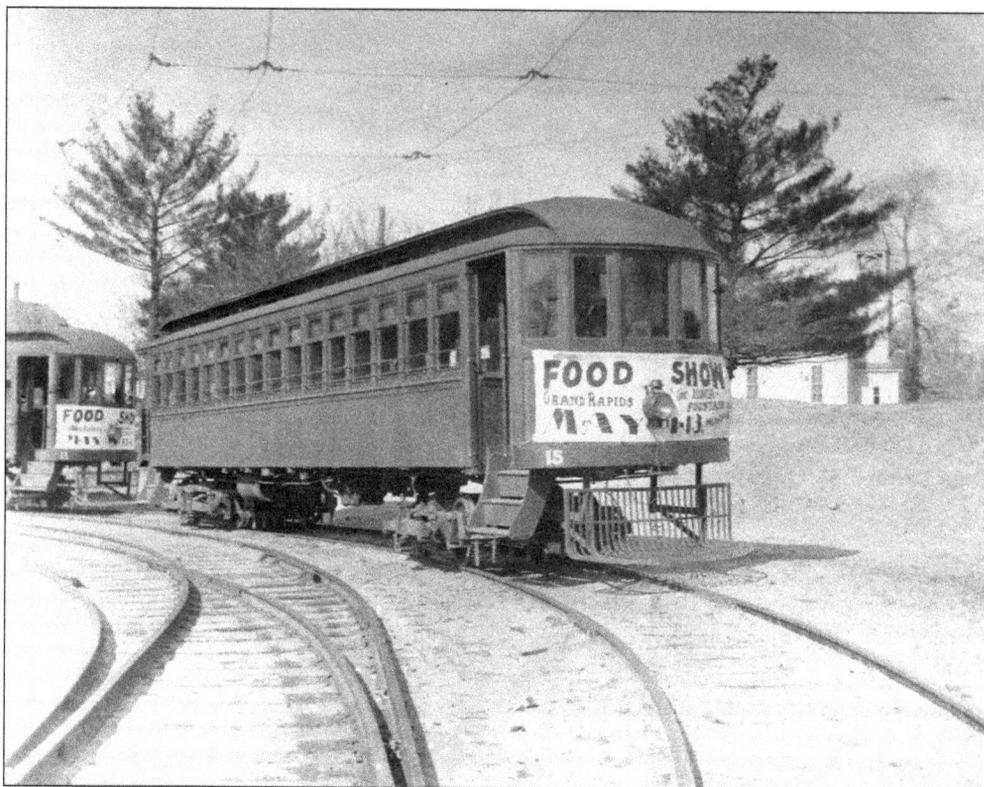

Cars No. 15 and 13 stand on the tracks in front of the carbarn at Fruitport. Both cars are outfitted with banners promoting the Food Show, an annual trade event held by the Grand Rapids Retail Grocer's Association. The interurban often used its cars to help promote events, and sometimes transported attendees to and from these affairs.

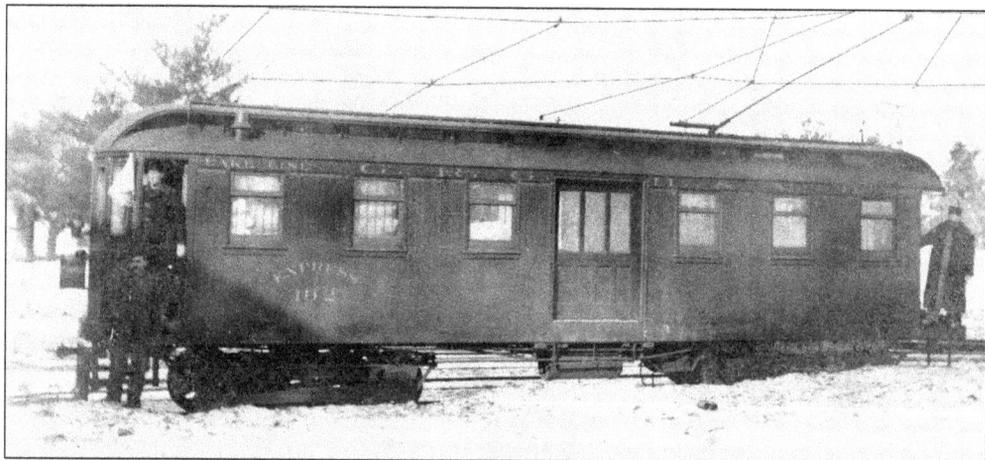

Car No. 102 was typical of the freight cars operated by the line. It was one of the three original freight cars built by the Barney and Smith Car Company, and each car was self-propelled. This car had two Westinghouse motors, both mounted on the rear truck. Like the passenger cars, busy runs required two or more cars running separately, spaced three minutes apart. The freight motors had their gears set for lower speeds than the passenger cars, but they were capable of carrying heavier loads.

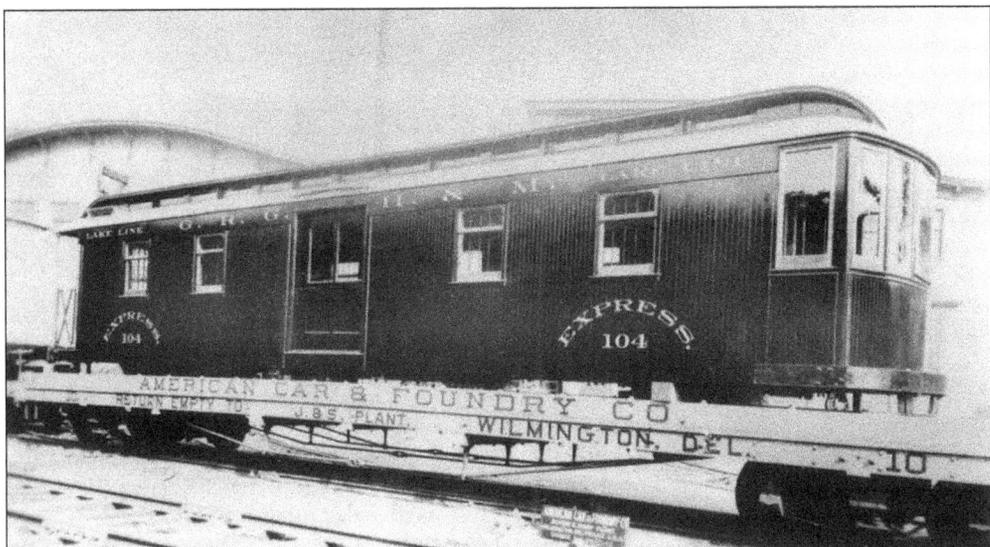

More freight cars were needed in 1904 to meet the growing demand for freight service. This series of cars was ordered from the Jackson and Sharp Division of American Car and Foundry in Wilmington, Delaware. The Jackson and Sharp cars were almost identical to the original Barney and Smith cars, differing mainly in the number of windows and the door details. The newer cars were also three feet longer than the original cars.

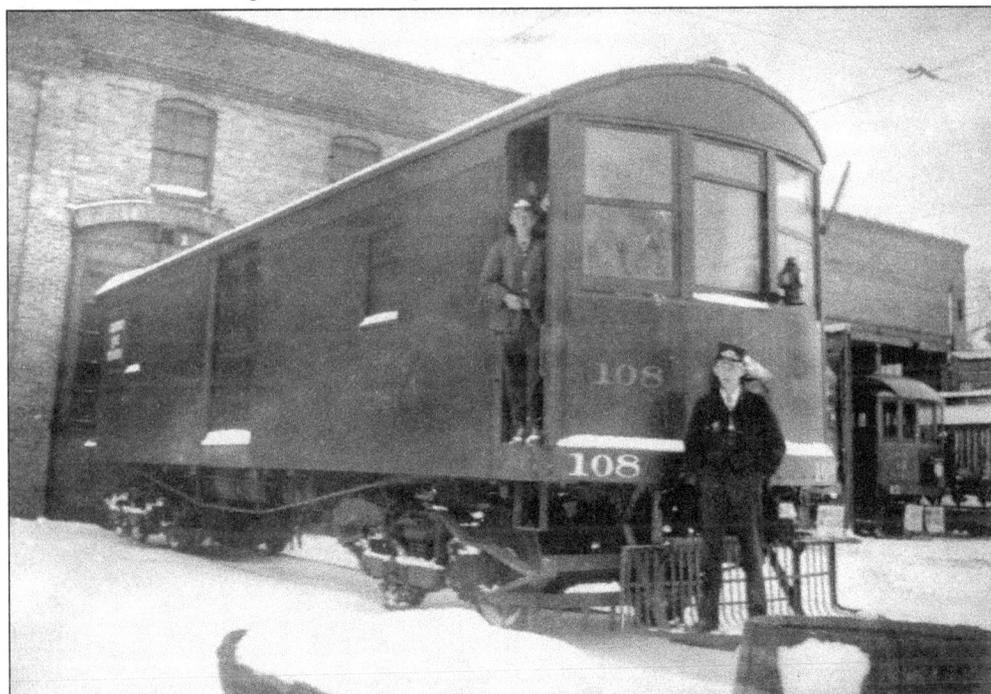

Additional cars were needed by 1906, and the Wasson Company built cars No. 107 through 109. Car No. 107 is shown here at the Fruitport carbarn in 1908. The distinctive flat front set the cars off from the others in the fleet. The freight cars were scheduled as extra trains, which meant they had to keep clear of the passenger trains on the line, making sure they pulled into a passing siding well before a passenger car was due to pass by.

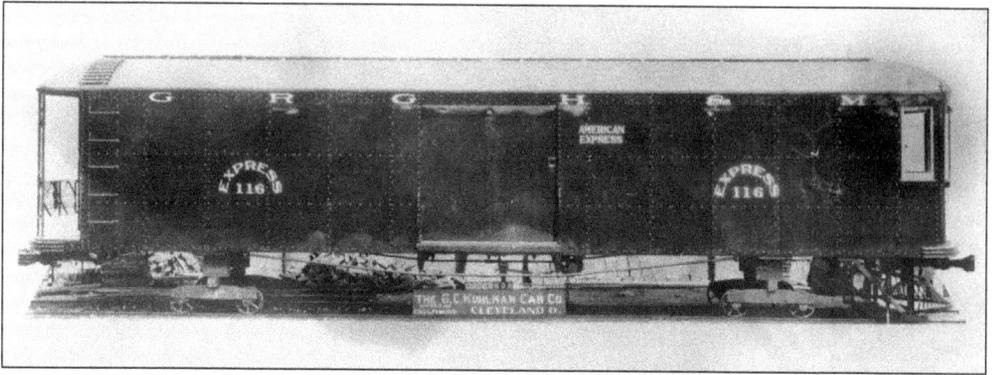

By 1917, the company was purchasing cars made of steel rather than wood. Car No. 116 was manufactured by the G.C. Kuhlman Company in Cleveland, Ohio. Shown here at the factory, the car is sitting on a set of factory trucks used to move it during construction. The operating trucks, as well as the motors and controller, were installed at the interurban company shops in Fruitport after the car was delivered. This series of cars included numbers 116 through 118 and was the last set of freight motors purchased by the company.

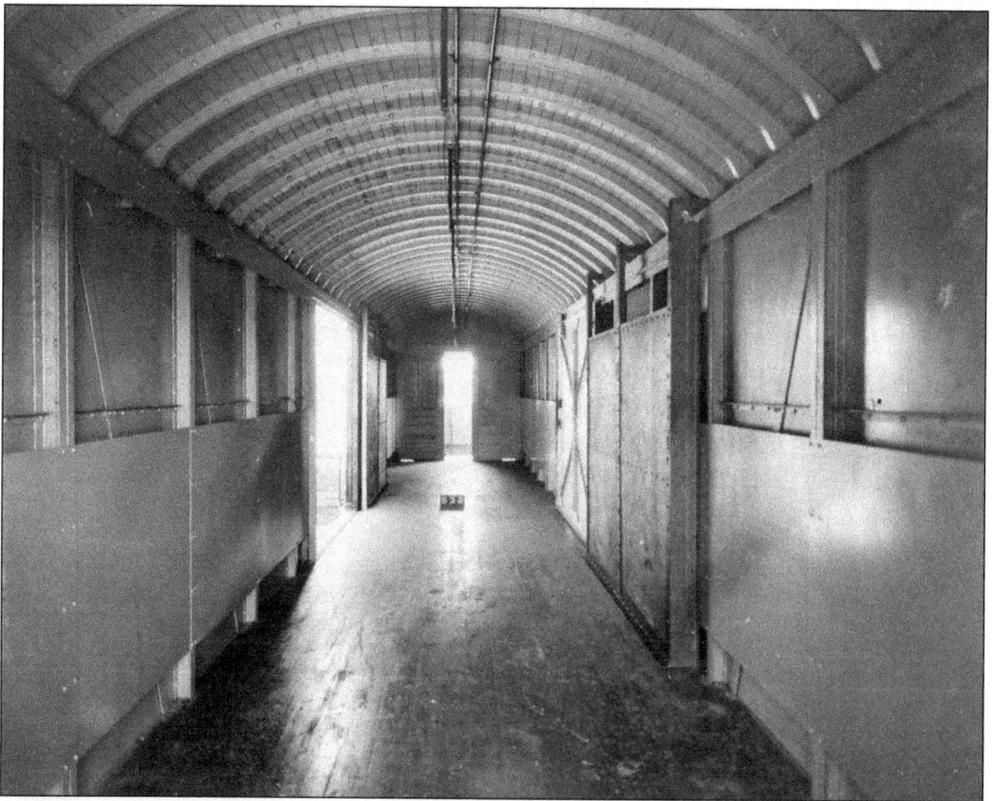

This is an interior view of car No. 116. A freight motor was essentially a box on wheels, with large doors on both sides to allow loading and unloading. Since the motors were mounted on the trucks beneath the car, the entire interior of the car could be loaded with cargo. (Courtesy of the Pennsylvania Historical Museum and the Pennsylvania Trolley Museum.)

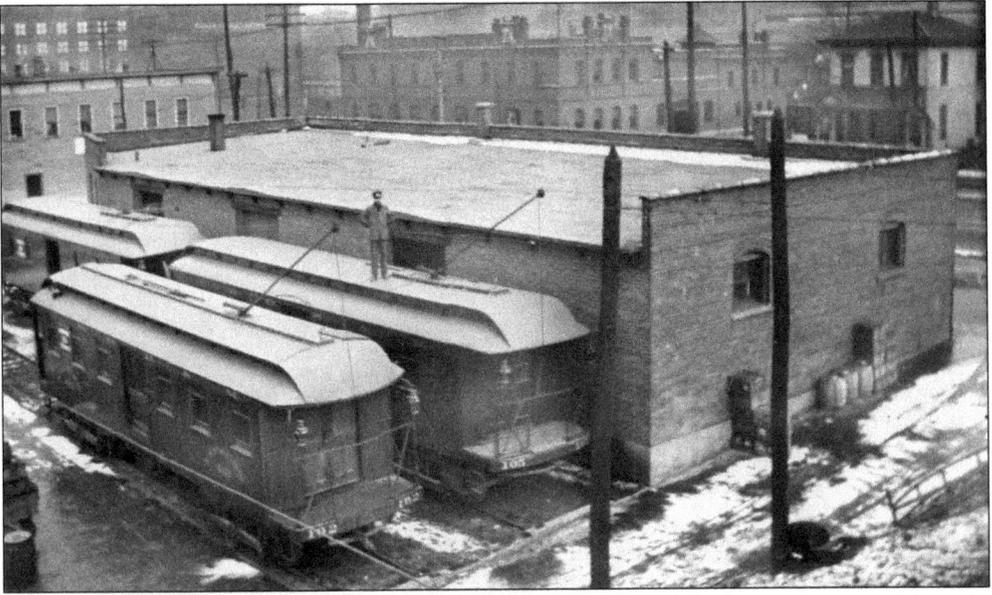

Three freight motors are loading at the original freight house in Grand Rapids. Two parallel tracks made it possible to load or unload up to four cars at once. The cars on the far track were loaded through the double center doors using a short bridge between the two cars. Both of the cars in the foreground are equipped with marker lanterns. The building in the background at center is the Anheuser-Busch icehouse, built to store beer brought from St. Louis, Missouri, in refrigerated rail cars. This building still stands in Grand Rapids.

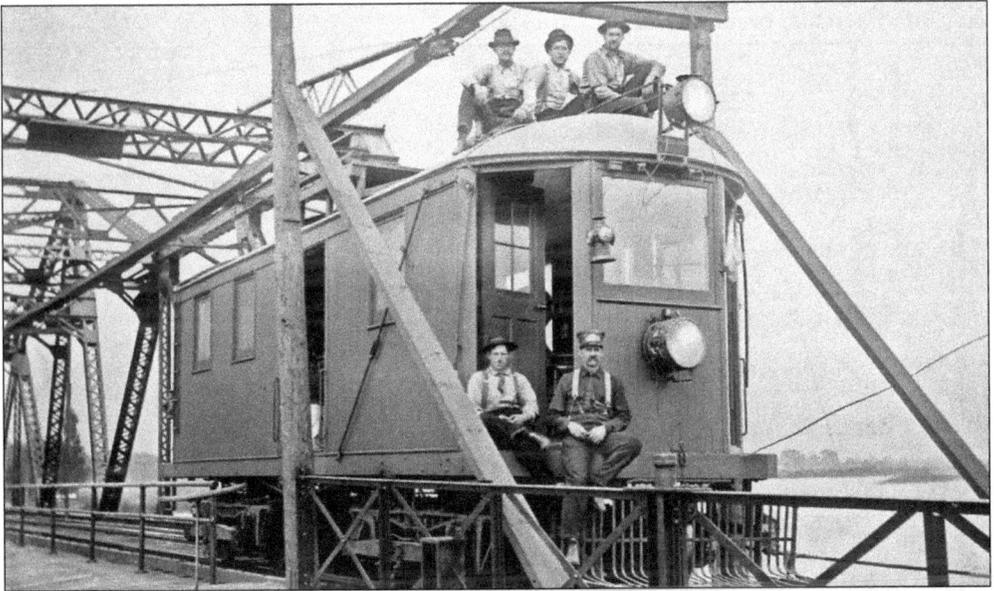

Car No. 99 served as the main work car for the GRGH&M; it was outfitted for maintenance and repair work throughout the system. The car was equipped with four motors rather than two, making it the most powerful car on the roster. A platform on the top of the car allowed workers to stand on the car to work on the overhead power lines above the streets. Inside was a winch, used for righting cars that had left the rails. This car was painted bright red for visibility and nicknamed the "Red Devil" by the crews who operated it.

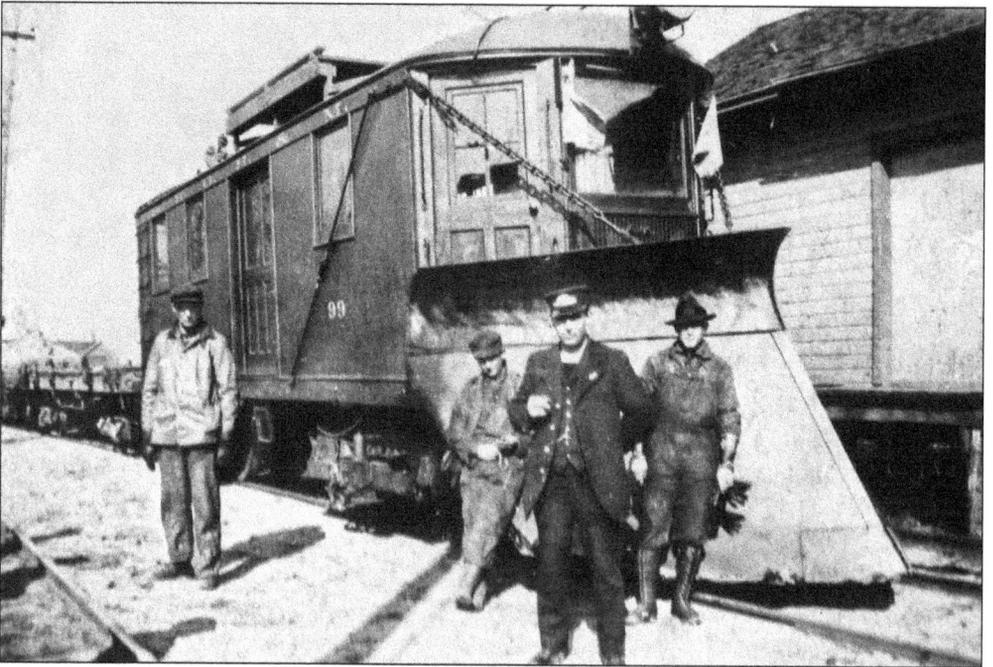

In the winter, the Red Devil was outfitted with a large plow and became the line's main snowplow. west Michigan winters were a tremendous challenge to the interurban operations. An especially large storm in January 1904 caused cars and passengers to become stranded on the line overnight. Dispatchers learned that it was better to cancel trains than send them out into a storm. Unusually difficult winters also occurred in 1910 and 1913.

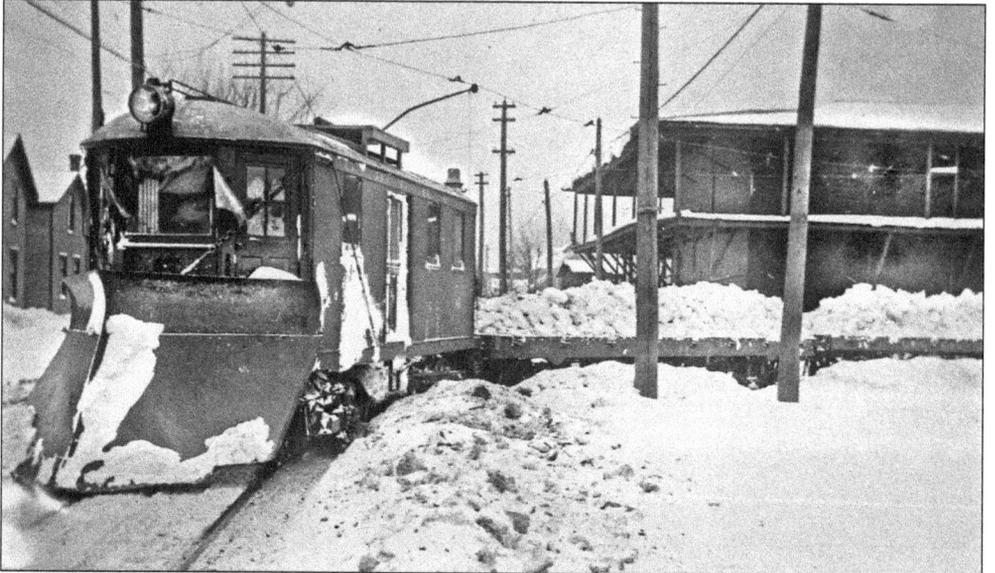

Car No. 99 pulls a string of flat cars loaded with snow. Crews shoveled snow onto the cars to clear city streets. This photograph was taken at the turning wye at Seventh and Elliott Streets in Grand Haven. The wye and siding were built so maintenance equipment could be turned at the edge of town. Directly behind the flat cars is the Grand Haven Basket Company, which produced wooden packing crates for the fruit and produce that was grown in the region.

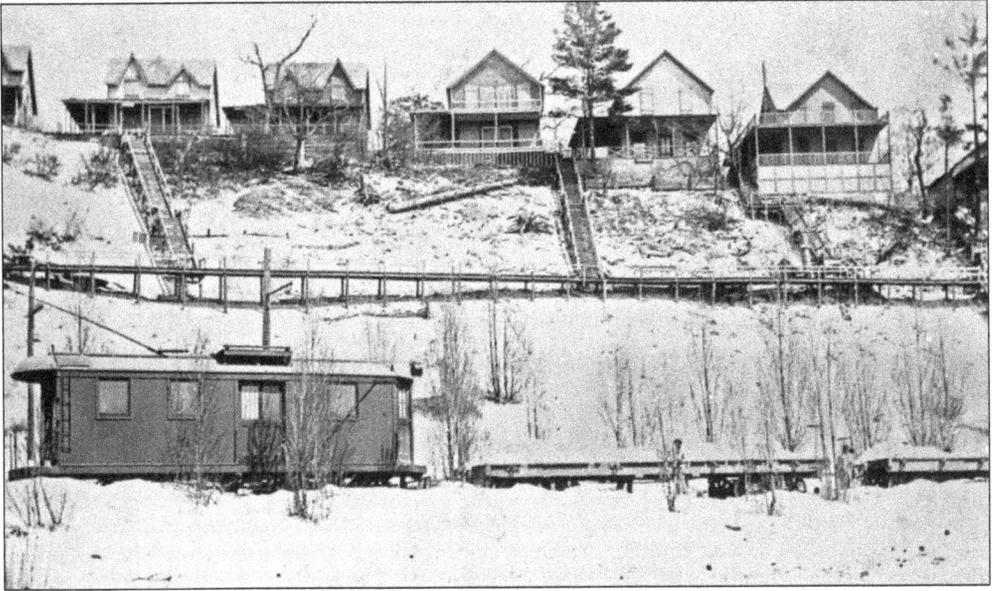

Car No. 99 is pushing a string of flat cars onto the beach at Highland Park. The line along the beach was not used during the winter; cars ended their runs at the depot at Franklin and Water Streets. Each spring, crews faced a massive cleanup operation along the beach to get the branch open for the resort season. Both snow and sand that had drifted over the tracks during the winter had to be shoveled onto cars and hauled from the beach. Above the train, a row of still-vacant Highland Park cottages stands along the boardwalk, waiting for the cottagers' arrival.

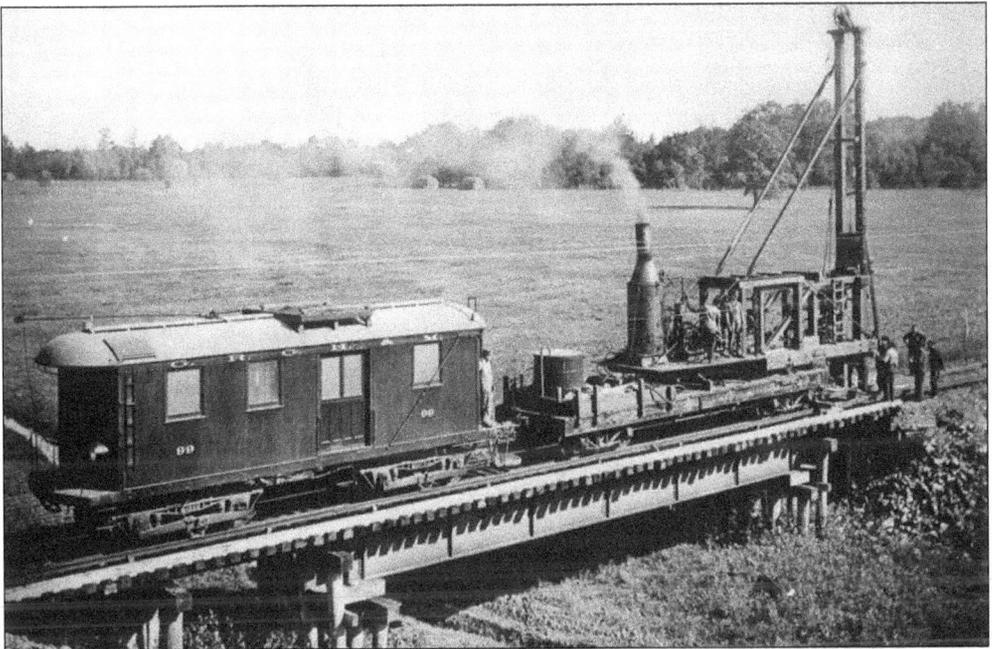

Other special cars were used to maintain the tracks and structures. A steam-operated pile driver set piers for bridges and trestles. Here Car No. 99 and the pile driver work on the bridge across De Vries drain, one of two bridges that crossed outlets of Crockery Creek east of Nunica. This photograph was taken during the drier months, when the creek was only a small stream.

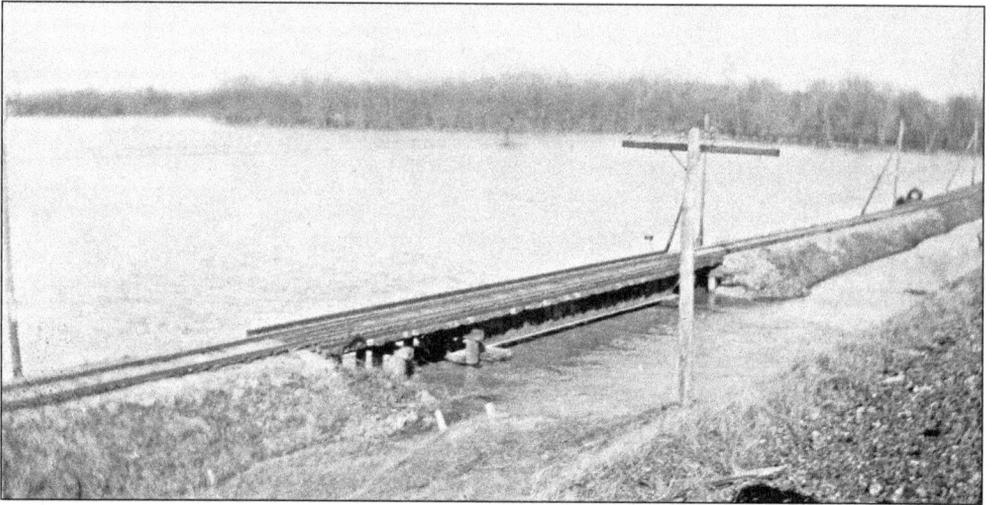

Here is another view of the same location, De Vries drain at Crockery Creek. During most of the year, the stream of water was small, but during the spring floods, the marsh behind the bridge was almost completely submerged by water flowing toward the Grand River. Floods in 1905 severely damaged the bridges of the Grand Trunk Railroad, but they left the interurban bridges intact.

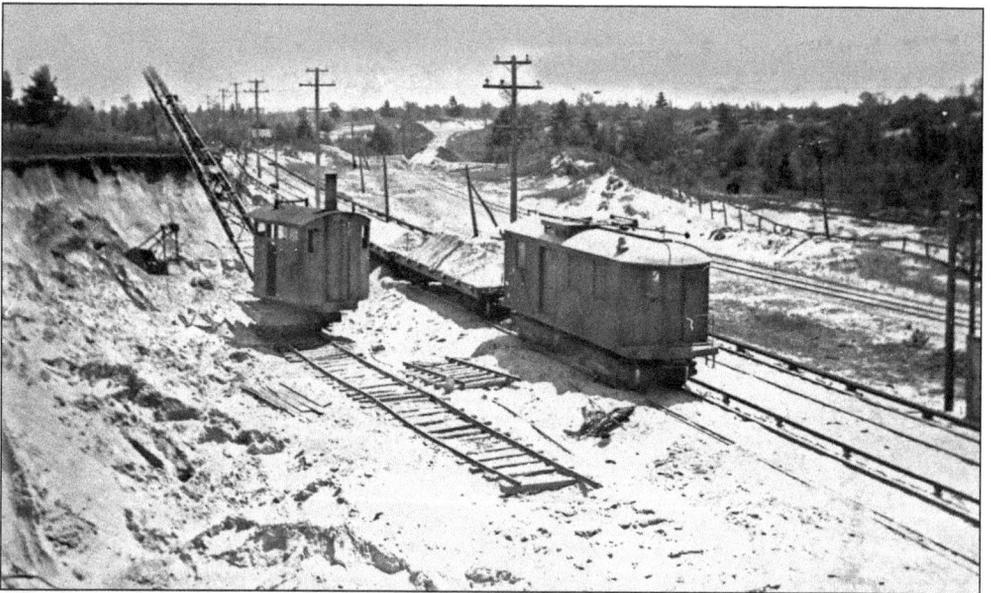

The steam shovel on rails, which originally was used to construct the trestle at Mona Lake, continued to work at the Shettler sand pits throughout the life of the line. After the trestle was complete, sand was still needed for various repair projects along the line. In this photograph, the Red Devil has three flat cars in tow. The railroad in the background is the Pere Marquette (later Chesapeake and Ohio) line between Muskegon and Holland.

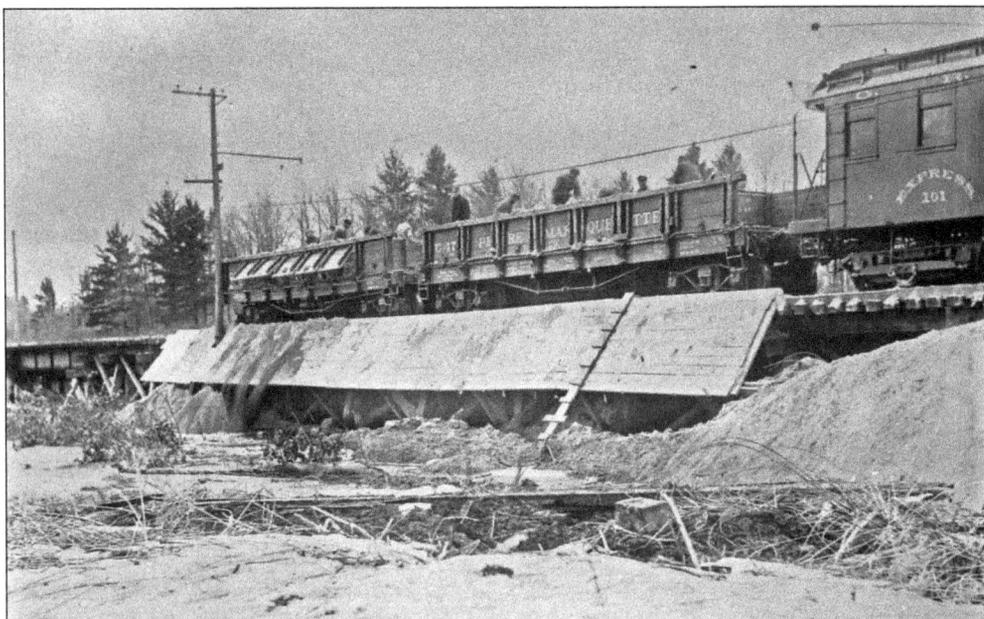

One project that required a massive amount of sand was the effort to create a fill along the trestle across the northern tip of Spring Lake at Fruitport. This photograph shows a series of gondolas from the Pere Marquette railroad on the trestle. Workers in the cars shovel sand through doors in the car side onto planks positioned to guide the sand. The unstable lake bottom had given way, and the trestle shifted three feet to the side.

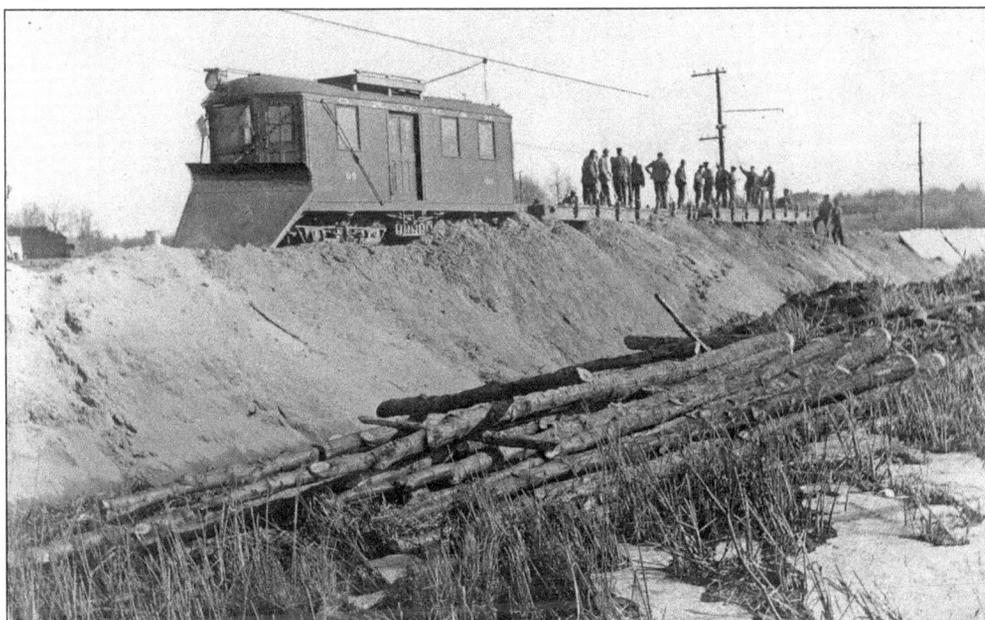

In another view of the Spring Lake trestle, workers shovel loads of sand to extend the fill out into the lake. The logs and wood piled at the base of the fill will be submerged to finally stabilize the structure. The shift in the trestle alarmed the GRGH&M's management to the point that additional engineering help was brought in from the United Light and Railways operations center in Davenport, Iowa, to help analyze the situation.

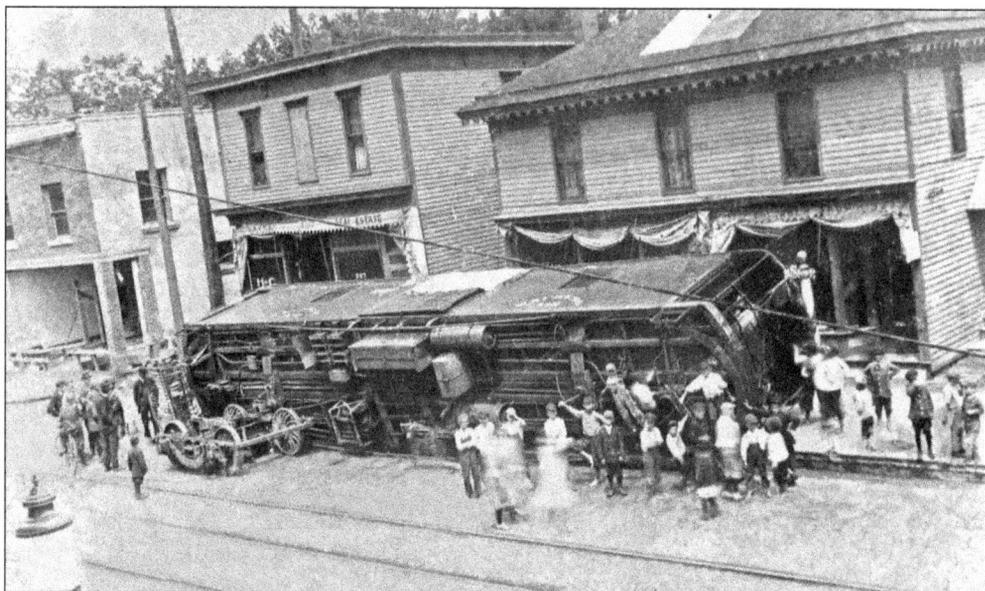

Safety was always a concern, but accidents happened throughout the life of the GRGH&M. Here, onlookers pose next to Car No. 112. The freight motor had tried to turn the sharp curve at Leonard Street and Scribner Avenue at too high a rate of speed. The car flipped on its side and skidded along the street before finally coming to rest on the sidewalk in front of Wheeler's drugstore.

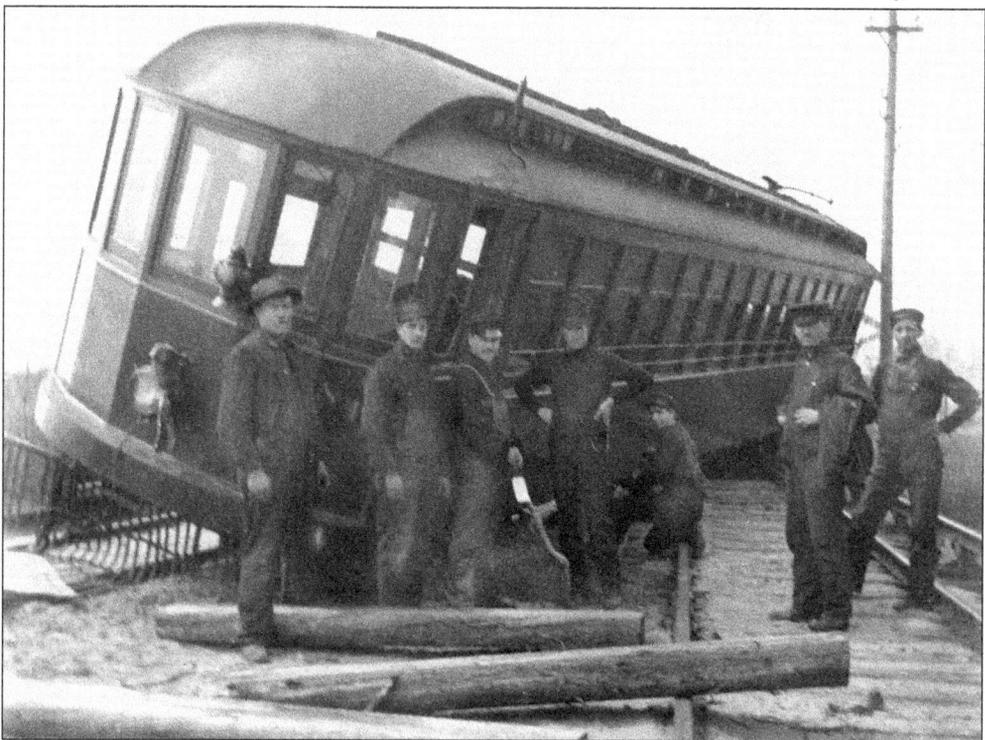

In another mishap, Car No. 4 derailed as it tried to enter a siding. The front truck of the car became hung up on the switch, and the car left the track. Here, a work crew is trying to jack the car up to place timbers underneath the frame so the car can be lifted back onto the truck.

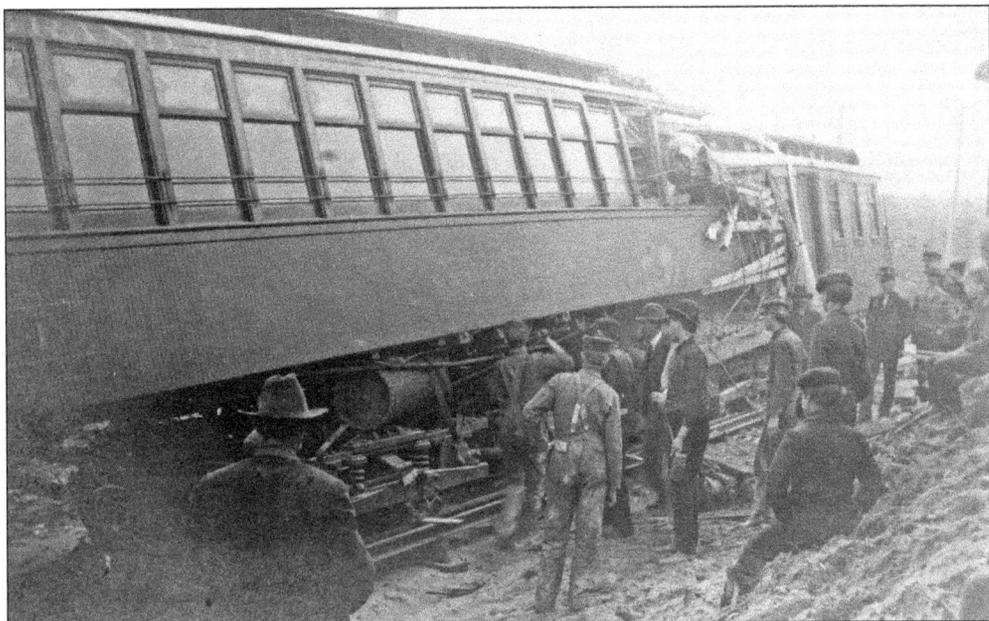

One of the worst accidents in the history of the GRGH&M occurred a mile east of Muskegon Heights near Mona Lake on May 24, 1907. The motorman of freight motor No. 101 on the early morning freight run from Grand Rapids relied on a faulty watch and did not wait on the siding for Car No. 4 to pass. The two trains met head-on near Turner's Crossing, one mile east of the Muskegon Heights depot.

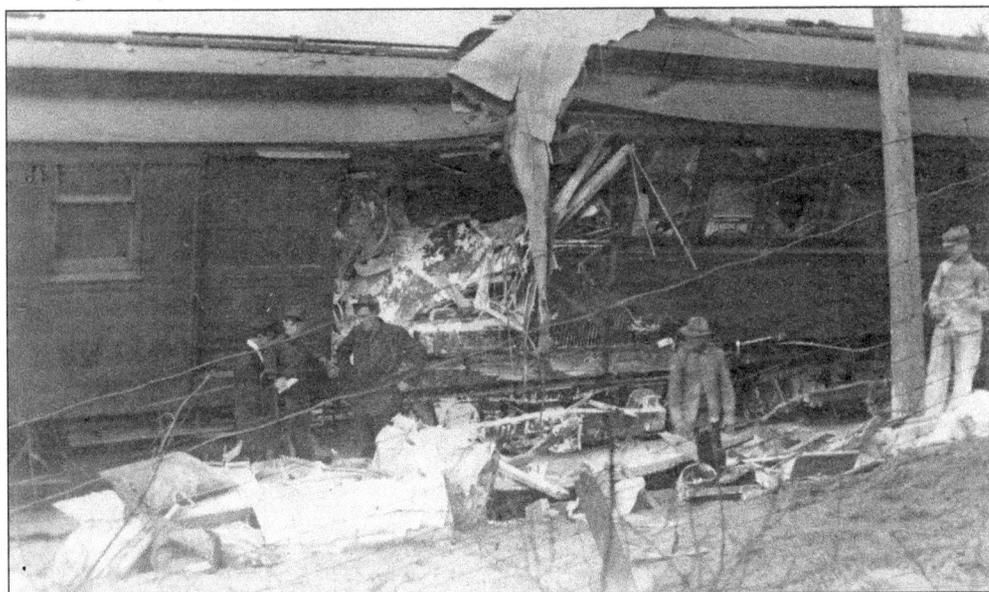

The force of the collision drove the front of the passenger car into the front section of the freight. The motorman of the freight, Chalmers Bettes, and the motorman of the passenger car, James Edmond, were both killed in the accident; the conductors of each car and the 10 passengers aboard Car No. 4 survived. A coroner's inquest found that the watch Bettes had relied upon was running almost five minutes slow, leading him to believe that he had adequate time to reach the Muskegon Heights depot before meeting the passenger train.

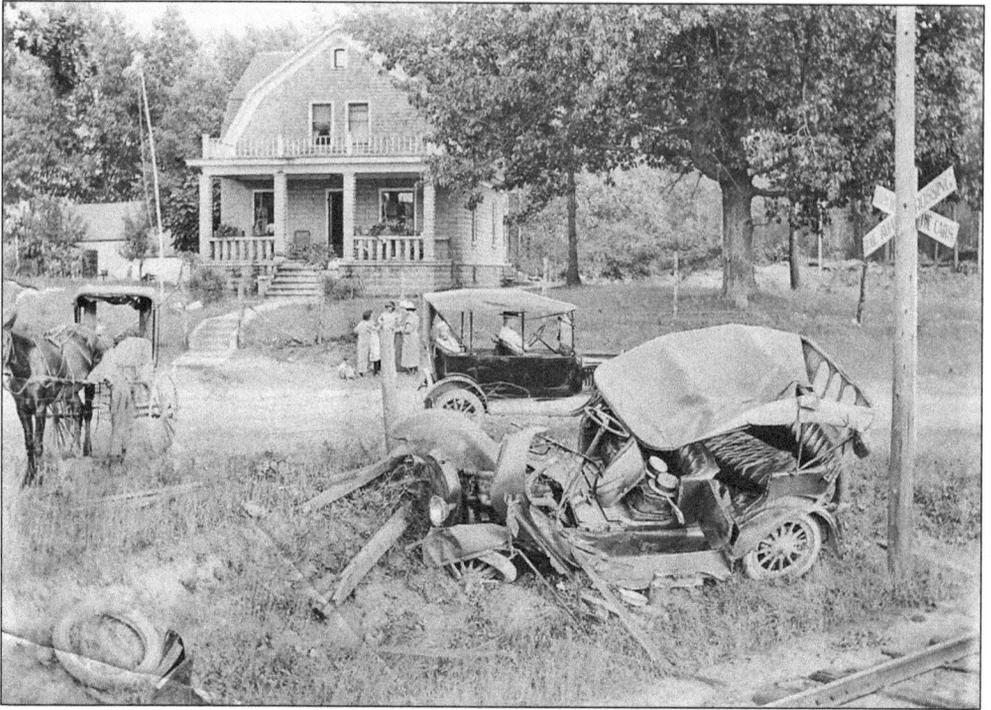

During the early days of the interurban operations, accidents frequently involved an interurban car and a horse and wagon or buggy. By the beginning of the 1920s, accidents began to involve automobiles. Like the wagon, an early automobile was no match for an interurban car. This wreck occurred when a Spring Lake summer resident from Chicago pulled in front of an interurban car just east of the cemetery. Both the driver and a passenger survived. (Courtesy of Richard Brook.)

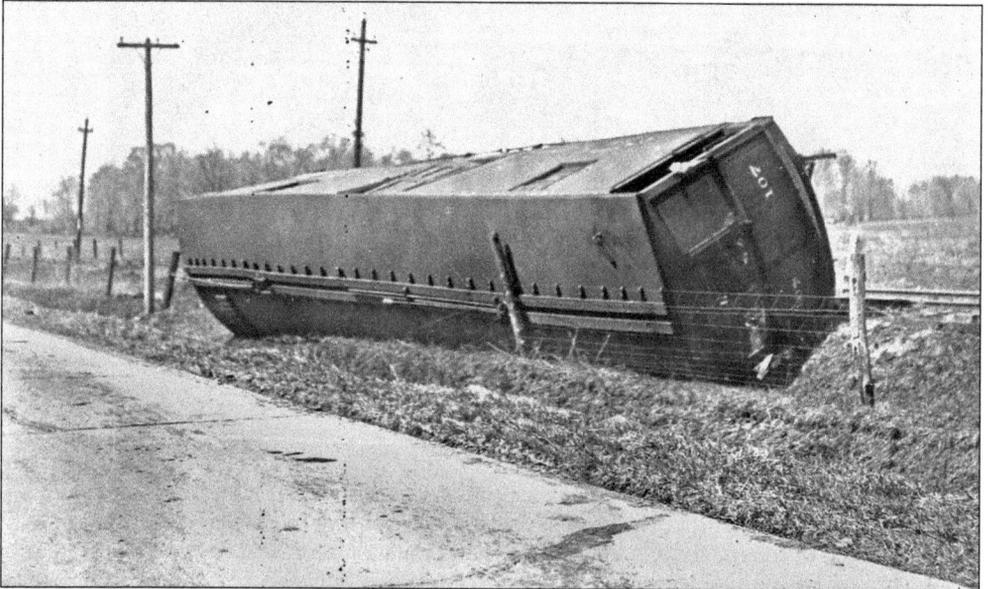

Occasionally an accident was caused by a mechanical failure. Car No. 107 was on a stretch of track that paralleled Remembrance Road in Walker Township when a wheel broke, causing the freight motor to flip onto its side.

Six

MAKING THE CARS RUN

An electric interurban railway is a complex operation, requiring people with a wide range of skills working together to give the public a safe and efficient transportation service. The riding public came into contact with a small number of these employees: the motormen and conductors on the cars, station agents, and those running the line's resort at Pomona. The rest of the staff was rather invisible but no less essential. This group included managers and bookkeepers at the administrative office in Grand Rapids, solicitors who canvassed businesses for freight traffic, and purchasing agents who kept necessary supplies on hand.

The staff in the Grand Rapids office handled the business affairs of the company. For most of the line's existence, the management group was headed up by two individuals: Wilmot Morley, vice president and general manager, and Sidney L. Vaughan, traffic manager. When Morley retired in the early 1920s, Vaughan was promoted to general manager. The two men managed all aspects of the interurban operations as well as relations with the owners and bondholders.

The shops and powerhouse at Fruitport were the operations center for the line. Crews generated power in the early years, and blacksmiths, electricians, and mechanics repaired and rebuilt cars and kept them clean. The train master and his staff created schedules. Dispatchers worked to keep the cars on time and the public safe. In the field, section gangs maintained the tracks and shoveled snow in winter, linemen kept electricity flowing, and bridge tenders opened and closed the bridge on the Grand River.

Despite occasional mishaps, this group of people performed their tasks with care and precision, not to mention a great deal of pride. The following pages feature some of the people who made the cars run through the years that the GRGH&M was in operation.

To the riding public, the most familiar GRGH&M faces were those of the motormen and conductors on the cars they rode. In this photograph, Perry McClellan (left) and an unidentified motorman pose on the fender of Car No. 2. GRGH&M conductors generally wore a more formal uniform than the motormen, who might be called on to fix a minor mechanical problem.

Crewmembers gather on Car No. 14 at the Muskegon yards. Motorman Raymond Kinney is in the car on the right, and Charles Gibbs is standing at far right. Cars frequently laid over at the Muskegon terminal until they were needed for service.

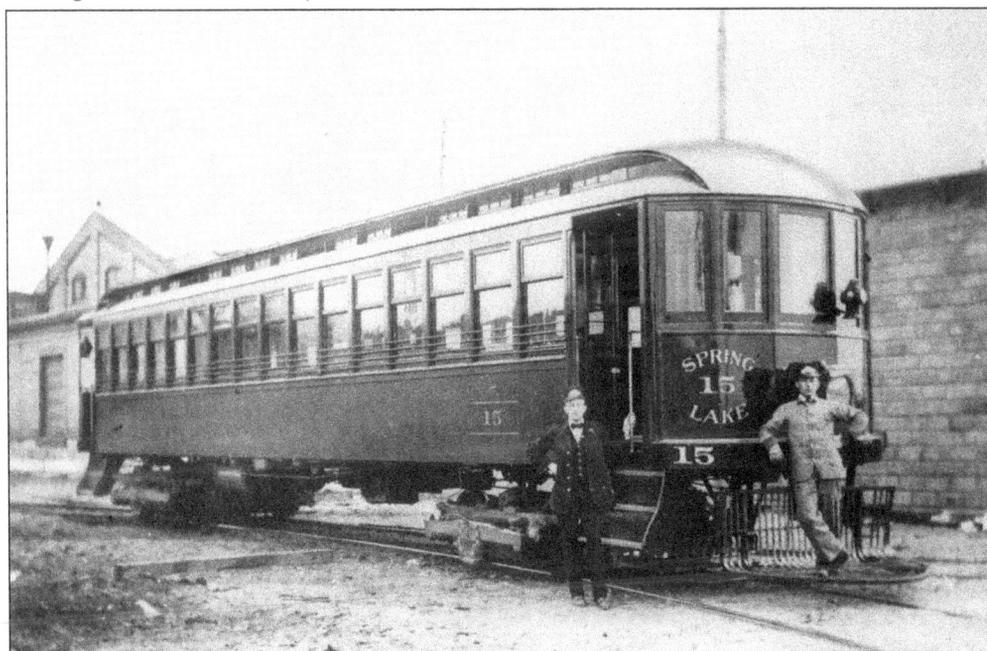

Conductor W.A. Kinney (left) stands at the front entrance of Car No. 15 and motorman Hazen Penny leans on the fender. The front entrance to passenger cars was used exclusively by the crew; passengers entered and left the car through the rear platform.

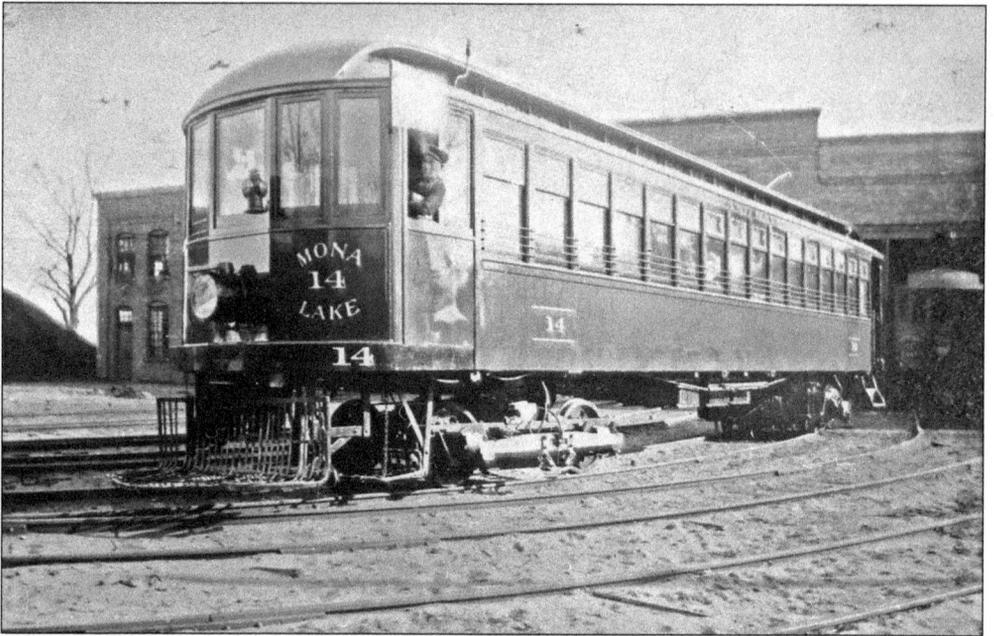

William Gleason is in the cab of Car No. 14 at the GRGH&M carbarn in Fruitport. Car No. 14 was one of the original Barney and Smith coaches and operated from the first day of service until the last.

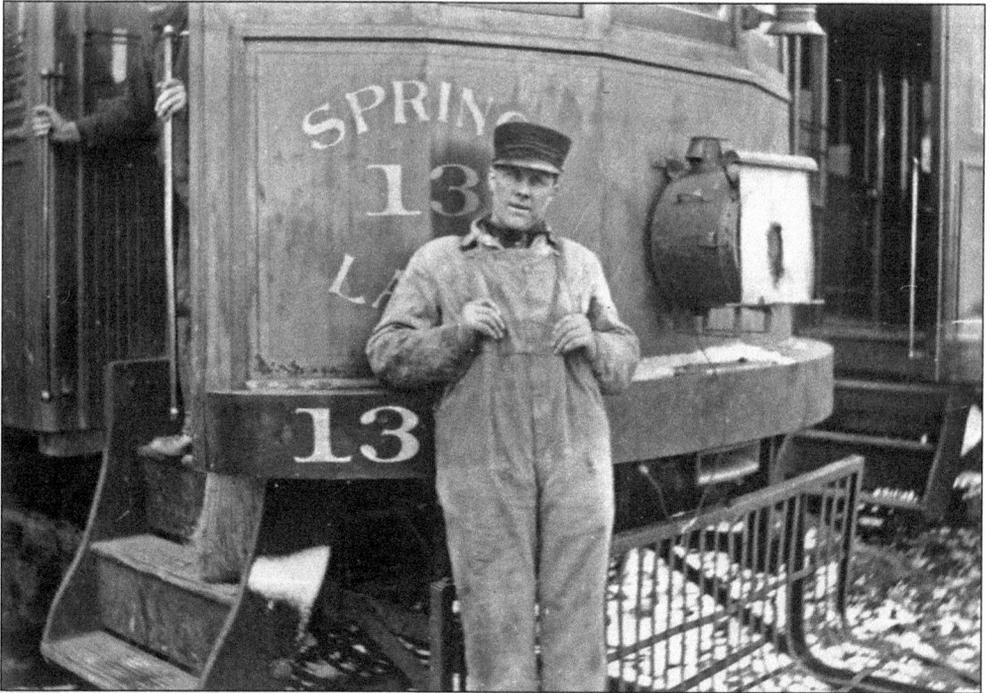

Motorman Westover stands on the fender of Car No. 13 at Fruitport. The fabric shade on the headlight was used to dim the powerful light in towns. Over time, the beam of light from the lamp's carbon-arc filament has burned a hole in the shade. Two members of the Westover family, Chauncy and Clinton, worked for the line.

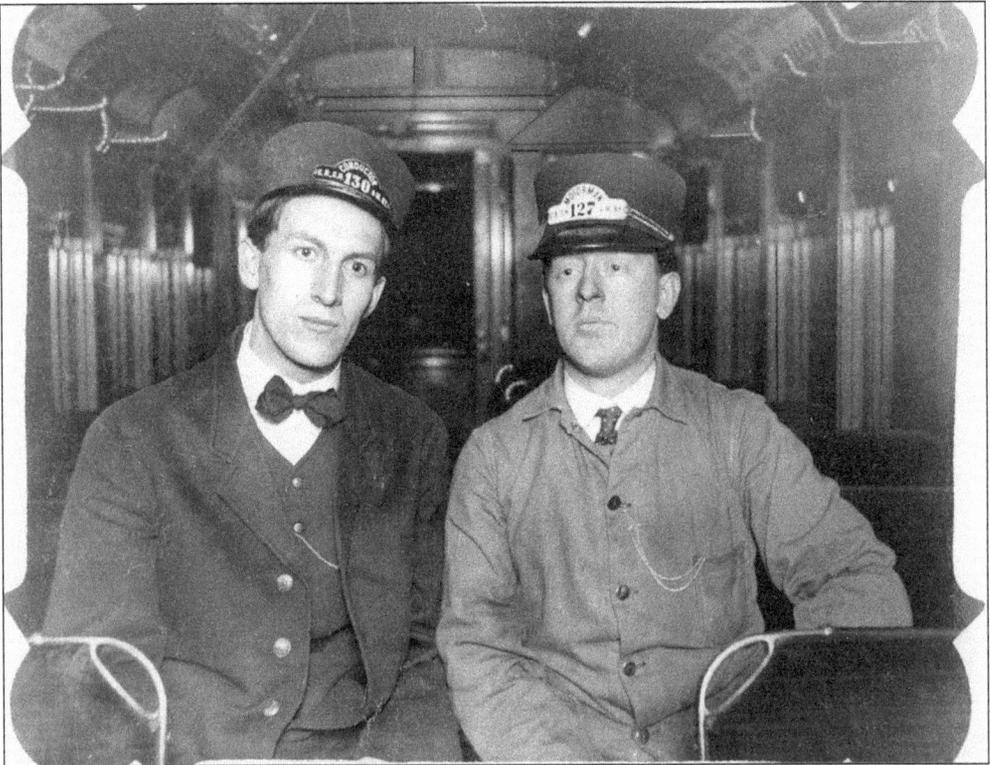

Conductor Leroy McNaughton (left) and motorman Raymond Jubb sit inside a passenger car for this photograph. This is the only photograph in the Coopersville Historical Museum's collection that shows the interior of a Barney and Smith car. The interiors were finished in white oak with holly inlays, and the seats were upholstered in red plush.

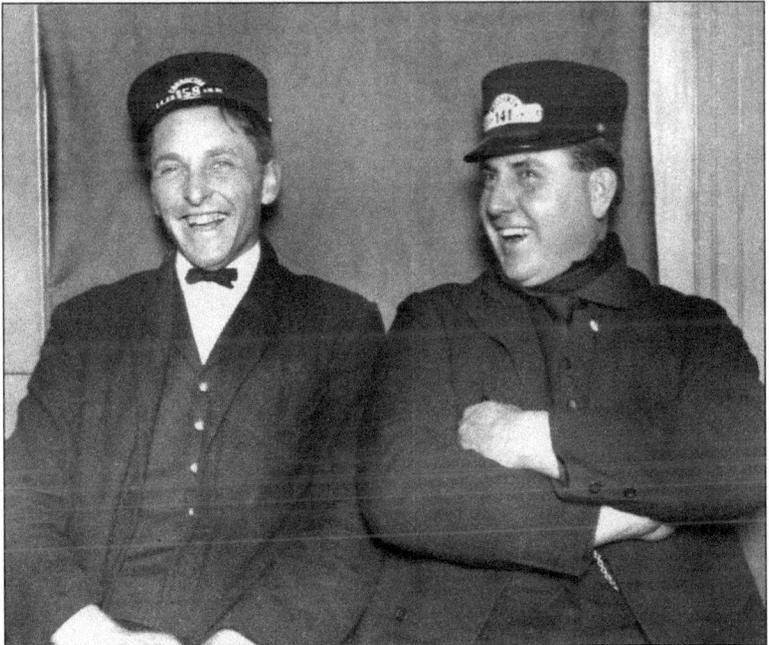

Conductor Ben Crawford (left) and motorman Harry Wood enjoy a laugh between shifts at the Fruitport carbarn. The company provided a lounge for crews on the carbarn's second floor.

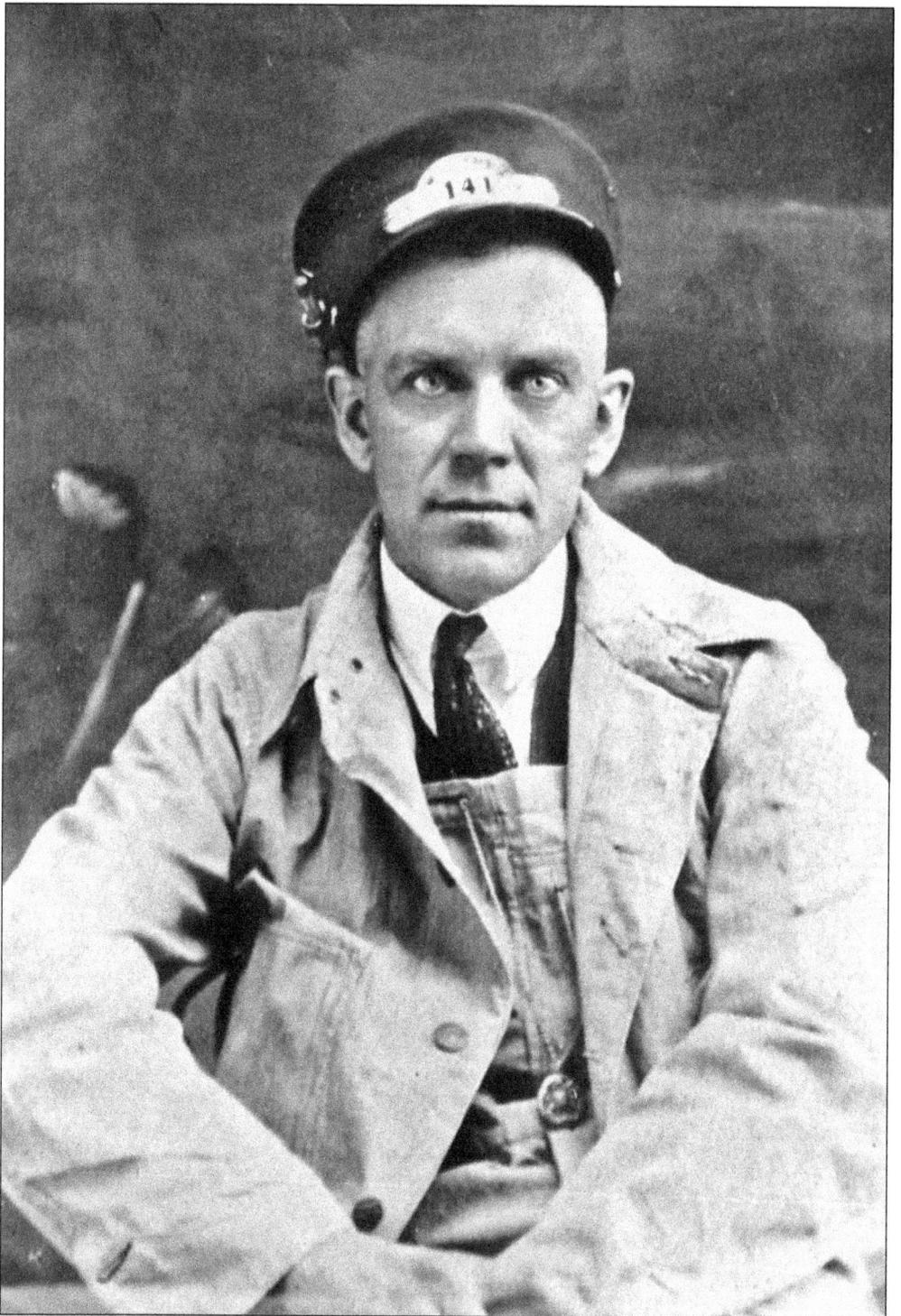

Earl Averill poses for his official identification photograph. During World War I, identification was required for anyone on the docks at Grand Haven. Pinkerton guards were brought from Chicago to enforce the restrictions.

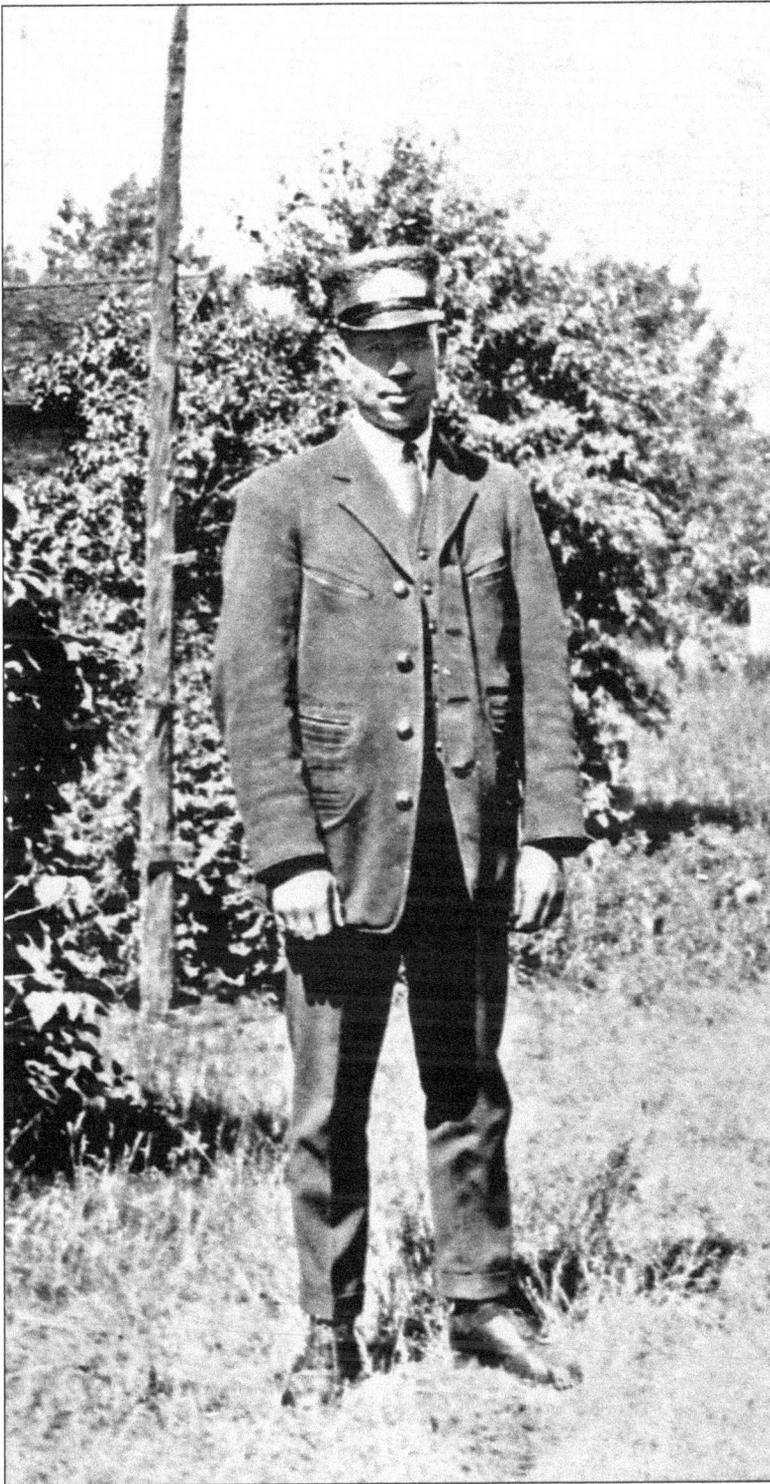

Conductor Guy Burdsall poses for the camera. When a car was on the line, the conductor was in charge of the car and responsible for its safe operation.

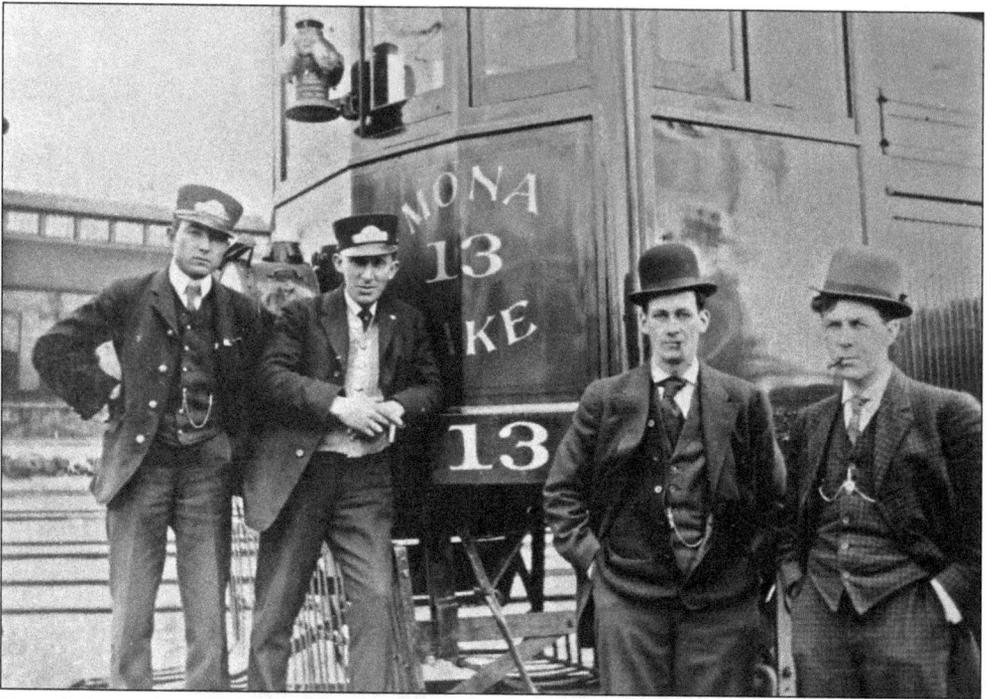

From left to right, conductors Roy Kinney and Apolis "Polly" Griswald stand on the fender of Car No. 13 next to Louis Christopher and William Smith. Christopher and Smith were office employees for the company.

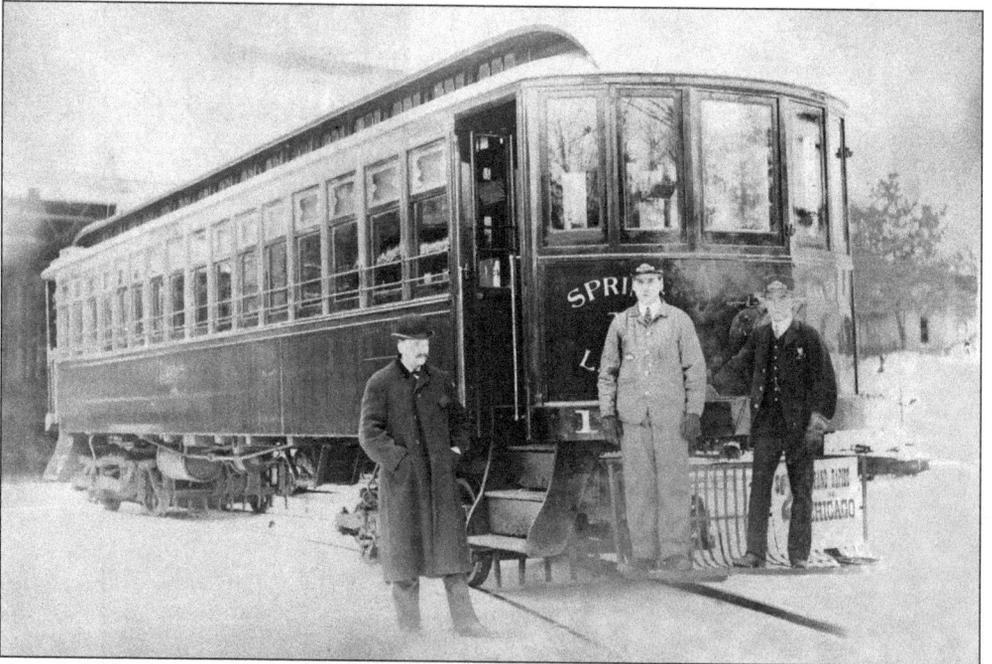

From left to right, Michigan senator Vincent A. Martin poses with motorman Clyde Tissue and conductor Roy Kinney by Car No. 1 at Fruitport. Senator Martin had been an employee of the GRGH&M, working as a motorman, dispatcher, and trainmaster before his career in politics.

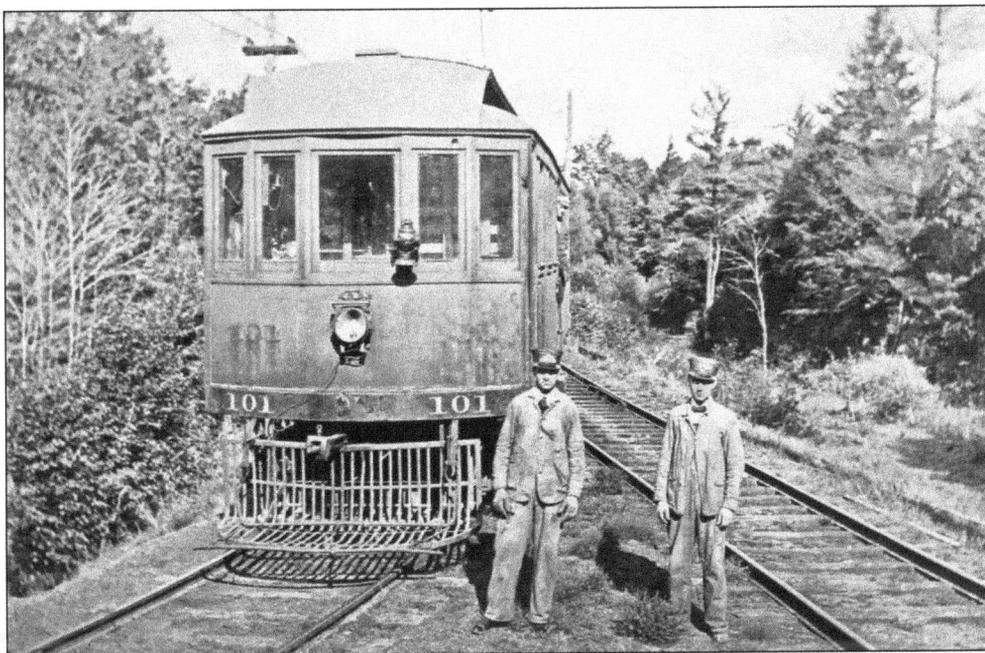

Motorman Eugene Wilkerson (left) and conductor C. Rickard stand near the switch into the yard at Fruitport. An unidentified freight handler is in the freight door. Car No. 101 typically served in two capacities, both as a freight motor and as a maintenance-of-way car, backing up Car No. 99, the Red Devil.

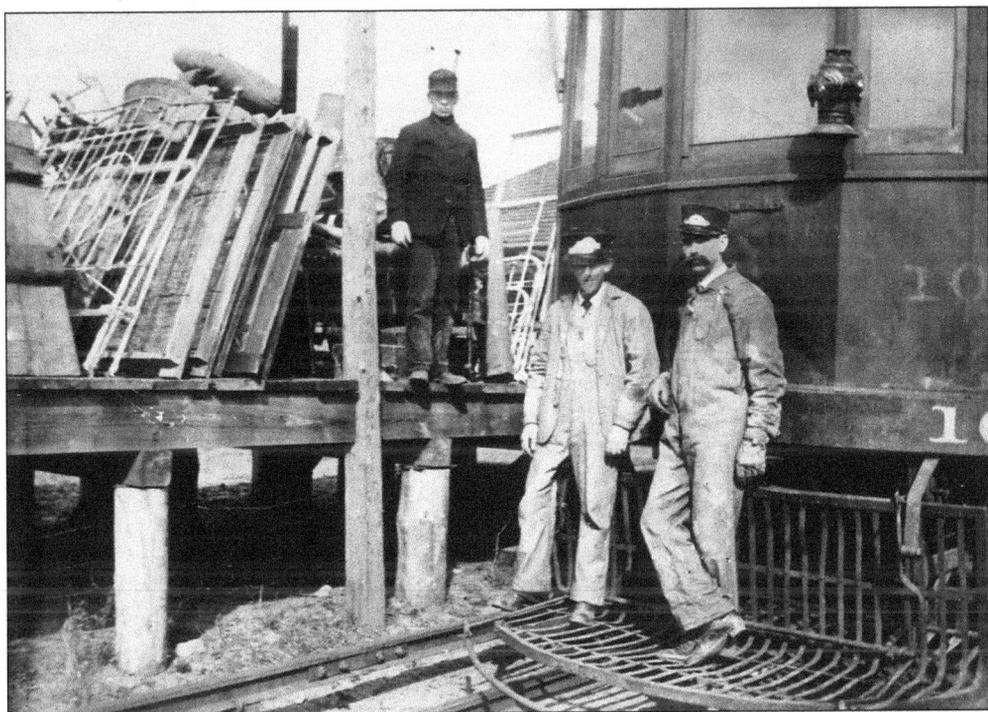

A freight car unloads brass bed parts at Nunica. Clarence Bond is on the dock, and the crew, Polly Griswald (left) and ? Aldrik, are on the front of the car.

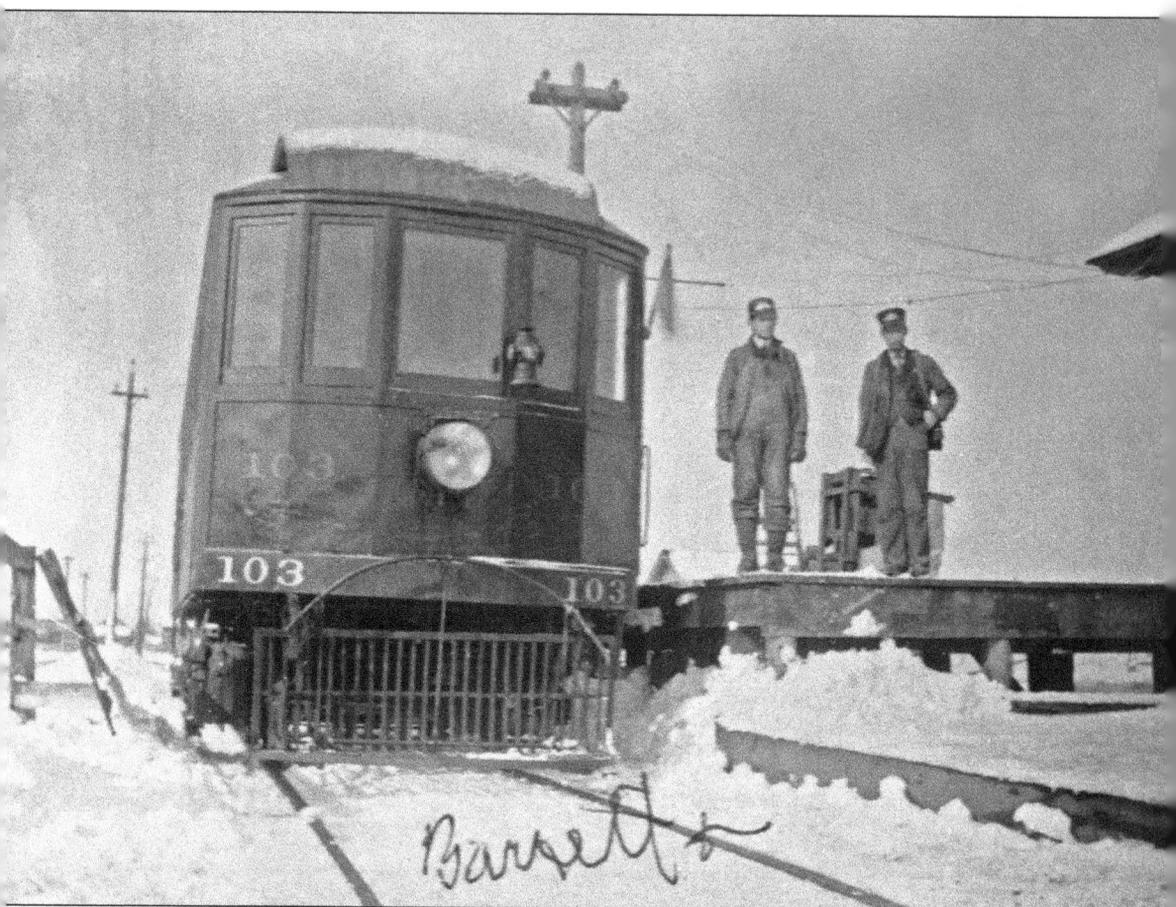

Motorman Guy Barrett (left) and an unidentified conductor stand on the Nunica freight platform on a wintry day. Barrett was a longtime GRGH&M motorman who was frequently assigned to the early morning freight run out of Grand Rapids. One morning, as Barrett was making his run, his car derailed just as it made the transition from private right of way onto the Coopersville city streets and came to a stop virtually in front of Barrett's home. Barrett and Gene Wilkerson, the conductor, walked to the Barrett home and called for Car No. 99 and a wrecking crew from Fruitport. Mrs. Barrett quickly sent their daughters to the local bakery for doughnuts. Throughout the morning, the Barretts served coffee and doughnuts to the crewmembers as they took turns warming themselves at the Barretts' stove.

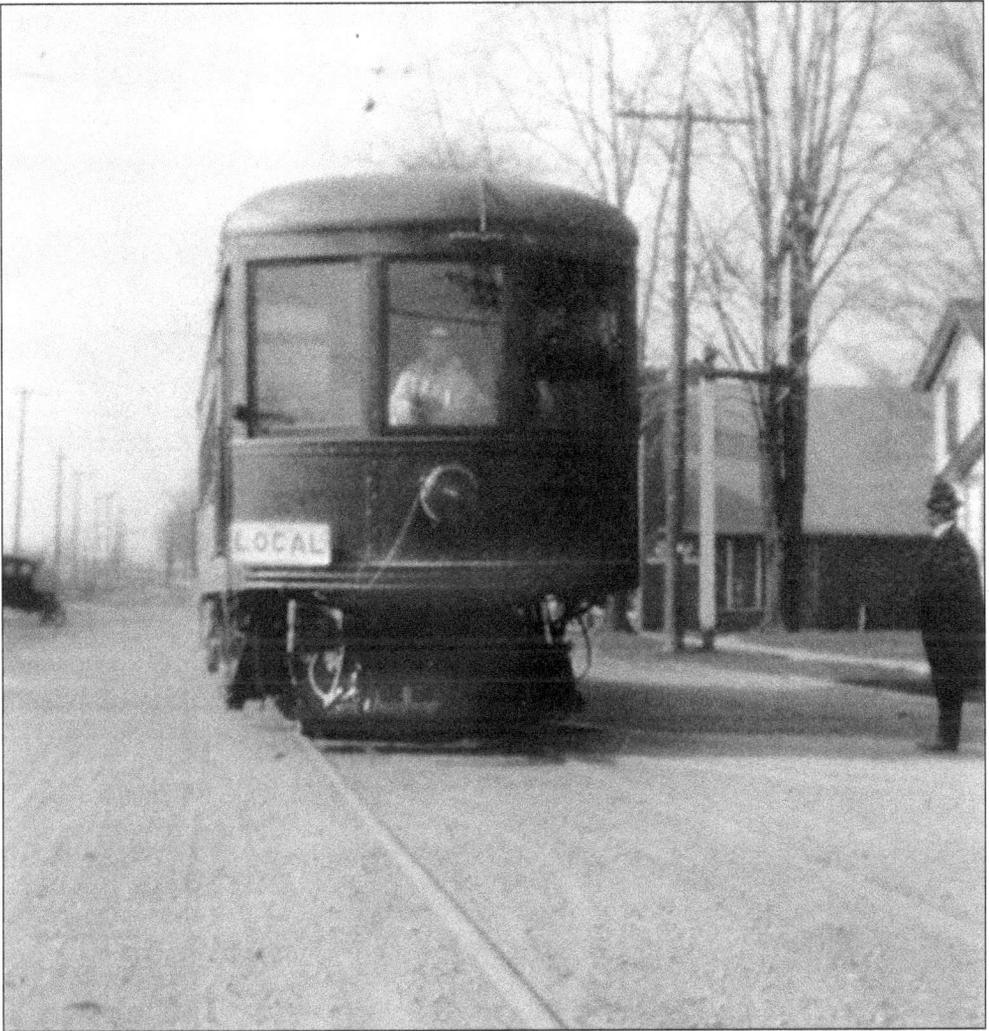

Walter Treloar, just visible above at the controls of Car No. 20 entering Coopersville, was a longtime GRGH&M motorman. His hat badge, pictured below, was No. 139.

Working Card

Division No. **855**

Located at **GRAND HAVEN**

E. Gustafson.

Dues /.75 for Month of March 19 28

Special Assm't —— Local Sec., R. P. Reff.

25

PRINTED IN U. S. A.

W. D. Mahon Int. Pres.

ASSOCIATION OF STREET AND ELECTRIC RAILWAY · EMPLOYES OF AMERICA · ORGANIZED · SEPTEMBER 15 1892

This is Edward Gustafson's union identification card. Although the company and employees had a generally good relationship, it became strained in the early 1920s. Inflation during World War I led to increased prices and higher wages for interurban companies, which put a serious strain on profits. In 1921 and 1922, the company tried to roll back the hourly wage for motormen. In 1921, the workers accepted a 5¢ wage cut. But when the company tried to cut wages again in 1922, the car workers formed a local chapter of the Amalgamated Association of Street and Electric Railway Employees of America. Negotiations broke down, and the car workers began a four-day strike that all but stopped operations on the line.

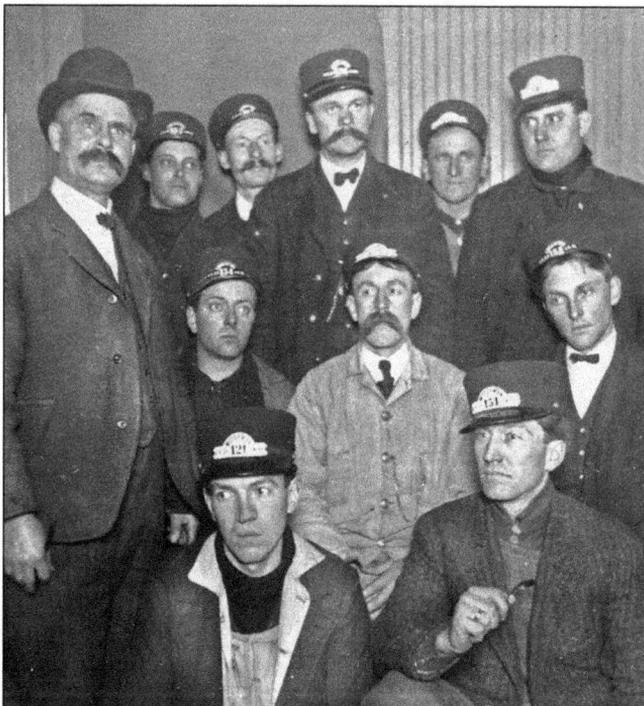

Wilmot Morley (far left) poses with a group of motormen at the Fruitport shops. In 1904, Morley became the vice president and general manager of the GRGH&M and remained in that position for the rest of his career. In 1921, he had recently retired, but the company asked him to return to help resolve the strike. During his years with the company, he had earned the trust of the employees and was able to help convince them to return to the bargaining table. Negotiations resumed, and the company and the workers agreed on a 2.5¢ wage cut. Shortly after the strike was settled, Morley returned to retirement, and Sidney Vaughan, another longtime employee, became the general manager for the rest of the line's existence.

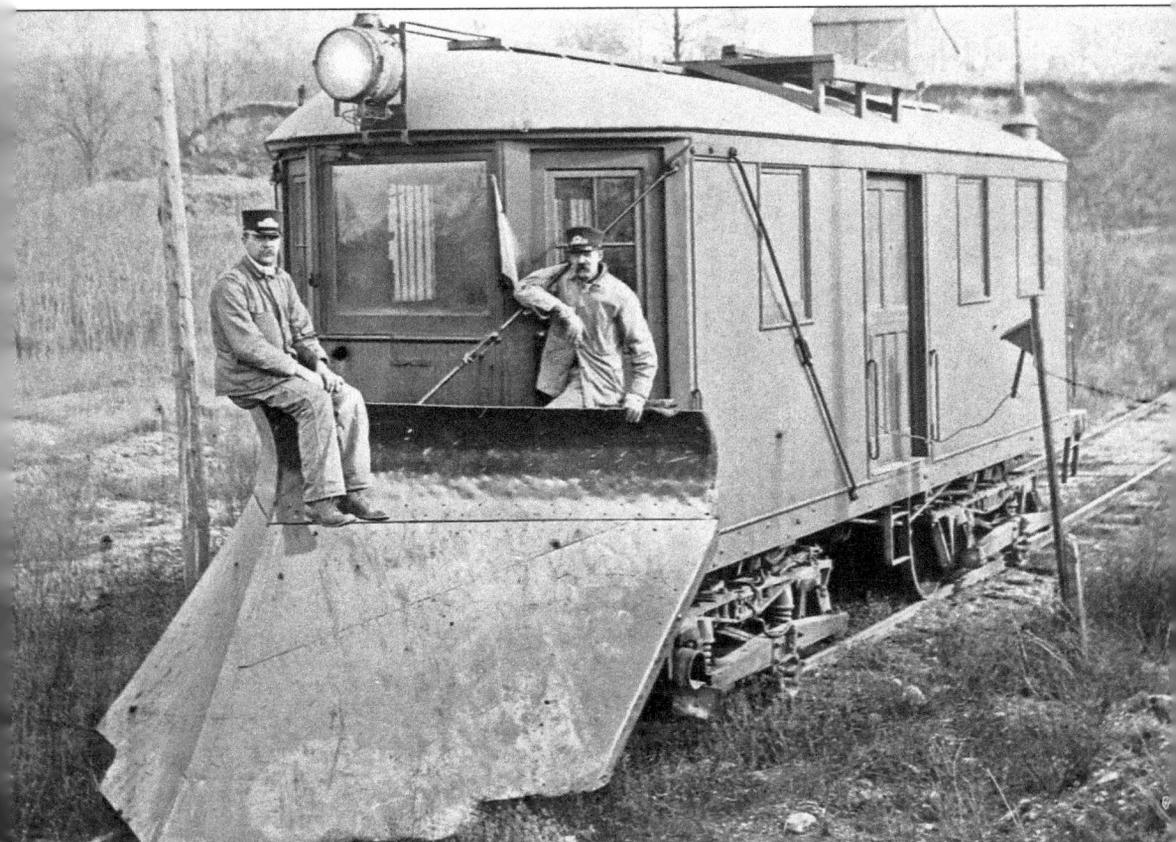

Car No. 99 has been outfitted with its plow for winter. Crewmember A.B. "Bert" Martin is on the left, and Walter Seymour is on the right. The car is pictured on the siding at Berlin. During winter storms, the Red Devil's crews worked day and night to keep the track open.

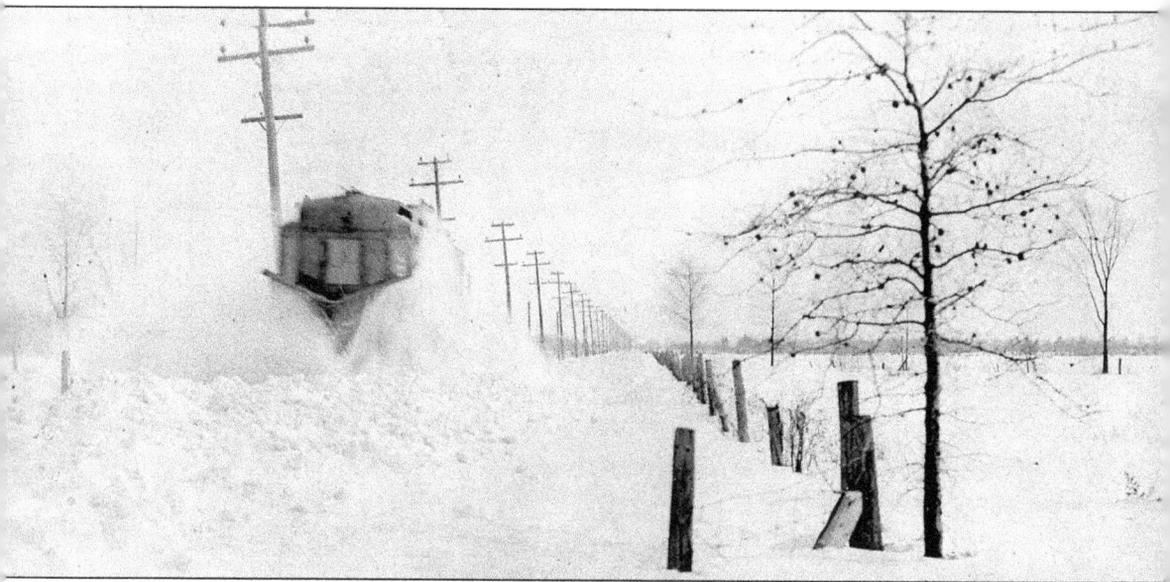

Car No. 99 sends up a wave of snow as it plows near Jeanott Crossing, between Fruitport and Muskegon. Winter storms were formidable foes that succeeded in shutting down the line on several occasions. At times, passengers were stranded in cars overnight until crews arrived to rescue them.

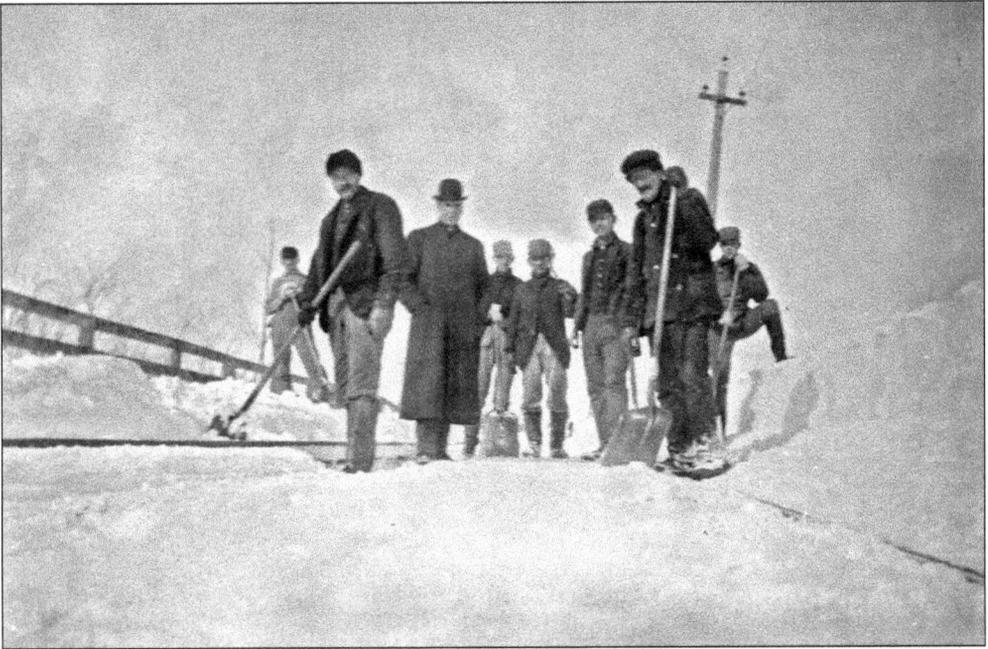

While the Red Devil could make an impressive spectacle, much of the work of keeping the line open was done by hand. Here, a group of eight men clear the track with shovels. From left to right are Edward Flanders, unidentified, Clyde Tissue, ? Rollenhagen, Abraham Verhow, Loren Verhow, William Cornwall, and Oscar Larson.

Clyde Tissue, standing on a snowdrift in this photograph, was the conductor on a snowbound car during a storm in the early years of the line's operation. The car was rescued after being stranded for 28 hours. Dispatchers soon learned that it was better to hold cars in stations during heavy snow and not risk having them stranded in the countryside.

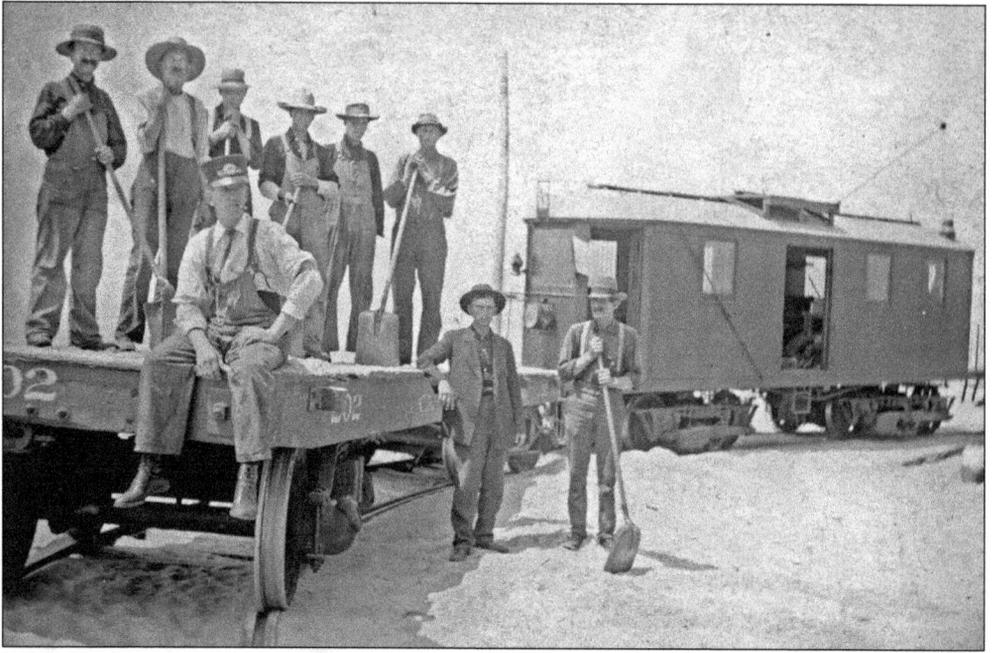

Besides snow, sand could be a difficult obstacle for track crews, especially along the Lake Michigan shoreline. Winter storms buried the line each year, forcing crews to uncover the tracks each spring. In this photograph, the Red Devil has pulled a flatcar with a crew to the loop at the end of the Highland Park branch for the annual spring cleaning.

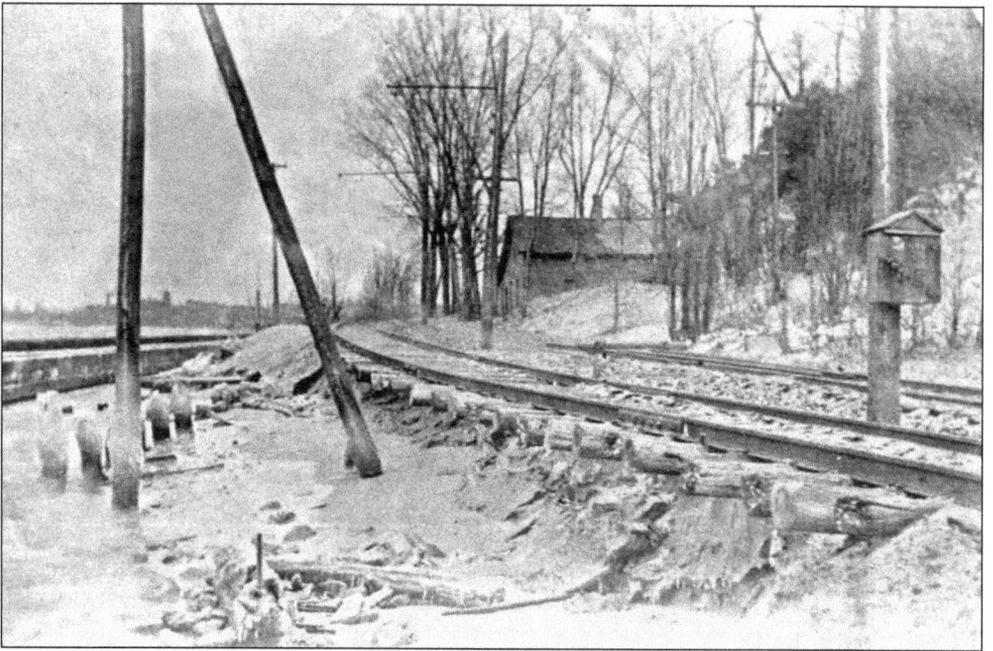

Erosion was yet another complication of running tracks onto the beach. This is the track along the Grand River channel, below the original Grand Haven lighthouse. In the background, the beach siding is visible, along with a telephone call box. Call boxes were placed at sidings and other points along the line so crews could contact the dispatchers for orders or to report problems.

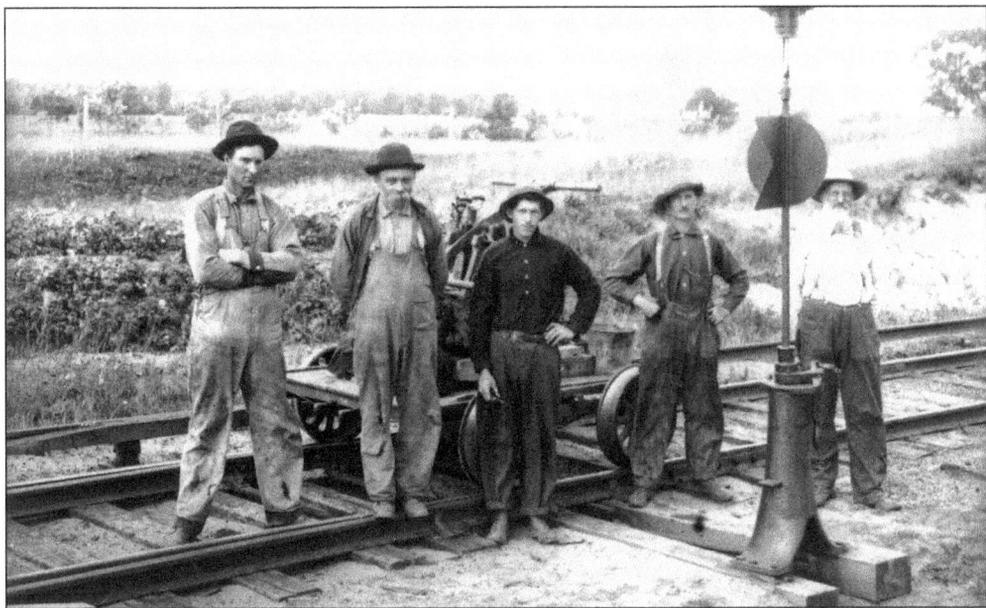

A track crew pauses from its work on the line near Dennison, a small community between Coopersville and Nunica. From left to right are John Holtrop, Casey DeYoung, Daniel Nichols, Frank Scott, and Delbert Haywood.

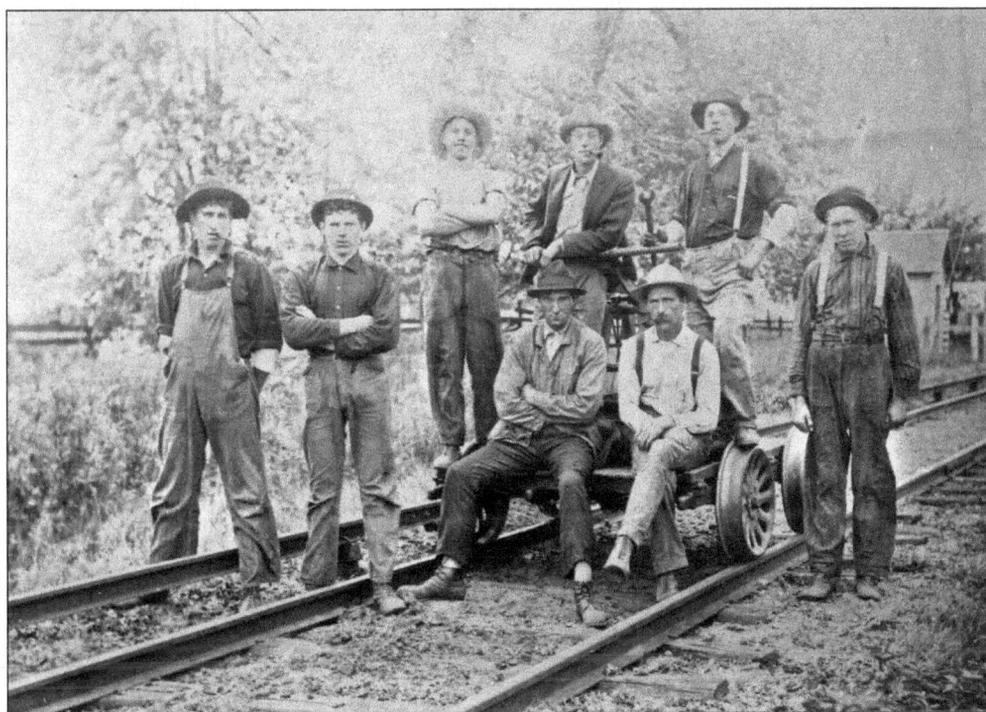

Another track crew is at work on the line with a handcart. Standing from left to right are Gert Holtrop, John Dendorf, Warner Kinney, Walter Stark, Myron Stark, and Edward Shears. Seated are John Holtrop and William Wildy. The railway was divided into sections, with a specific crew responsible for upkeep within each section.

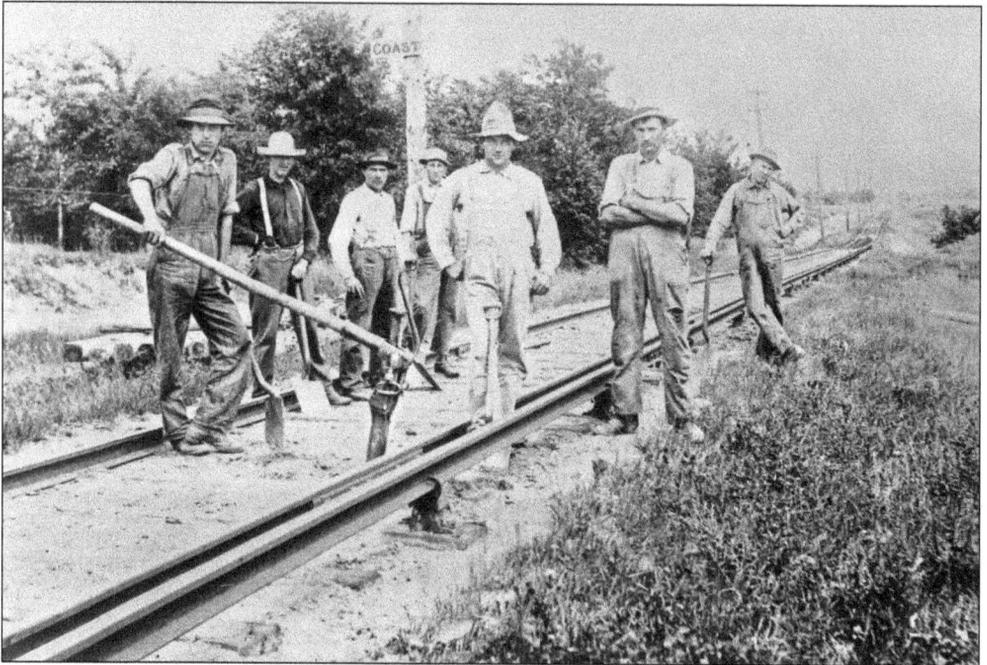

This crew is at work near the Brandy Creek trestle. From left to right are Earl Nickols, Andrew Andree, Edward Stark, Peter DeMull, George Edwards, John Holtrop, and Edward Shears.

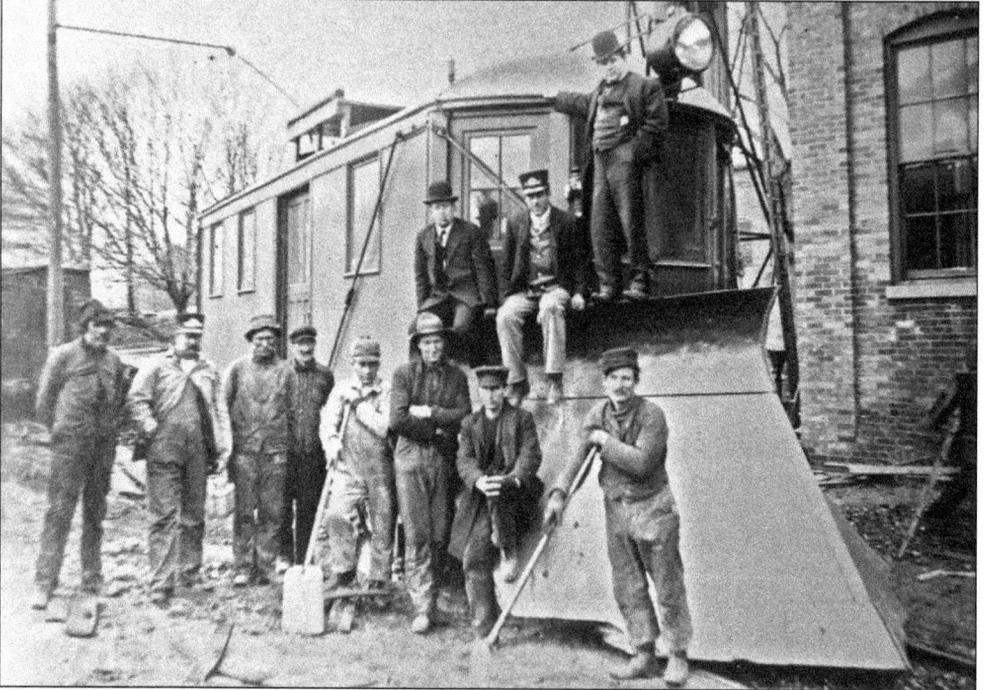

A mixed group of employees gathers around the Red Devil at the Fruitport carbarn. On the plow are Raymond Jubb (dispatcher), Harry Alexander (motorman), and Casey Hedges (dispatcher). Standing in front of the car are, from left to right, Bert Legar, Charles Jubb (conductor), Art Van Etten, William Cornwall, Charles Tissue, John Holtrop, Dryan Rickert, and Joe Bettes.

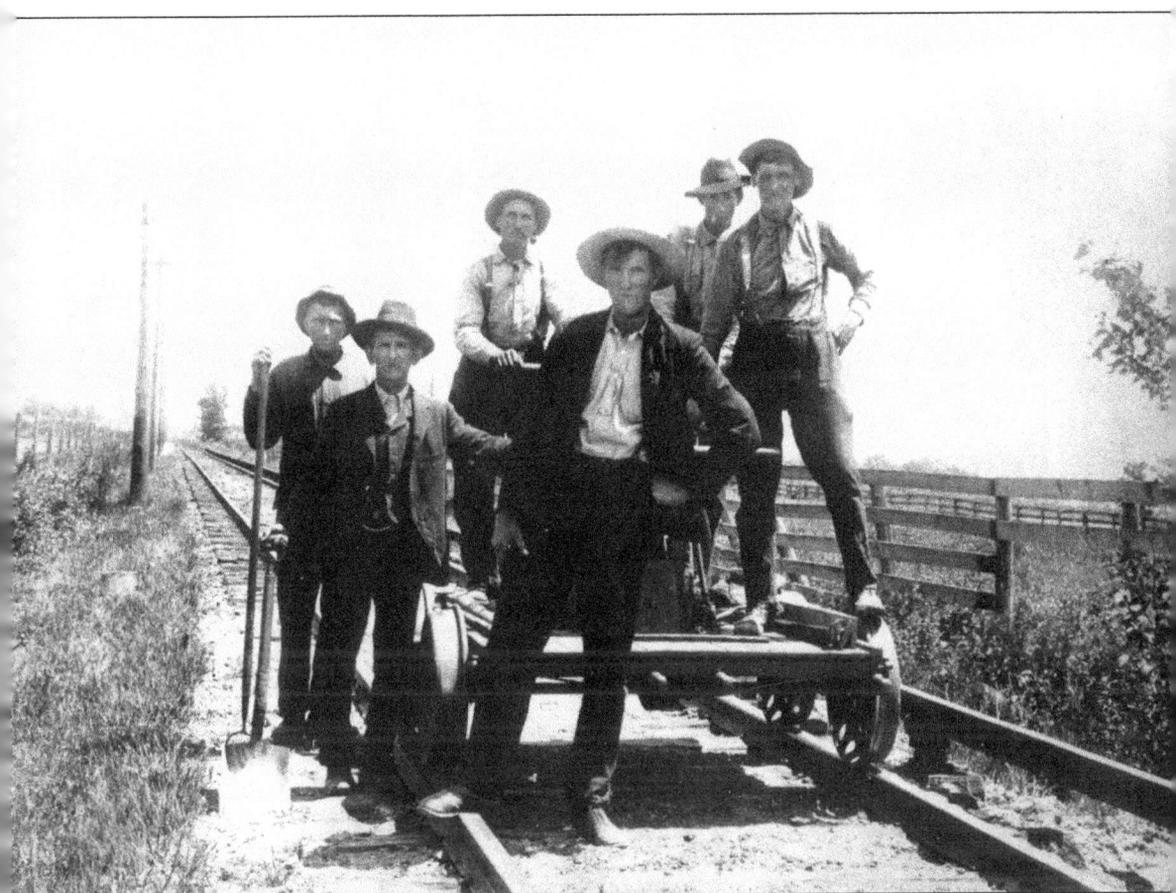

A work crew stops for a photographer in the Nunica area. Members of a section crew were usually from the local area. Pictured here from left to right are Arthur Van Etten, Abraham Verhow, Delbert Hayward, John Holtrop, John Nickols, and Burt Lyon.

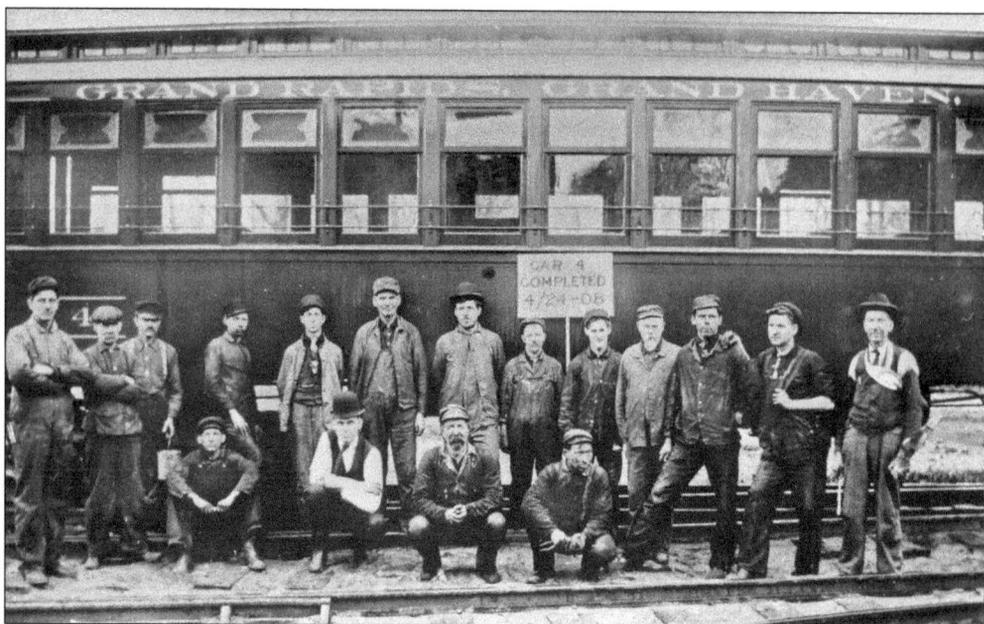

The crews in the repair shop were also an essential part of keeping cars moving. While much of the work was routine, the shop crews were capable of nearly rebuilding an entire car. In this photograph, the shop crew gathers around Car No. 4, which was almost destroyed in a head-on collision with a freight motor in 1906 (see page 83). The shop crew returned the car to service two years after the wreck.

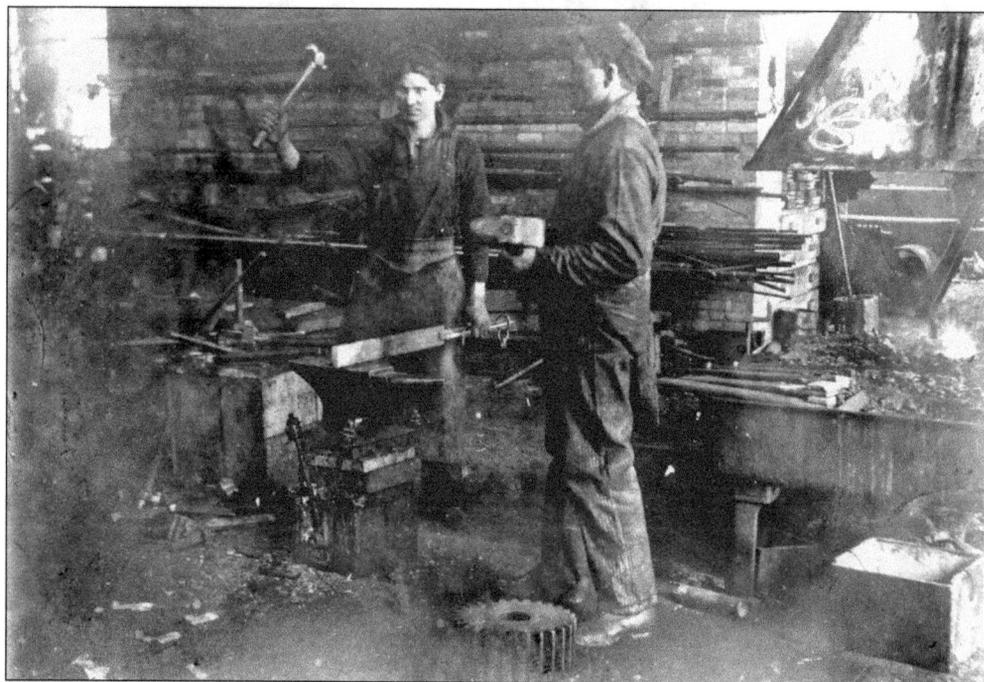

Two unidentified employees work in the blacksmith shop. The company had the ability to fabricate new parts from metal to replace damaged parts on the cars. On the right behind the workers is a small forge for heating metal.

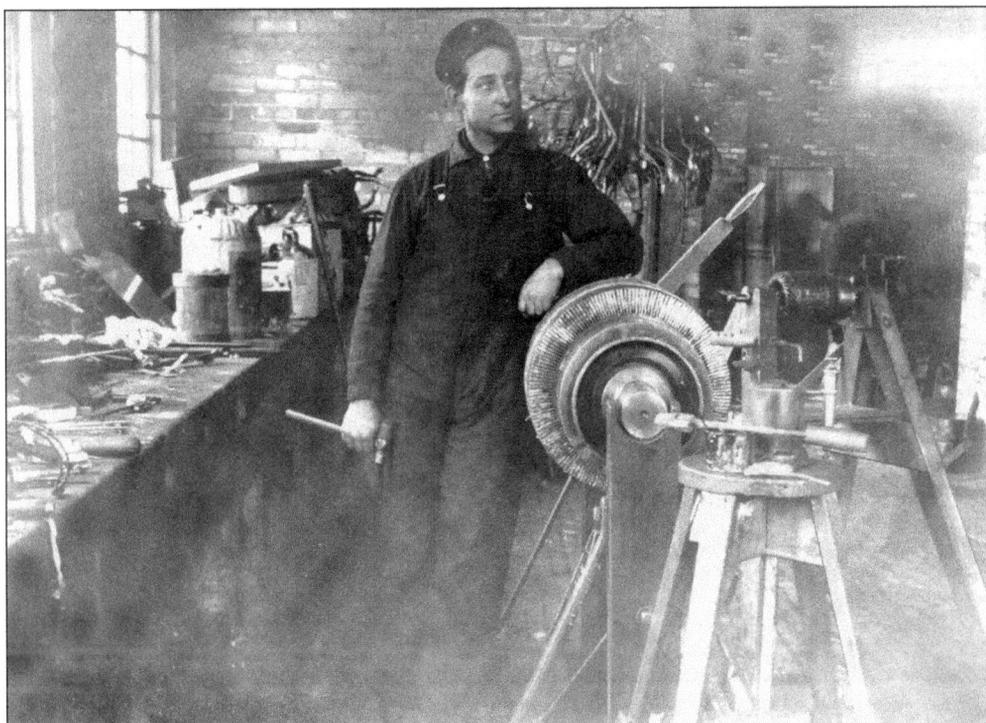

The shops also contained an armature room for rebuilding electric motors. Motors were removed from the cars, disassembled, and rebuilt.

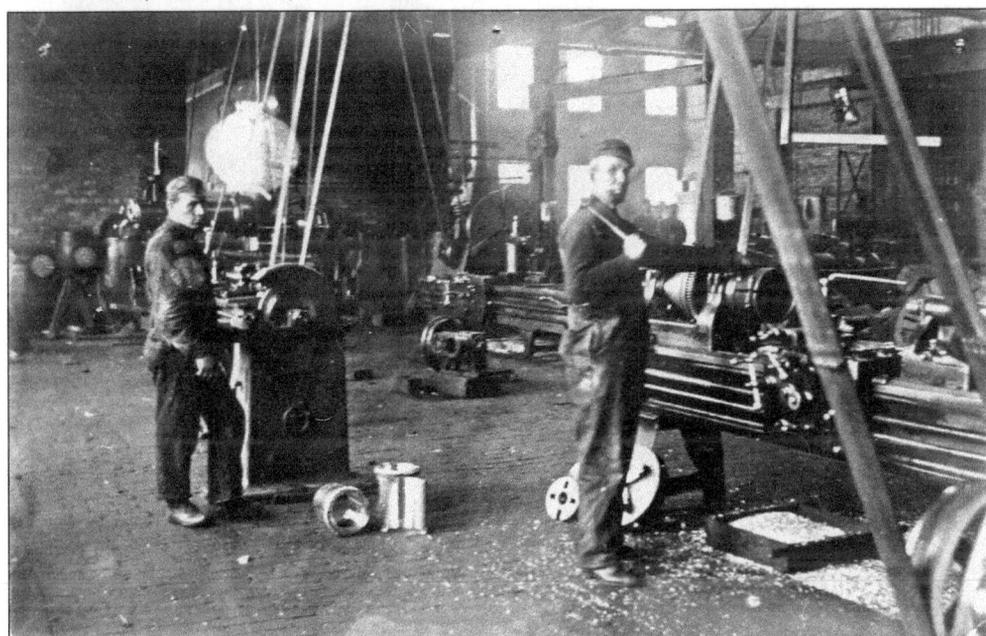

Large lathes allowed crews to machine metal parts for cars. Before electric motors were adapted to industrial tools, the equipment in shops was driven by a single steam engine in an engine house. A system of spinning shafts, pulleys, and belts transmitted power from the steam engine to the various machines. The belts driving some of the lathes are visible in this photograph.

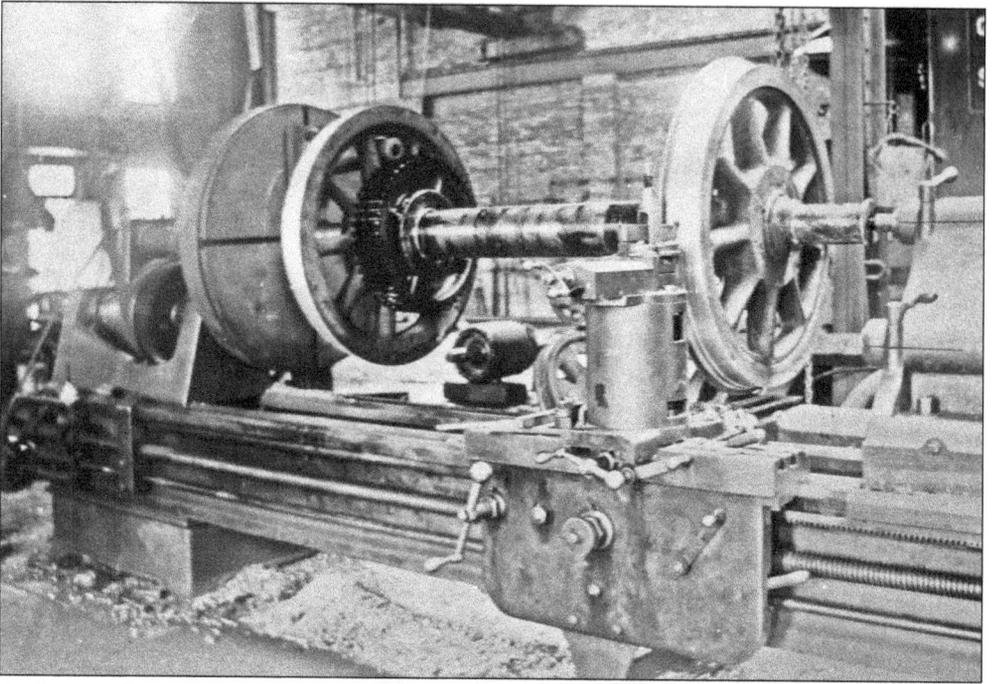

A close up shows a complete axle with wheels mounted on the lathe. The tread on one of the wheels is being machined. The gear mounted at the left end of the axle indicates where the motor would be attached to the rear truck set to power the car.

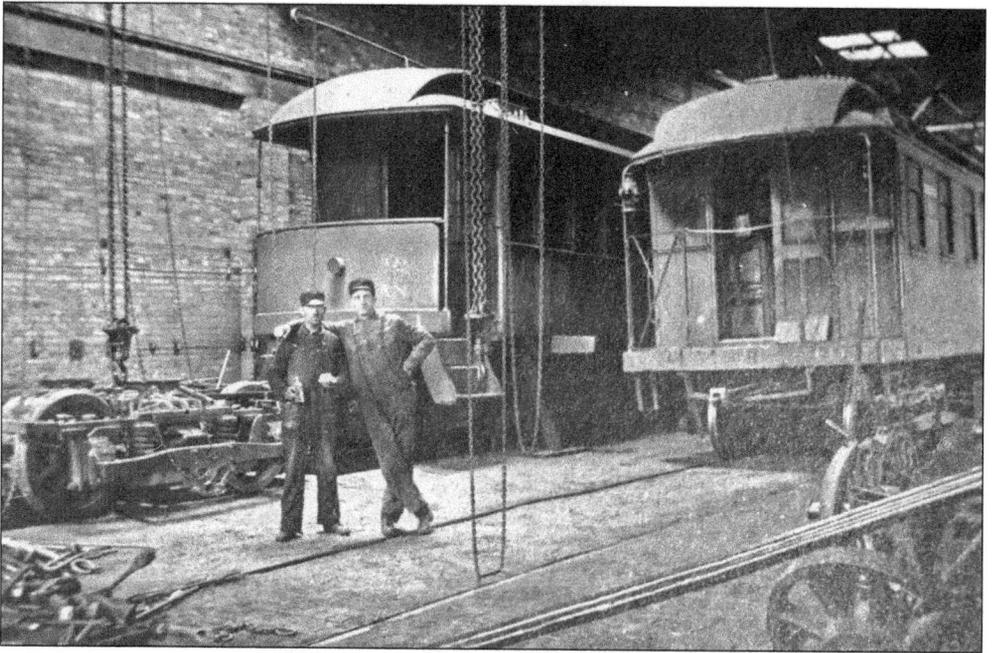

James Gleason (left) and an unidentified employee stand behind a freight motor and passenger car, both in the shop for repairs. Chains from an overhead crane hang above each track. Using the crane, workers were able to lift a car body and then disassemble the trucks to service the wheels and motors.

William Thielman stands in front of a car in the car storage section of the building. Nicknamed "Carbarn Bill," Thielman was a longtime employee who serviced car interiors.

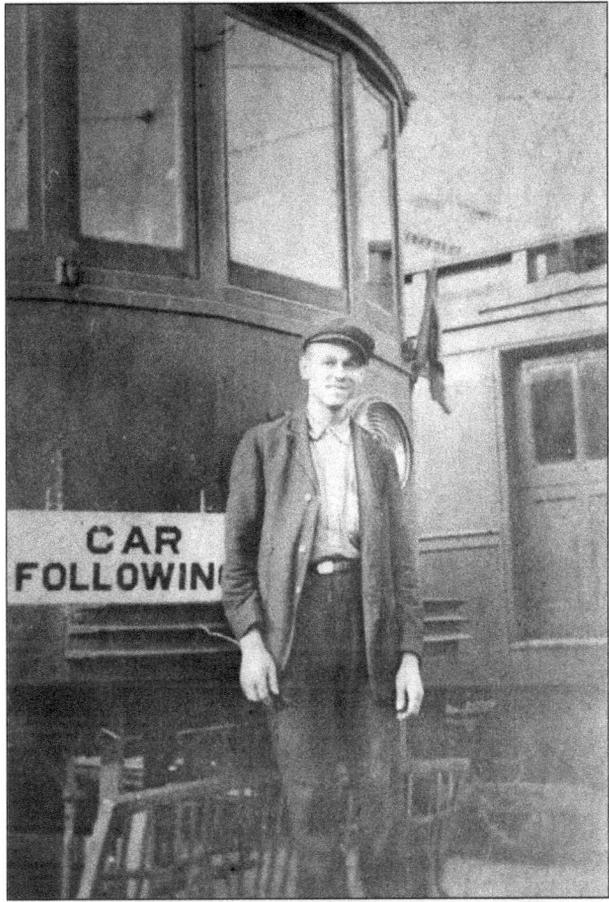

The shop crew is seated for a portrait in front of the carbarn doors. Employees pictured here from left to right are (first row) ? Miles; (second row) ? Thorstenson, Charles Tissue, Thomas O'Hearn, Art Lawton, William Gleason, and Robert Dillon; (third row) George Gelakaski, Harry Worden, Dudley "Dud" Worden, Charles Johnson, unidentified, Jule Farazen, and George Kinney.

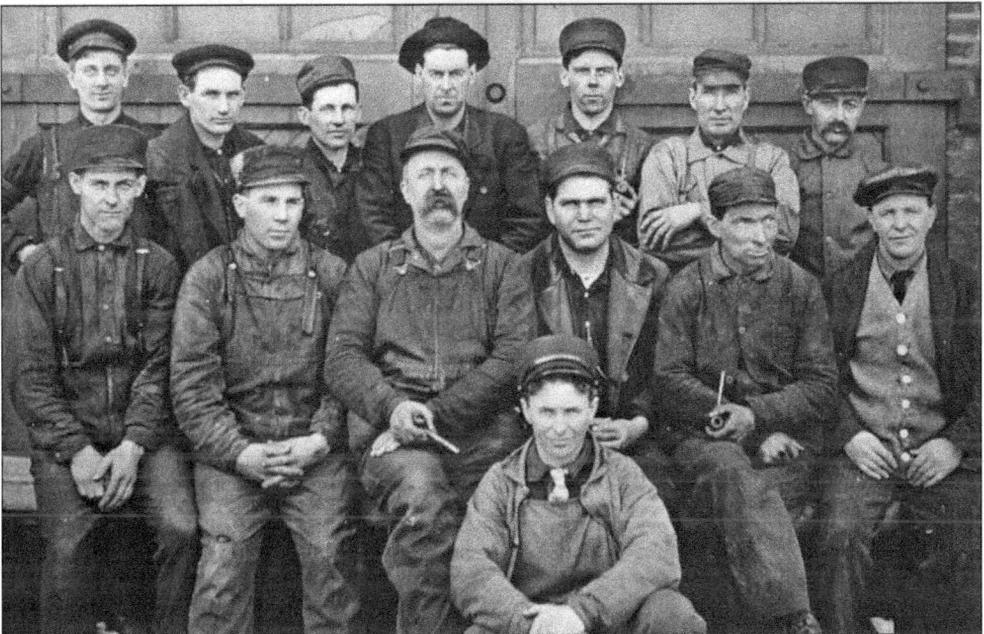

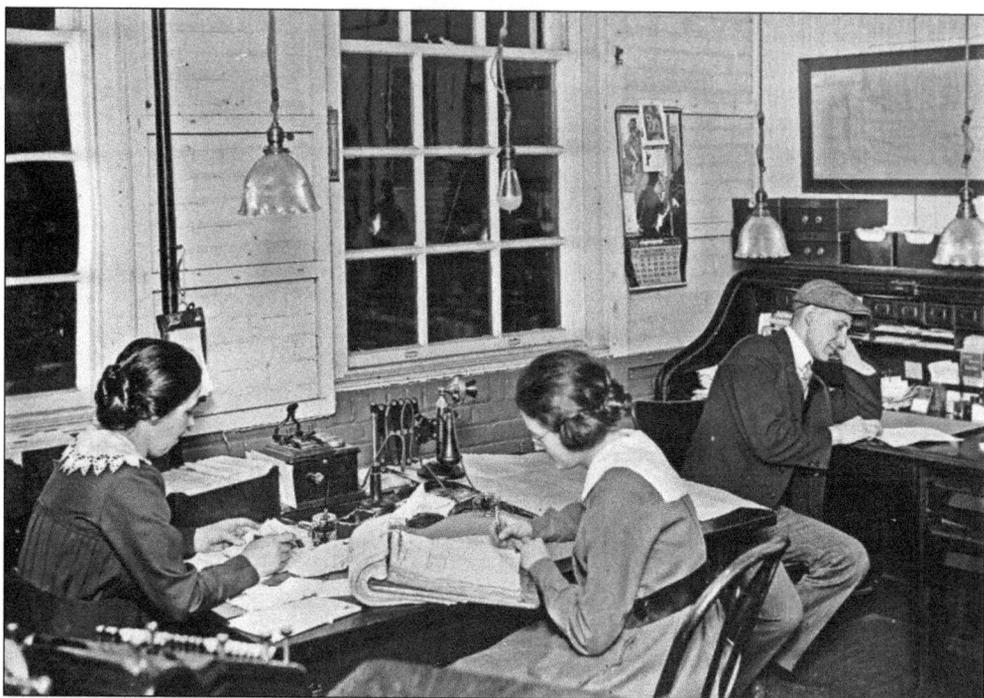

The activity in the shop generated a large amount of record keeping and administrative work. Two unidentified female employees organize the work orders that documented the repairs.

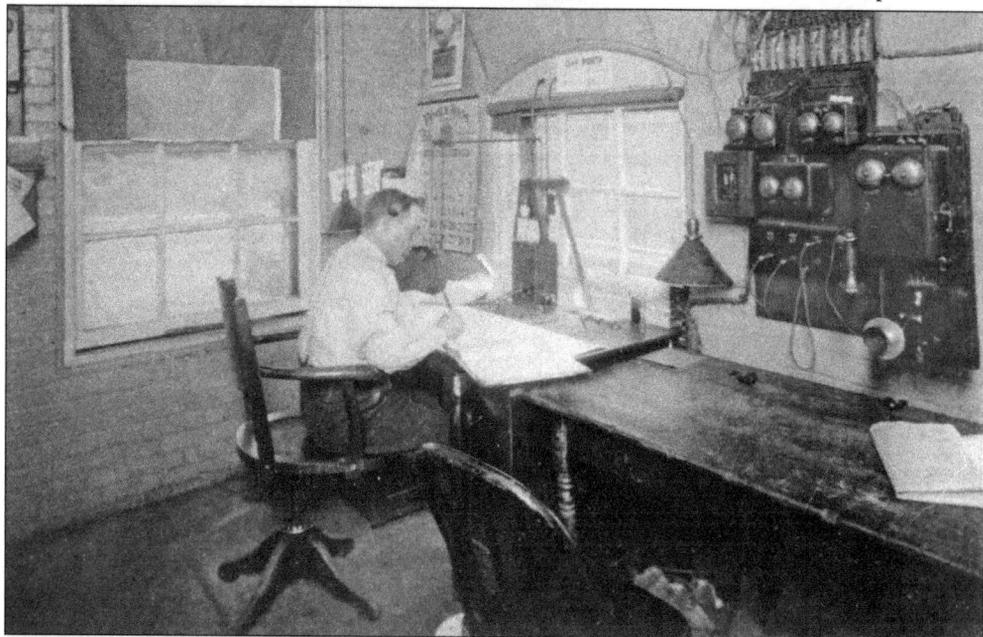

The dispatcher's office was located on the second floor of the carbarn. Dispatchers were responsible for controlling the movement of cars on the line in order to avoid unnecessary delays or, at worst, a collision. Dispatchers monitored the movement of cars, issued train orders, and kept detailed records. Here, the dispatcher makes an entry on a train sheet, a record of all car movements during his shift.

Form T M. 11

The Grand Rapids, Grand Haven & Muskegon Railway Co.

Order No. 9 Date Nov. 29 1917

To Conductor and Mortorman,

No 16 Car No. 3-14-20-18 Coopersville

No 13 No 13-12-10 meet first

and Second No 16 No 3-14 at

Pulliam, Second + third No 16

No 20-18 at Coopersville.

Complete 10:36 a M. Vail Dispatcher

CONDUCTOR	MOTORMAN	TIME	OPERATOR
A. J. Walcott	A. Griswold.		
P. D. Brown	W. A. Bates		16
C. M. Jones.	J. Doster		
A. Bergren	G. Bigford		
H. C. Richard.	E. D. Baur		13
C. VanAntwerp.	L. Harrison		

EACH PERSON ADDRESSED MUST HAVE A COPY OF THIS ORDER.

C. M. Vosburg, C. W. Gibbs

This train order illustrates the complexity of the dispatcher's job. Train No. 16 is a limited bound for Grand Rapids. On this date, it consisted of four separate cars, numbers 3, 14, 18, and 20, all running three minutes apart. Train No. 13 is a local headed to Muskegon, consisting of cars 13, 12, and 10. Westbound trains have the right of way, so Train No. 16 will wait on the siding for Train No. 13 to pass. Because of the number of cars, the trains will use two sidings to pass each other. The first two cars of Train No. 16 will wait on Pulliam siding, between Coopersville and Nunica, for the three cars of Train No. 13 to pass. The process will be repeated at the siding at the Coopersville depot, where Cars No. 18 and 20 will wait on the siding.

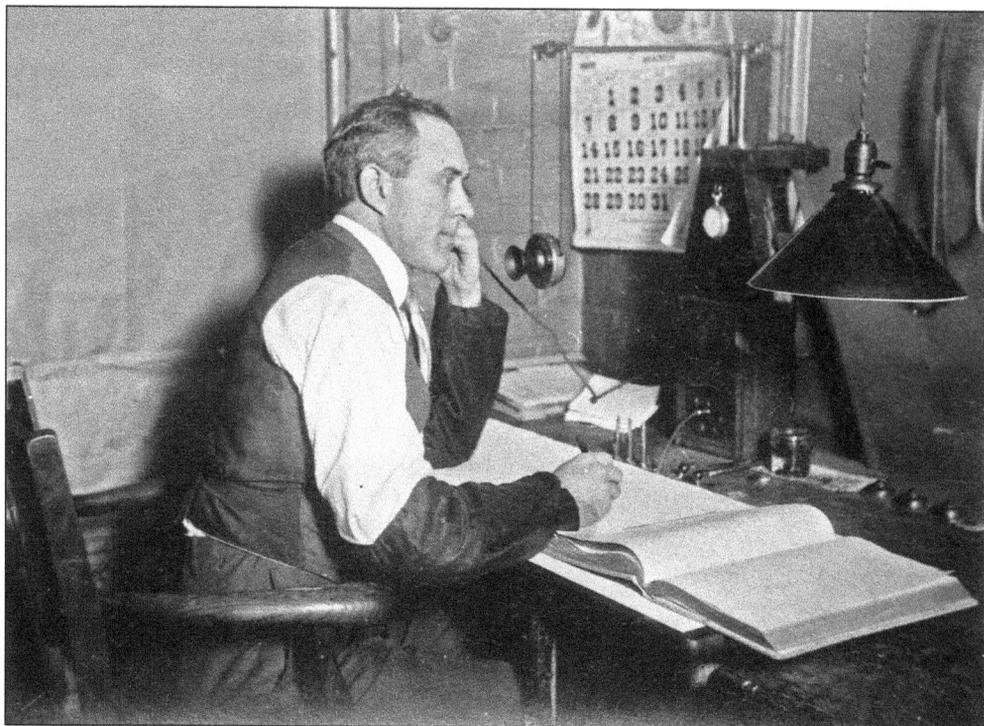

Hermann Schaefer sits at the dispatcher's desk at Fruitport. The pocket watch hanging in the stand in front of him is critical for controlling trains. At the beginning of each shift, dispatchers and crewmembers synchronized watches to maintain consistency as the orders were carried out.

Form TM-4

Grand Rapids, Grand Haven & Muskegon R'y Co.

WATCHMAKER'S CERTIFICATE. No. _70_

THIS IS TO CERTIFY, That on _May 13_ 191_6_

the Watch of _G E Burdsall_ employed as

Conductor on the G. R., G. H. & M. R'y Co.

has been inspected and found to be a reliable Time Piece, and in such repair as will in our judgment, with proper usage, enable it to run within a variation not to exceed forty-five seconds per week.

Name of Maker, _Elg_ _1655/360_

Brand, _379-17 J adj_ No. of Movement, _18296569_

Gold or Silver, _Nikel_ Open or Hunting Case, _O H_

Stem or Key Winder, _Stem_ Old or New, _New_

Signed _J N Wallace_

Watchmaker.

Address _Muskegon Mich_

Knowing the correct time was essential if a crew was to estimate the position of another train and be on a siding at the right time. By law, the watches used by motormen, conductors, and dispatchers were required to be inspected by a certified watchmaker. Shown here is the inspection certificate for Guy Burdsall's watch, certifying that it will not gain more than 45 seconds in a week.

Dispatchers stayed in touch with station agents and train crews by telephone, a new innovation during the early years of the line. Phone booths were placed at key points along the line, such as sidings and Grand Haven Junction. There was also a portable telephone in each car that could be plugged into a jack on line poles along the route. At Fruitport, dispatcher L.R. McNaughton is using one of the phone systems.

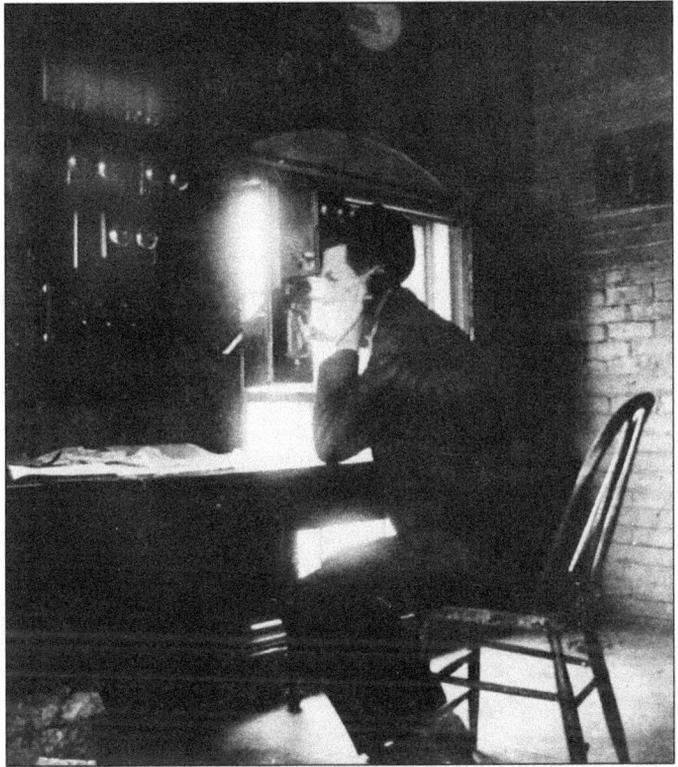

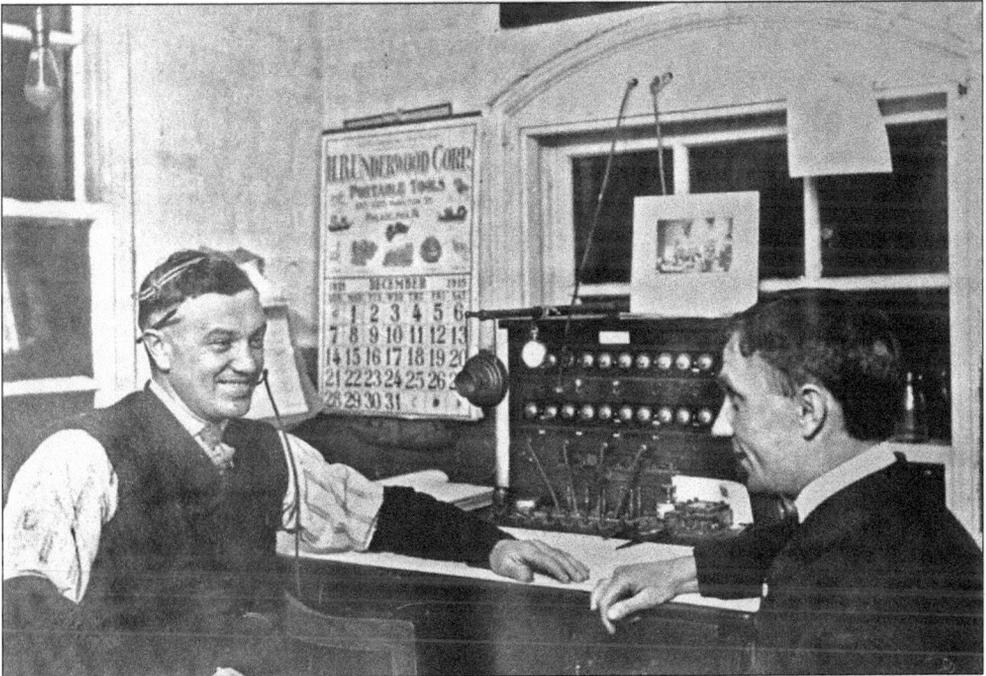

Dispatchers Thomas McEntee and Hermann Schaefer are shown during a shift in Fruitport. The year on the calendar is 1919, and the telephone system has expanded considerably from the photograph on page 110.

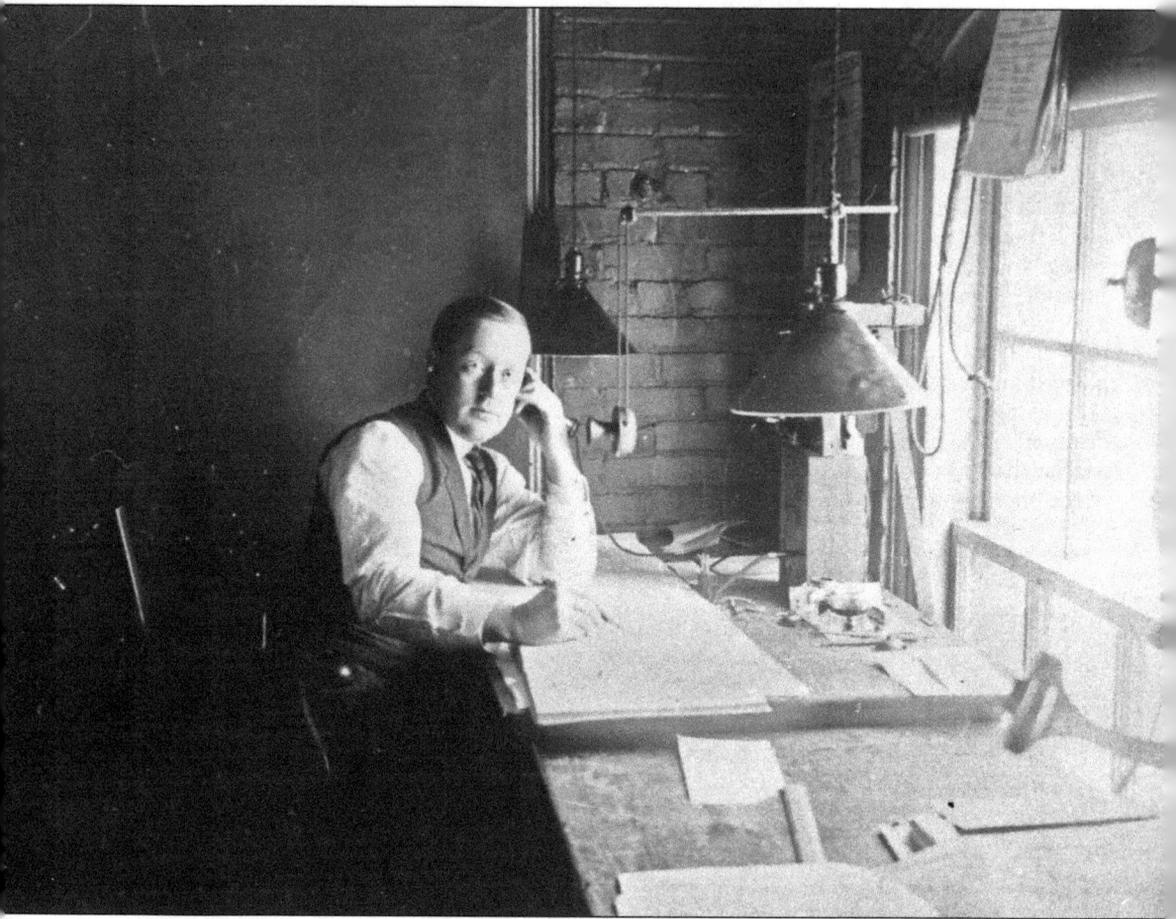

Raymond "Ray" Jubb was the GRGH&M's chief dispatcher for many years. The interurban created new employment opportunities for towns along the way, and Ray was one of three Jubb brothers who worked for the company. Prior to becoming a dispatcher, he had worked as a motorman for the company. He told others that the promotion to dispatcher had likely saved his life. On the day he became a dispatcher, he had been scheduled as motorman on the first train out of Muskegon. The night before, he was told to report to Fruitport instead, and the car he was scheduled to operate was involved in a head-on collision (see page 83).

Carrie DeVries was the station agent at Spring Lake. Agents were an important part of the operation: they ran the depot, sold passenger tickets, handled paperwork for freight shipments, and played an important role in the dispatching system. Agents were responsible for ensuring that train orders were passed on to train crews. Each station was equipped with a semaphore signal. If the arm on the semaphore was extended, the motorman was required to stop the car and check with the agent for new orders.

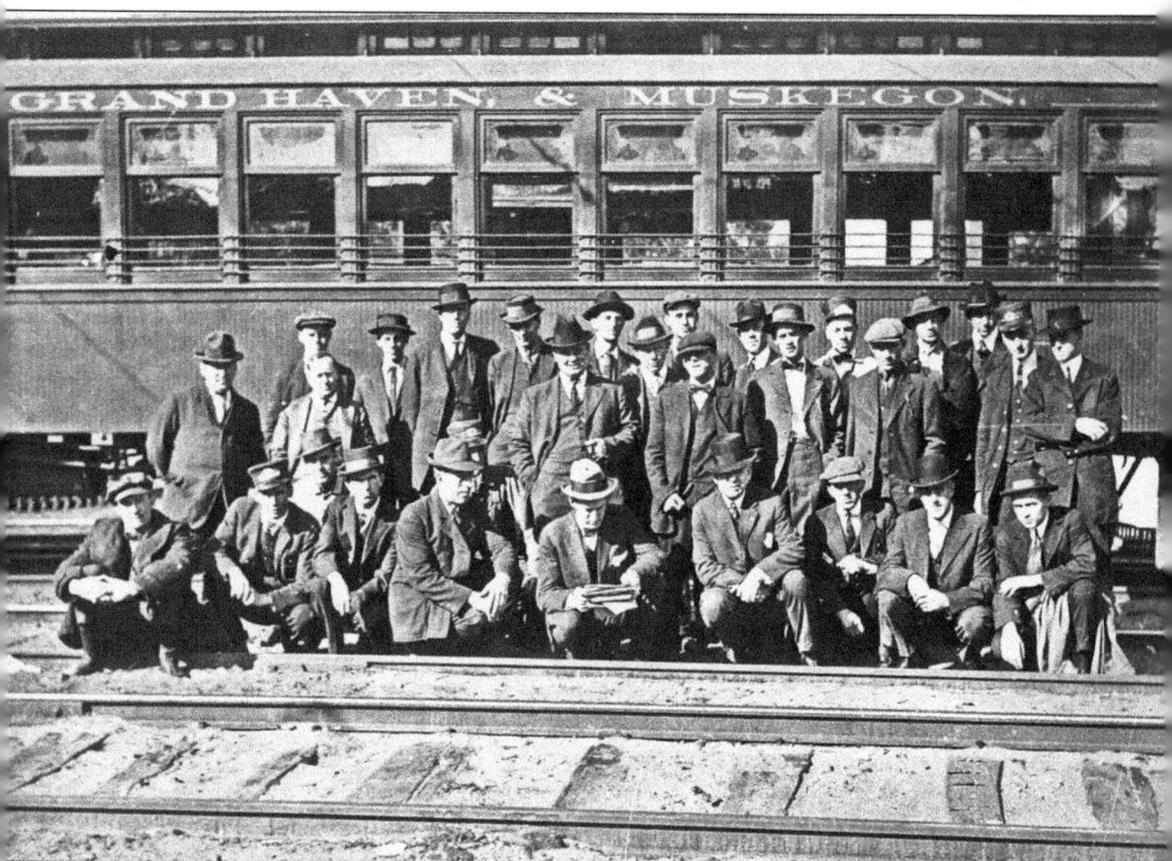

A group of GRGH&M employees poses for a photograph in front of the carbarn at Fruitport. Representatives of both the business and the operations sides of the company are in the group.

Seven

END OF THE LINE

In 1919, Michigan voters overwhelmingly approved a $50,000 bond issue to begin construction of concrete trunk line highways. Soon, ribbons of concrete connected the towns and cities of west Michigan, and motorists took to the roads.

At first, the Grand Rapids, Grand Haven & Muskegon felt little effect. Gross revenues from the line hit an all time record of $668,527 in 1920, and the management felt their prospects looked good. The year 1920, however, was the peak. Revenues declined a bit in 1921 and held steady until 1923. Then the bottom dropped out, and revenues fell to $464,216 in 1924. The company could no longer pay the operating expenses and the interest on its bonded debt.

In 1926, the company failed to make payments on its bonds and was in default. The bondholders sued to foreclose, and the company had no choice but to enter receivership. The line continued to operate in receivership for two years, but it became obvious that without an increase in ridership, the company would not be able to survive.

Service was discontinued on April 8, 1928, the equipment auctioned off, and the tracks taken up for scrap. The interurban era had reached its end.

Fred M. Raymond, the US district judge who presided over lawsuits between United Light and Railways and the bondholders, characterized the reasons behind the closure in his decision on the case: "The entire property, within the space of a few years, became worthless as an interurban railway, for want of patronage . . . and the almost universal use of the automobile for short journeys, largely eliminated the demand for the type of service for which this public utility was designed."

In short, the riding public had moved on. The automobile and the concrete highway had opened a new era of personal transportation that would transform both travel and the American landscape in the coming decades. And the interurban service that had seemed so convenient and efficient just yesterday had become a relic of the past.

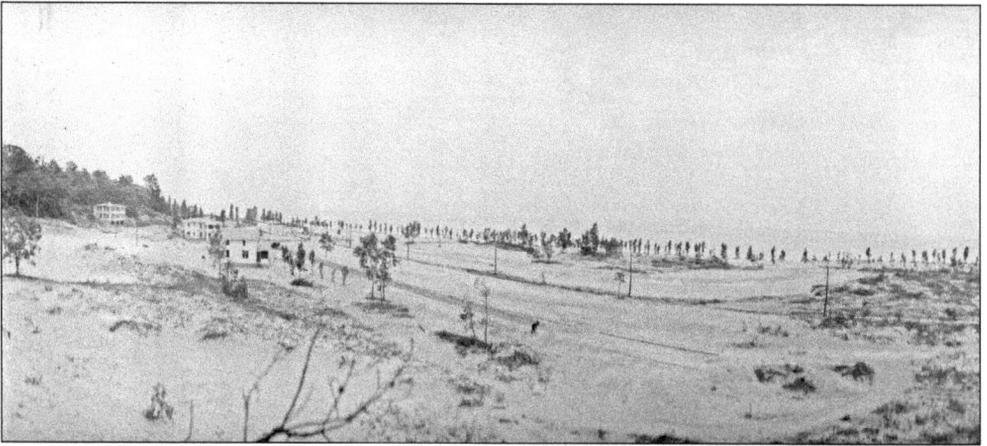

These two photographs illustrate the problem faced by the GRGH&M in the 1920s. The picture above shows the area at the mouth of the Grand River channel as work to develop Grand Haven State Park was just beginning. The beach is largely undeveloped. The image below, taken a few years later, shows the park with development complete. With the completion of the road, visitors to the park began to arrive in scores of automobiles, rather than by interurban, and ridership to the beach began a steep decline.

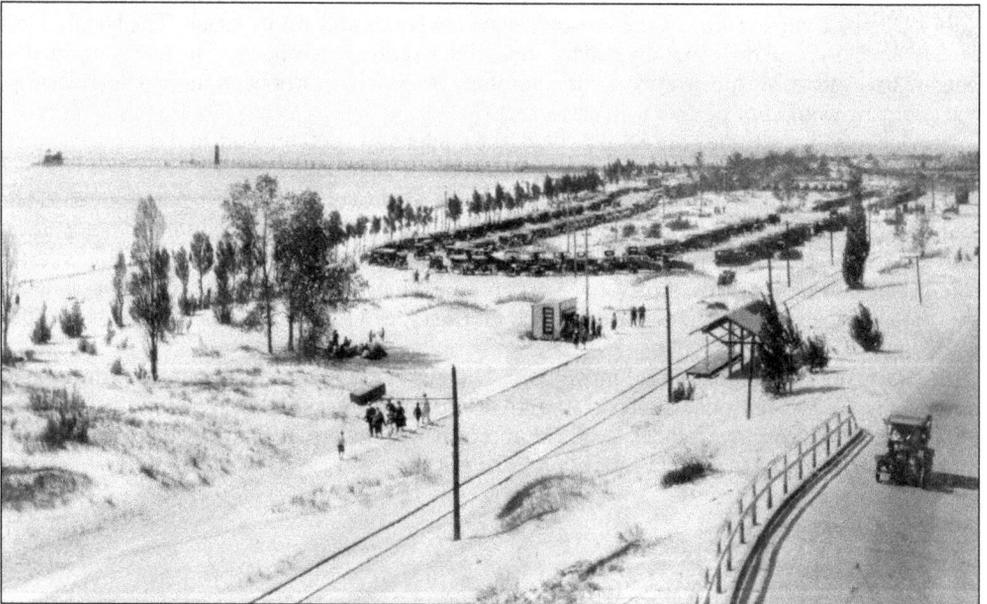

The freight service offered by the GRGH&M suddenly faced stiff competition from independent trucking lines. To compete, the Lake Line began to offer door-to-door freight services. The company purchased a fleet of trucks that picked up and delivered freight in Grand Rapids and Muskegon. The shipments were consolidated at freight houses and moved between cities by the freight motors. In addition to delivering freight in Muskegon itself, the trucks ventured north to Shelby, Hart, and New Era in Oceana County.

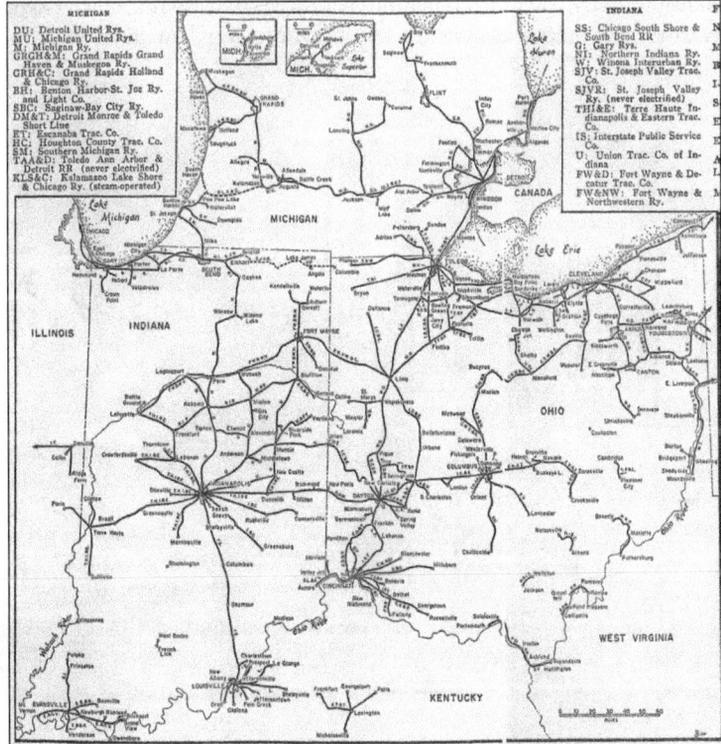

The company also became a member of the Central Electric Railway Association and began to exchange freight with other interurban lines. Freight from the lakeshore could be transferred to the Michigan Railway in Grand Rapids and delivered in Battle Creek, Jackson, Detroit, or cities in Indiana and Ohio.

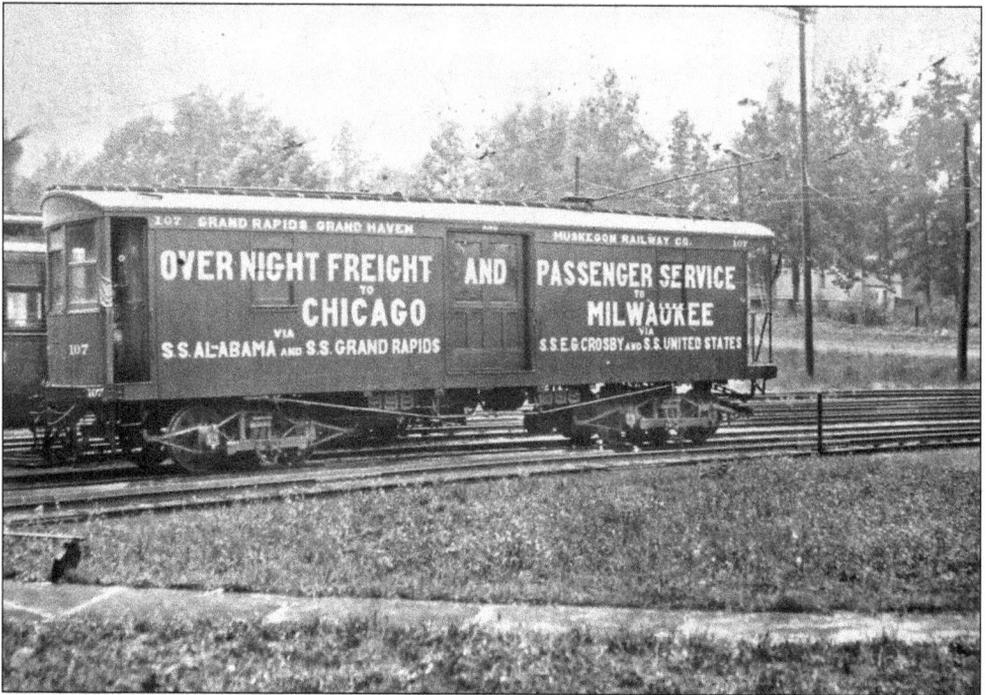

The company turned its freight motors into rolling billboards, advertising the advantages of shipping by interurban. The car pictured above highlights the steamship connections to Chicago and Milwaukee. The slogans in the photograph below take direct aim at the emerging trucking industry. Early trucking companies were known as "wildcat" truckers, emphasizing their ad hoc nature. Many motorists blamed trucks for causing damage to the concrete highways.

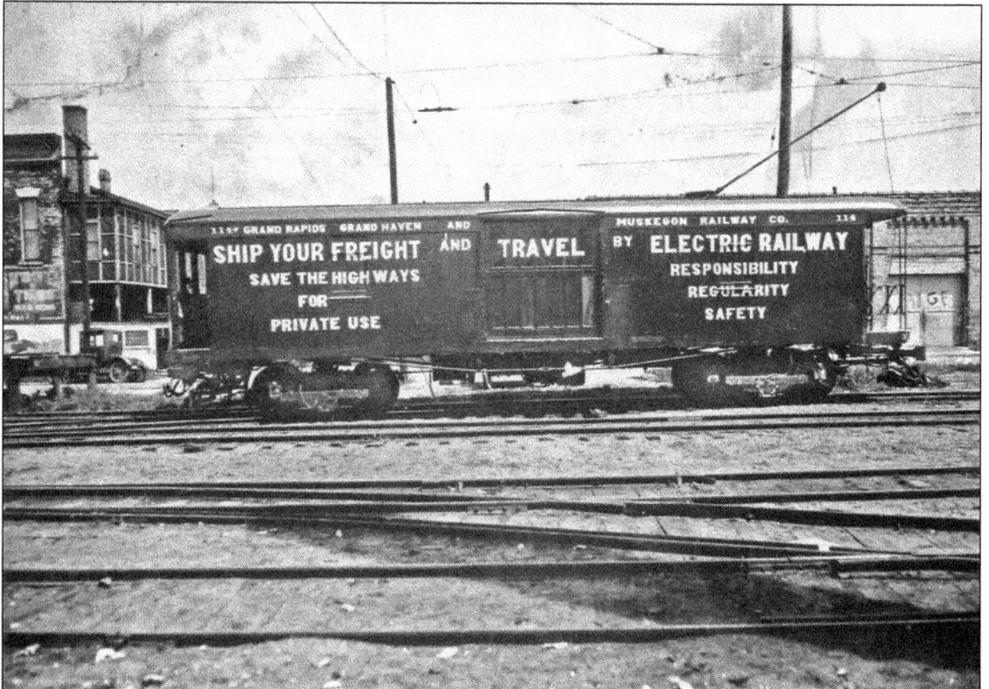

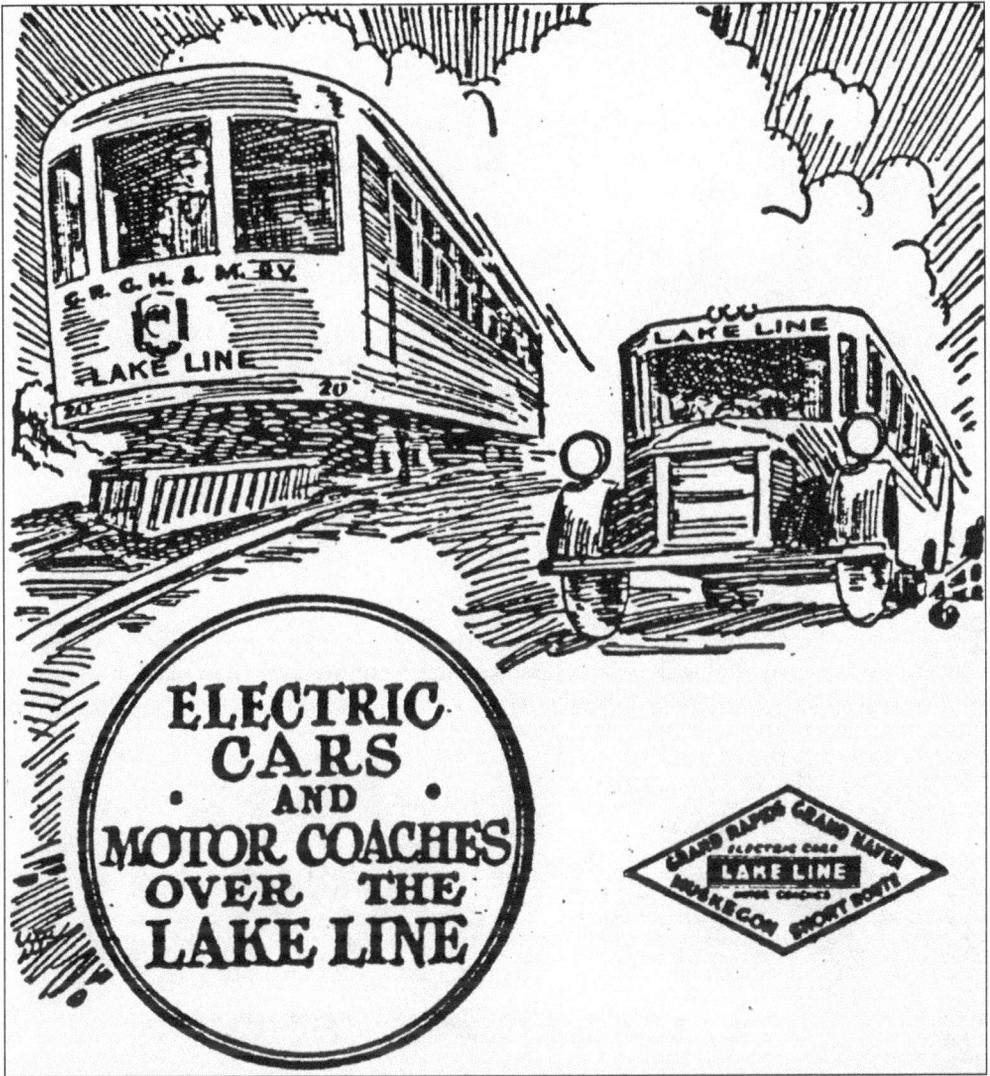

ELECTRIC CARS AND MOTOR COACHES OVER THE LAKE LINE

Interurban companies also began to face competition from bus lines. Although many bus operators were independent, organized bus lines began to appear. A forerunner of Greyhound began carrying passengers in west Michigan and eventually, directly to Chicago. The Lake Line responded with its own fleet of buses. During its last days of operation, the company used buses to cover the less crowded periods in the middle of the day and ran the larger interurban cars during the morning and evening rush periods.

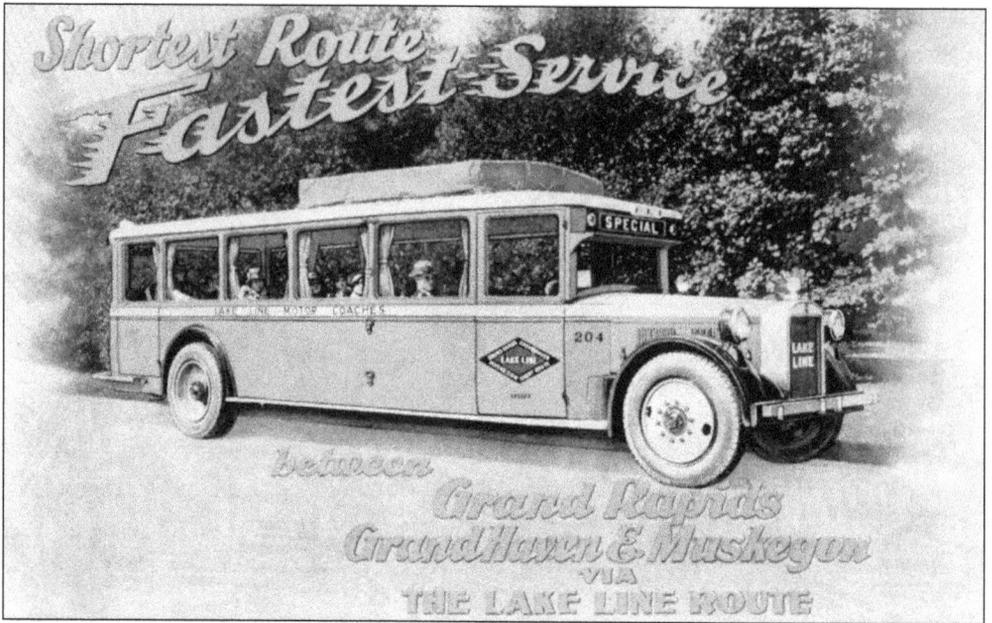

Shortest Route Fastest Service

SPECIAL

204

LAKE LINE

LAKE LINE MOTOR COACHES

between

Grand Rapids
Grand Haven & Muskegon
VIA
THE LAKE LINE ROUTE

The Lake Line buses were painted orange to match the interurban cars. They ran on the new concrete road that passed through Marne, Coopersville, Nunica, and Spring Lake. This highway connected to a north-south route running to both Grand Haven and Muskegon. The highways virtually duplicated the route of the GRGH&M.

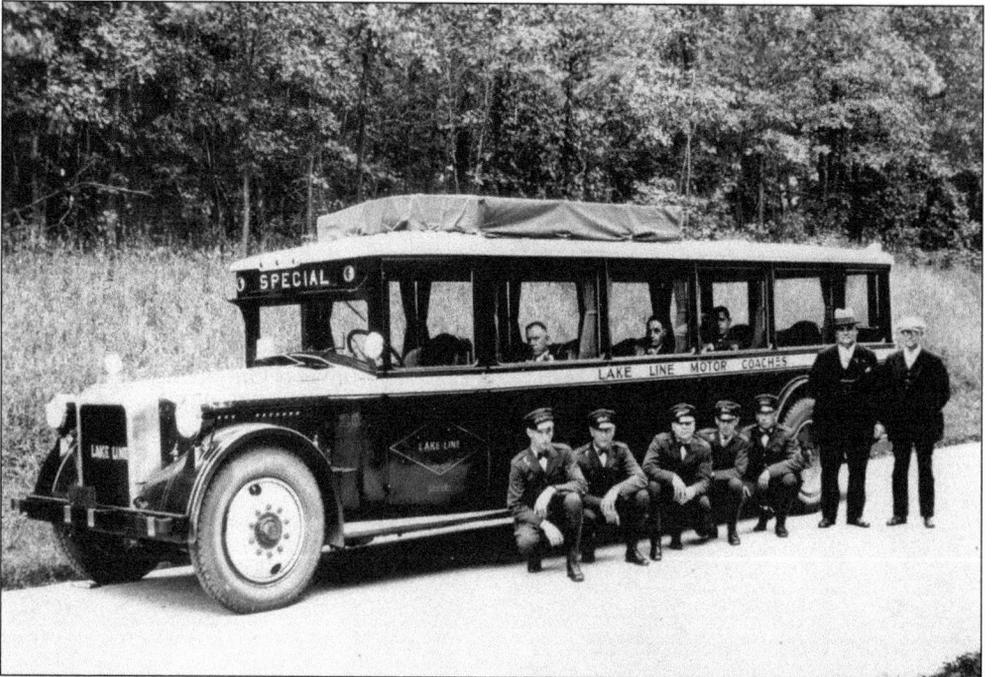

SPECIAL

LAKE LINE MOTOR COACHES

LAKE LINE

Lake Line motor coach drivers pose in their new uniforms. Crouching from left to right are Fredrik Rickard, Patrick Patterson, Earl Averill, Harry "Frenchie" French, and Howard Rickard. Standing are the master mechanic for the line, George Bigelow, and at far right, an unidentified professional Greyhound driver brought to instruct the line's new bus drivers, all prior interurban employees.

This photograph was taken on the Lake Line's last day of operation, April 8, 1928. The photographer stood just east of the interurban crossing at State Street in Nunica. The station and its semaphore are visible behind the houses.

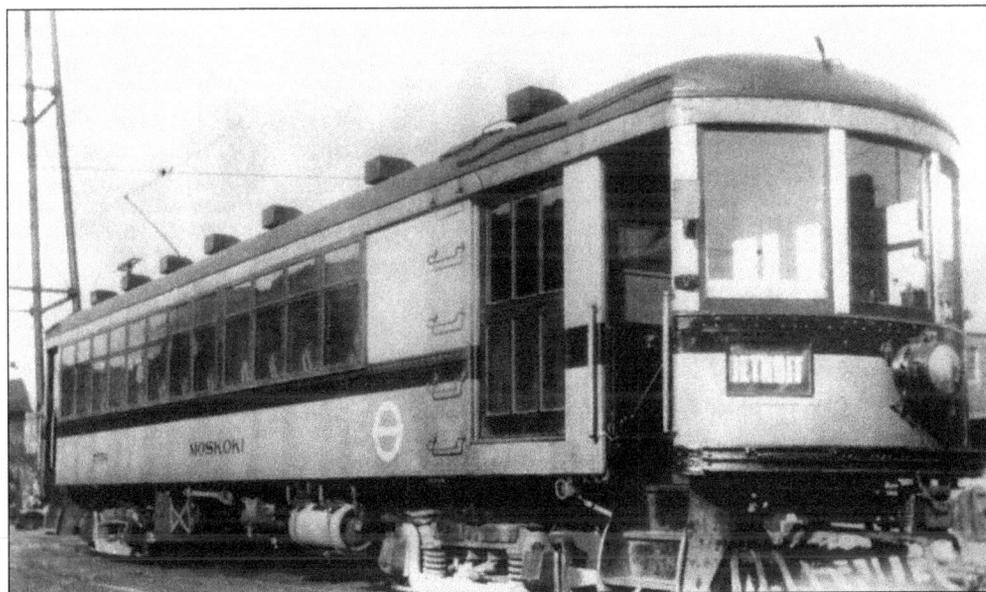

After the shutdown, the court ordered the equipment sold at auction. Several of the newer cars were sold to other interurban railways. Car No. 20, the newest passenger car, was sold to the Detroit United Railway (DUR). This photograph shows the car, now the *Moskoki*, in the DUR paint scheme.

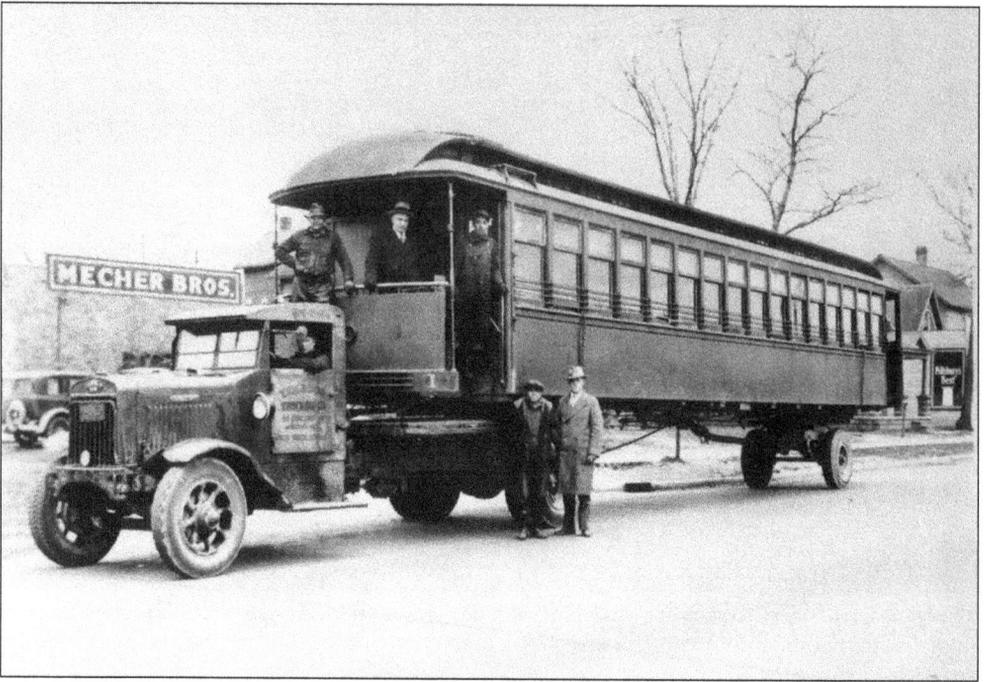

The older wooden cars were sold for other purposes. Some became field offices for construction firms and other businesses. Others became lake cottages, diners, or even homes. Here, Car No. 1 has been loaded on a truck, on its way to become a residence.

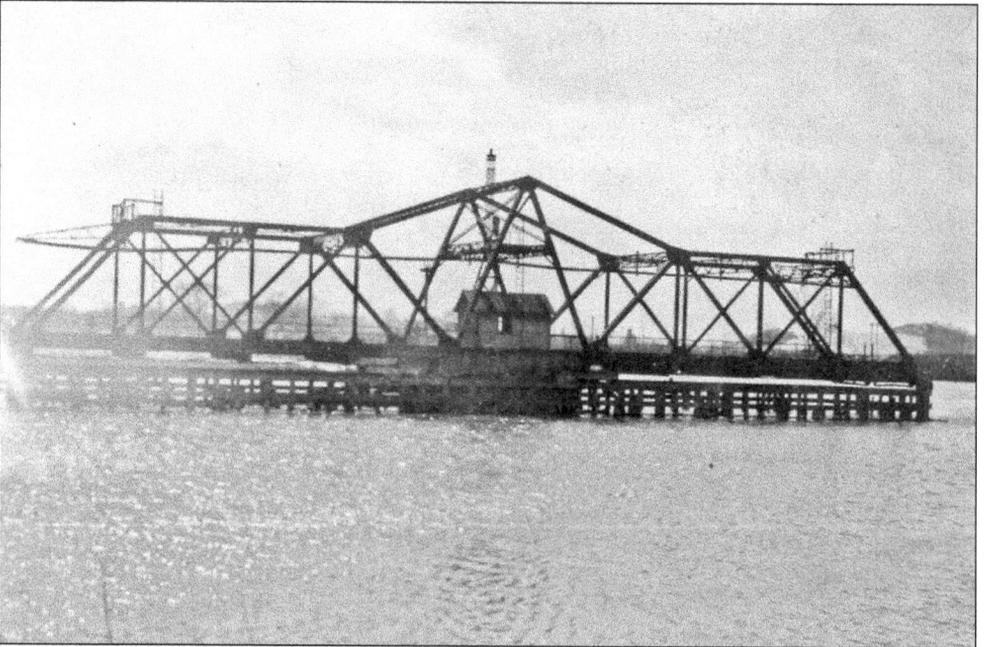

Track and other metal structures were dismantled and sold as scrap. In this photograph, the swing span of the bridge at Grand Haven awaits the scrapping crews. The north and south approaches have already been dismantled, leaving this disconnected framework in the middle of the river. (Courtesy of the Ottawa County Michigan Road Commission.)

EPILOGUE

An interurban railway will persist in the landscape long after it ceases to operate, and so it is with the Grand Rapids, Grand Haven & Muskegon Railway. In areas where the land has not been disturbed, sections of the right of way still stand quietly. Grades, cuts, fills, even occasional bridge pilings in creeks are all in place.

Other stretches of the roadbed have been adapted for reuse, mostly for automobiles. The State of Michigan purchased sections of the right of way and used them to expand its trunk line highway system. Interurban cars once traveled sections of Airline Road in Muskegon County, Apple Drive in Ottawa County, and Remembrance Road in Kent County. Other sections of the former right of way were purchased by electrical power companies as right of ways for their power lines.

The buildings and structures of the interurban have found new use as factories, offices, and restaurants. The shops and carbarn still stand on West Fruitport Road in Fruitport, and the Berlin depot serves breakfast and lunch in Marne. The Walker substation and depot is currently a veterinary clinic along Remembrance Road. The other original depot and substation in Coopersville was used by a garden club for may years before becoming the home of a historical museum.

Even the cars have found new uses through the years. Several provided Depression-era housing for families, mostly in rural areas. Car No. 8 became a diner and gas station and later a home. Today, Car No. 1 is still in use as a river cottage, and Car No. 8 is undergoing restoration at the Coopersville Area Historical Society Museum.

In the early 1980s, Jack Rollenhagen, a Nunica resident who assembled much of the photograph collections used for this book, sought out the remnants of the line and photographed them. To conclude the book, here are some of Rollenhagen's images, as well as others in the collection.

In the aftermath of the line's closing, parts of the right of way became places for exploring. Here, a group of children tours the line near Nunica in a homemade handcar. The boy in the center is a young Jack Rollenhagen. Rollenhagen was fascinated by the interurban and assembled the core photograph collection used in this book.

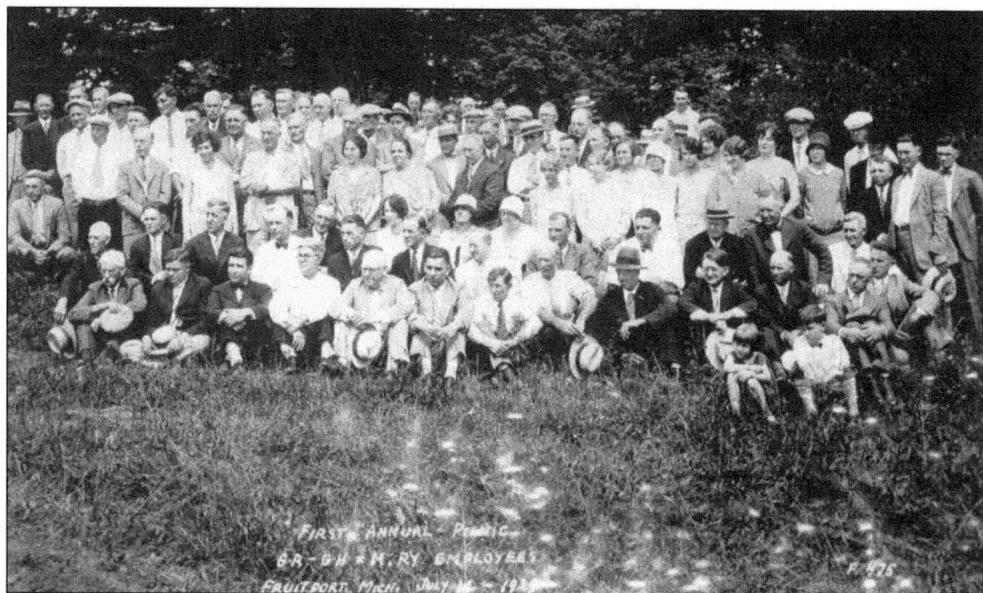

Although no longer employed by the GRGH&M, the former employees felt connected by years of working together. They organized a GRGH&M employees association and continued to hold reunions for the next 40 years. This photograph shows the group at their first reunion, held at Pomona Park in Fruitport, the former site of the company's Pomona Pavilion resort.

124

Many of the company buildings continued to be useful structures but served other purposes. This photograph of the Fruitport carbarn was taken in the 1980s. The structure has been slightly altered to serve as a factory.

This photograph shows Car No. 1 adapted as a lake cottage. After passing through a series of owners, the car body settled into northwestern Allegan County, where it has stood for many years. The adaptation has disguised many of the car details, but the window, windowsill, and trim boards all provide clues to the cottage's true identity.

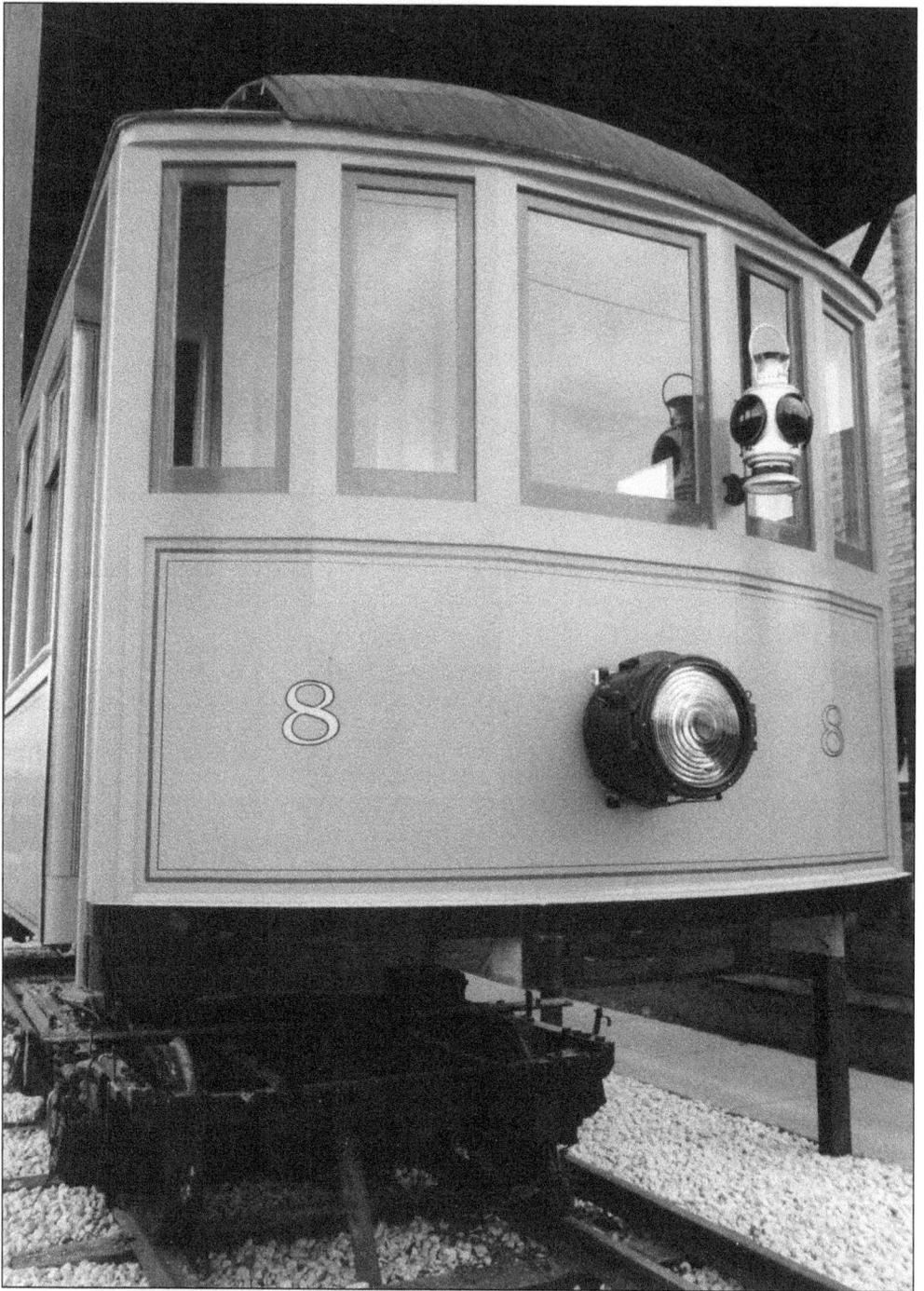

Car No. 8, *Merlin,* is shown at its current location, the Coopersville Area Historical Society Museum. After 27 years as an interurban car, *Merlin* became a diner and gas station in northern Muskegon County during the Depression years. Later, it was a residence in the same area. In 1990, the car was brought to the museum, where it has been undergoing restoration.

About Coopersville Area Historical Society Museum

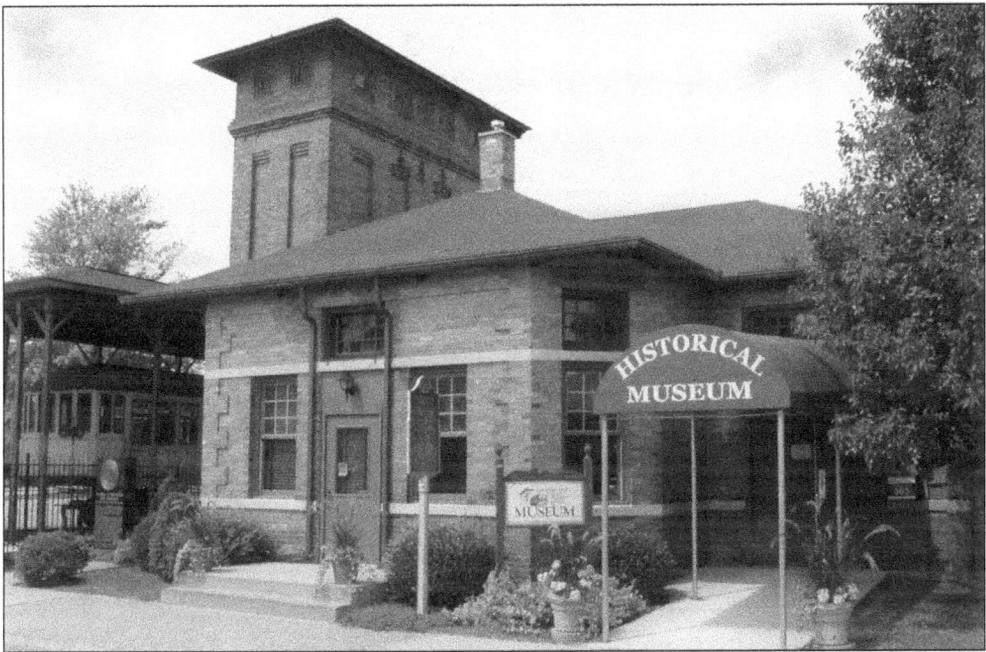

A considerable amount of Grand Rapids, Grand Haven & Muskegon Railway history has been preserved at a location that was so much a part of the line throughout its operation: the Coopersville Area Historical Society Museum at 363 Main Street, Coopersville, Michigan. From 1902 to 1928, the main museum building served as a depot and substation for the GRGH&M. Materials, photographs, and artifacts from the line have found their way into the museum collections throughout the years.

The former depot and substation portion of the museum is an official Michigan Historic Site and is listed in the National Register of Historic Places. The structure is said to be one of the best preserved of its kind in Michigan. With its tall tower and vintage red brick exterior, the building is a town landmark.

Another rare survivor of the GRGH&M era sits beside the museum—Car No. 8, *Merlin*. This rare wooden-body passenger car was acquired in 1990 before it was to be destroyed. Car No. 8 continues to undergo restoration.

Besides preserving interurban history, the museum, established in 1988, has on exhibit other types of railroad collections and much local and regional history.

Visit us at
arcadiapublishing.com